BRING ME
OF SAL

NIGEL ELY

BRING ME THE ARSE OF SADDAM

First published in Great Britain in 2017by
Trebletap Books
© Nigel Ely 2017

This edition published 2021

www.nigelely.com

ISBN 978-09956605-0-2
Front cover photograph taken by the author of two US Marine Corps CH-46 Phrogs during the battle for Al-Nasiriyah.

Cover design by John Amy
www.ebookdesigner.co.uk

To the fallen.
To the wounded,
both physical and mental.

ACKNOWLEDGEMENTS

Special thanks are due to Sheikh Homoud, Brigadier Abdul, KA, Rtd. Colonel Reed Bonadonna, USMC, Rtd, JY, Nick Purnell and all the Sky News Maverick Team, Duncan Raban for his kind permission to use his Arse on The Run collection of photos, Andrew Cameron, Linda and Eran Bauer, and of course the ever-tenacious Jim Thorpe.

For operational reasons,
the names of certain individuals
have been changed.

ABOUT THE AUTHOR

Nigel 'Spud' Ely's soldering career in the Parachute Regiment, the SAS, as a military consultant and as a war photojournalist has taken him to some of the most deadly, high-octane, violent battles of the modern era.

From Northern Ireland, the Falklands War, to Africa, Afghanistan and Iraq, Spud has been in the tick of the most ferocious and disturbing fighting of modern times. He writes with passion, pace and the knowledge of someone who's seenit and done it—because he has. His style is gritty and no-nonsense, indicative of his background. His books exude authenticity as he writes from first-hand experience. The true gauge of his fast-paced, in-your-face is that men who have been to the dark places Spud has been to recognise itsauthenticity.

Also by the author

FIGHTING FOR QUEEN AND COUNTRY
One Man's True Story of Blood and Violence in the Paras and the SAS.

NO FEAR
The True Story of My Deadly Life After the SAS.

GUN FOR HIRE
SAS to CivvyStreet.

www.nigelely.com

BRING ME THE ARSE OF SADDAM

INTRODUCTION

I was the first person in the world ever, to be arrested by British Police, bailed seven times and threatened with a ten stretch for breaching the United Nations Sanction—Iraqi Cultural Property Order of 2003, Article 8, (stealing or knowingly taking Iraqi cultural proper). Now, I know what you're thinking, do I hold that up as a badge of honour? Well yes, of course I do.

The cultural property in question, was a large piece of bronze. In fact, it was Saddam Hussein's left buttock from that iconic statue the US Marines pulled down in Baghdad of 2003. Well, years later, I was arrested while trying to sell it to raise money for The Royal Centre for Defence Medicine and the American charity, Hope for The Warriors.

This book covers the war for Iraq and my daring journey up to Baghdad. I then move to a more satirical tone as I fight against the British Establishment for the legal ownership of the bronze arse, and at an attempt to get a settlement with the Iraq Government who were claiming it for themselves. However, as we get to the critical stage of negotiation, the British Police said they had lost their file on the arse! Oh, please dear God no, not that old chestnut! Then a little while after, I took a trip to Kuwait where I bumped into an American Islamic art dealer, and he of course knew of the arse story, and suggested the bronze could be worth anything from $7,000,000 to $10,000,000, quoting the tale of the Mona Lisa, 'A ten buck painting at a garage sale, but only came to provenance when it got stolen,' he said. So, with that in mind, the arse went on the run.

Now, I'm an old soldier, but not the type one might visualise sporting a handlebar moustache and a blazer full of medals, but one of an army of veterans post World War 2 who, barring one year, 1968, have been in constant skirmish with the enemies of Her Majesty's Government, and like many of my fellow old and

bold, I've formed the British Square on more than one occasion and held it too!

I've still got all my limbs and most of my bodily functions still work, so I can say I'm still running on eight cylinders, albeit a bit smoky, but as I hurl through this period in my life, they call middle age, I have become astutely conscious of my own mortality. I think about it a lot these days in a way which may have shocked me ten years previous. I have this urge, or call it a need for myself maybe, to help those who have not been so lucky in combat. I can't say I've ever been a charitable man, but just the thought of helping fellow soldiers brings me such an inner strength. Have I found God? No, I doubt it. I put it down to part humanity and part survivors' guilt.

When a US Marines tank recovery vehicle pulled down that statue of Saddam Hussein in Firdos Square Baghdad on 9 April 2003 we were all told by experts, those political elites and those war mongers Blair and Bush it signalled the end of another tyrant and another Gulf war. It made world headlines, and that single powerful image went whizzing around the world in seconds, even before the statue had crashed to earth. It was truly amazing the speed at just how quickly the Saddambronze entered the homes. Mind blowing to many of us non-techy types at just how far the world of telecommunications and the internet had advanced since the first Gulf war in 1991.

Every war produces powerful images, and they don't have to be bloody either, yet they took time to reach the masses, and no doubt a certain amount of brushing up would have taken place beforehand, and sometimes it may have taken only a single photo to sum up the futility. There are some notable images from recent wars; take the Vietnam War, well it has to be the one of a young naked girl fleeing a napalm attack, or how about the photo taken by Eddie Adams of a Vietcong prisoner being executed via a shot to the head. Incredibly shocking to the viewers back home in the West. What about the piles of hundreds of Argentine rifles and helmets strewn around the battlefield of Goose Green during the Falklands War of 1982? In Gulf War 1, I would go for that smoky black against a bright orange sky of the burning oil fields in Kuwait, or that rather

nasty aerial shot of utter carnage, slaughter and destruction over Kuwait's Mutla Ridge where 80,000 retreating Iraqi soldiers were wiped out at a rock formation aptly nicknamed Death Valley. All these images instantly tell the viewer all they needed to know. Ask the same question to people about Gulf War 2, then I would suggest the toppling of the Saddam Hussein statue. What other image defined that war? And I never thought for one moment a piece of this dictator's arse would cause me so much hassle.

Ok, my life's complicated, it's been full on with in-your-face conflicts and other people's crap for far too long, and yes, I agree, it is about time I addressed some of these issues, and I have, but back in 03, I was the first un-embedded journalist to cross the border from Kuwait into Iraq on Day 1 of the liberation or invasion of Iraq, depending which side of the fence you sit on, and was one of the first un-embedded journalists to enter Baghdad too if not the first. I then found myself standing over that famous statue just hours after it had been toppled, where a US Marine armed with a sledge hammer broke a piece off and gave it to me as a memento. What a rather a nice gesture I thought.

For years it sat in my garden shed until a divorce finally forced the arse out into the open. Although it didn't form part of the matrimony estate, as it had no perceived value (it may well do now!) I thought it would be a nice gesture to sell it at auction as an object d'art lot, and to see what money it could fetch for military charities; after all, without the support of the British and American Army and the United States Marine Corps; their loss, their courage and self-sacrifice on the fight up, I would not be alive today, no question about that! And to give the bronze more appeal, its own genre, I coined the phrase War Relic Art.

When I put the arse up for sale I was amazed and truly humbled at just how much worldwide media interest it commanded. A Chinese businessman offered a large six figure sum, but as generous that offer was, especially for its first outing, I thought I should push for a bit more. I took professional advice and moved the estimate up to £250,000, but this is when my troubles started. Apparently, some

apparatchik in the Iraqi Government smelt money, easy money, so picked up the Iraqi equivalent of the Bat Phone hit speed dial then gripped ear of the local British Foreign and Commonwealth Office appointee bureaucrat, and I can just imagine how the conversation went.

'One of our arses is missing,' the Iraqi apparatchik shouts down the phone.

'Oh, sir, sorry to hear that, sir. What one, sir?' chirps Bureaucrat Three Bags Full Sir, from inside the security of the British Embassy, Baghdad.

'The Mother of all arses you idiot. The Arse of all evil, and I demand it back.'

'Of course, sir, I fully understand sir, but what's in it for me sir?

'Just bring me the Arse of Saddam, and bring it now.'

'Oh, righty'o sir, yes sir, wilco sir, over and out sir.'

Bureaucrat Three Bags Full Sir, hangs up. Ah, he thinks, Christmas has come early. Then a weak and subservient British Government jumped to attention and did what it can do oh so well, and racked up a mass of unnecessary legal costs to the British taxpayer.

As the wheels of the British Establishment spun in toaction, I got a tip-off from a friend in the Security Services telling me the Police were coming mob-handed to get the arse. A Police Sergeant was assigned to find the arse and to take down the thief. He was so eager to please his Master.

'Don't worry, sir, no arse will be left unturned. And no sir, I will not turn the other cheek. I'll get the thieving slag, you can count on me, sir!'

So, in full expectation of a promotion to Inspector, the Sergeant was dispatched in hot pursuit of me and the arse. Had the Police just gone plain raving bonkers? Had we moved to DEFCON 2? Who was pushing the buttons of the British Establishment? And just who was dropping the full weight of the law down on me and why?

PART ONE

1. The Plan

I was working out of Kuwait long before Gulf War 2, Operation Iraqi Freedom 2003. Operation Iraqi Freedom was the name given to the US-led invasion, while Operation Telic was the name given to the British-led invasion. In fact, my time in Kuwait goes back to Gulf War 1, Operation Desert Storm 1991. Operation Desert Storm was the name given to the US-led liberation of Kuwait while Operation Granby was the name given to the British-led liberation of Kuwait. Confusing I know, but here's a secret, for several months leading up to Operation Iraqi Freedom, the military air traffic above the skies of Kuwait during the hours of darkness was very busy, yet no journalist I knew, ever reported on it, and no news outlet ever covered it, but all who lived in Kuwait, (Kuwait has one of the brightest night skies of any country with very little light pollution) during this time, knew for certain, Iraq was going to be on the receiving end of some very nasty ordnance, no doubt about it. So, it was no big surprise to me when the war monger and war criminal Tony Blair and his front bench voted in total defiance against the United Nations and invaded Iraq. I'm guessing here now, but this is probably because they weren't the ones going to fix bayonets and close with the enemy!

Back at the beginning of February 2003 I was standing on the old stone bridge in Hereford. Hereford is the capital of the county of Herefordshire, and in my opinion one of the best kept secrets in the entire United Kingdom. Herefordshire parallels that part of the Welsh border where one can see the start of the Welsh Black Mountains and Brecon Beacons National Park. Hundreds of years ago the English and Welsh were forever invading each other over this mountainous terrain. Cross border incursions were the norm, but these days it is quite a most glorious place to live. Quiet, rural, and still untouched by 21st Century correctness. Indeed, you ask the average Herefordian what's so special about the old bridge, and they will

surely say, 'Well, on a Sunday morning, you can legally shoot a Welshman with a bow and arrow of course.' I just love folklore! The old bridge was built in 1490. It spans the River Wye which flows around the City flows around the City. Hereford is famous for many things; its cider, the SAS (Special Air Service) and of course Hereford Cathedral which houses the Mappa Mundi or world map in Latin, the oldest known medieval map of the world. It depicts the world as seen in the 1300s and shows Jerusalem at the centre, and other places such as the Garden of Eden and the great Euphrates River, yet unbeknown to me or indeed the rest of the world, in just a few weeks the biggest battle in the biggest war for a generation was going to be fought across a bridge which spanned the great Euphrates, and I was going to be standing on that bridge in witness.

Life's a funny old business, because while I was looking upstream, enjoying a light winter dusting of snow watching the flurry of small fry breaking the water surface in the reaches, as a pike chased his supper, an old army buddy came walking across the bridge, JY, a tough, no nonsense Scotsman. We had served together in the Paras and 22 SAS and I hadn't seen him for a few months. We shook hands.

'Nice tan. You still in Kuwait?' JY asked.

'Yeah, flying back Sunday. I'm going to cover the war when it starts.'

'What! On your own?'

'Yep, gonna bluff my way right up to Baghdad if I can.'

'Funny that, I'll be there too.'

'What!'

'I've been contracted to run the security for the Sky News team.'

'Good effort mate,' I replied.

'Could do with your help in Kuwait!' JY asked.

JY was going to lead a five-man team into Iraq to follow the coalition forces. Back in Gulf War 1, Sky News was in its infancy, only launched in 1989, so didn't cover that war with much opinion, however, this time, they were determined to make up ground.

Since 1991, I've built up strong business ties in Kuwait and my plan was to use them to assist me in crossing the border on D-Day and to become the first un-embedded photojournalist to enter Iraq from the south. It was a massive challenge and an even greater personal risk, because for a start, I lacked the proper comms like a satellite phone and medical backup. Getting in, or to the right place for the story wasn't really a concern, I knew I could do that as well as anyone, else if not better, but filing my stories back to the UK, or getting immediate and correct medical treatment for a sucking wound to the chest, pray no, was another.

I've been around wars and conflicts long enough to know that one minute you can be on top of the world, confident with strength in numbers, enough ammo and a fresh brew to hand, then BANG, with the next second you could be lying there all fucked up with life seeping out of your body with only the will to survive. Watching one's blood pissing out of one's body and into the ground of a foreign land isn't the ideal situation to find yourself in, so common sense told me I needed to team up with someone who could cut it should it all go tits up. Someone who would have access to a good line of comms, and who had the ability to slap on a field dressing. Kuwait had a good mobile network, but it was patchy at best up on the border region, and non-existent across in Iraq. Satellite communications via a Thuraya handheld phone was only one of two sat comms systems available in-country, and the by-the-minute charge was truly expensive. Sky News would have these phones, and common sense also told me, JY was my only safe option. We arranged to meet up in Kuwait.

2. Break for the Border

Kuwait City was in full desert storm mode. Thirty-knot winds were driving a blizzard of hail sandstones, some the size of golf balls hard across the city, smashing into buildings, raining down on vehicles and knocking off their feet all unlucky enough to be caught out in it. Later, when the hail passed, a dry wind got up and lifted tons of sand from the flat open desert up into the atmosphere only to dump it down again hours later allover the city, leaving rivers of sand criss-crossing roads causing skid-row and gridlock. It was as if the gods were not happy about the pending war.

The storm passed, so I managed to make it across to JY's hotel where he introduced me to the Sky News producer, Nick Purnell, and the rest of the crew: Ross Appleyard the correspondent, Des, ex Royal Signals, the comms man, Kieron and Laurence the two cameramen and Ali, a Jordanian, the team's fixer and interpreter. I would be joining the Maverick Team as Sky News London office referred to them as. I would act as an unofficial unpaid security man while trading my time and expertise for the use of their satellite communication system, and of course, we'd all be benefiting from the all-important strength in numbers element.

The team had set up camp in the Sheraton Hotel, Kuwait City. I already had my own apartment. Our priorities were to source all necessary local purchases and disappear up to the border as soon as possible. JY hired vehicles and prepped them for the pending field trip, and luckily none of them had airbags to deactivate. Nothing like having a face full of airbag when using the ramming technique to get out of an ambush. He had uprated the tyres to all-terrain, fitted a safari-style roof rack, doubled up on spare tyres, and roped on eight jerry cans of fuel and four of water per vehicle.

I proposed we make our escape to the border in the utmost secrecy and away from all of the other news networks. Sure, be friendly and chatty with our fellow journos and pretend to a bit

naive and slow with our intentions, then we should covertly leave the hotel, nice and quiet, move up north and sit on the border until such time we spot an opportunity to cross it.

Living out of the comfort of a five-star hotel has its advantages as well as its disadvantages, because back then, there were really only two decent quality hotels in Kuwait, and the Sheraton was regarded as the best, so as a consequence, all the world's media booked into it, and as a consequence of that, the hotel's main conference room became the official military and Kuwait Government briefing room to inform us all of past incidents and future intentions. In normal times it would have made sense to hang about the hotel's foyer waiting for the official briefs, whilst at the same time disseminating any rumour control, but we weren't living in normal times and this was no normal gathering of the world's media. They were all hungry for war—a war in which there would be embedded and un-embedded journalists all cutting about the battlefield and military lines of every unit taking part, and no doubt making a damn nuisance of themselves.

This was the first war in history to use the terms embedded and un-embedded journalists. There are pros and cons to being embedded. Being embedded meant you were designated to a specific unit, be it up at the sharp end or on board a naval vessel perhaps several hundreds of miles away. Your designated unit would be your host. You would stay with that unit for the duration of the war. OK, you were relatively safe, you had access to top medical backup, you were fed and watered and you probably had more of an idea as to what was going on with the bigger picture than an un-embedded might. The constraints would be, your unit might not see any action at all; big problem if you're a budding Kate Adie or Walter Cronkite, and your stories, or what you could be allowed to report on, would more than likely be heavily vetted before you could file anything back. On the other hand, being un-embedded was a lot riskier and the content of your copy would be at your own professional discretion. I did not file anything back the Iraqis could use as propaganda. Only a fool would do that.

For an embedded or un-embedded, each organisation or individual had to submit names to the coalition force for

vetting. One had the option to be embedded or un-embedded, then once the embedded names passed vetting, they would now be officially termed as embedded and would be designated a host unit to embed with. Once the un-embedded passed vetting, they were left to get on with whatever they had to get on with. The un-embedded were given the relevant access all areas or not, passes, depending on who you were and what media outlet you represented. You were given official ID's which allowed you to attend certain Kuwait Government and military briefings in restricted facilities other than the daily Sheraton briefings. There were three really important ID's to collect and I managed to bag all three!

I didn't have the massive weight of a media network administration behind me, I only had myself. So, a few weeks earlier, I had planned a route through the bureaucracy of all military bases and government offices I had to visit in order to get my papers stamped with the correct authorisation and in the correct order, and anyone who has lived in the Middle East or Gulf Region will know what I mean about stamps. You can a have all the legally issued computer-generated ID's you want, but if you haven't got the right paperwork you ain't getting that paperwork stamped, and if you haven't got that paperwork stamped you ain't going nowhere! It can be catch 22 if you're not careful, and we can all thank the British for this baloney, because back in Victorian times they first introduced this form of bureaucracy into the region and the Arabs veraciously latched on to it, developed it with many more layers of breath-taking administrative nuance. Done well, it is a beautiful craft. To be able to pitch one's life skill set against these professional pen pushers, born from a long line of bureaucrats, can be as challenging as a rich man trying to pass through the eye of a needle to enter the Kingdom of God. That almost silent rustle of your paperwork as you make your approach to the person who sits at the table with that all-important stamp, that slight eye contact or none at all, the placement of said paperwork on to his or her desk, that given smile or not, are just some of the mannerisms which could get a refusal. And, there is no point us Westerners going all superior if our paperwork isn't in order. One has to accept a refusal, go away, learn a bit more of the

game then try again. Change your cologne maybe, and, in a country where heat is the enemy and time has little meaning, for a Westerner, it can be a very frustrating exercise, and of course, the Arab knows this all too well and takes great enjoyment from the game. At times it was very hard going, yet sometimes quite funny too because if the truth be known, I was really just on one big bluff.

The American Military Media Unit was based way down south, actually the furthest you could get away from enemy action, in the Hilton Hotel, and in the searing heat it was a bit of a slogto get to for many. However, after days of shoving paper and passport in front of uniformed soldiers, US and Kuwaiti, I eventually got the official title of un-embedded, and there was no doubt it, Operation Iraqi Freedom would be the first test of professionalism and courage for the un-embedded journalist in years, and not since the Vietnam War were journalists going to been given such a free rein over the battlefield.

Kuwait was not used to hosting so many journalists in one place. I knew the authorities felt very uncomfortable about it all, my friend the Sheikh who had the ear of the Government said as much, so the Kuwaiti figured the best way to control the herd of journalists was by feeding the foyer of the Sheraton copious amounts of believable disinformation, and it worked; it kept the journalists all very fluffy and contented. After all, the media were just so grateful for the opportunity to come along for the ride!

Operating in the field of battle, it was obvious, those who were embedded would be given priority on any update as the situation developed just because they were living within the units, and as for the rest of us, well, it would be up to us to break our stories and not be spoon-fed carefully vetted sound bites. But I knew, and so did JY, that once the massive, lumbering coalition forces who were camped out some twenty k's south of the Iraq border started their advance-to-contact, there would be just one chance and one chance only to get across the border with them. That was where the action was going to be, it was where the stories were going to come from, and where a high chance of death would come from too.

I knew from past experience, when a major ground force such as the one poised, sweating in the midday sun and wound up like a coiled spring in the northern desert of Kuwait starts to rumble forward towards enemy territory, the fog of war hangs around for a long, long time, even before the first shot has been fired. Utter chaos will probably ensue, it's the nature of war, and we would only have a four or five-hour window, max, before the military machine settled down and the generals start ordering military police on to the MSR (Main Supply Route) and adjoining roads to set up permanent vehicle checkpoints (VCP's) or roadblocks, and if you're not up front, and that's where you really need to be to get the scoop, because being behind the action, in the rear echelon or even sipping a large cappuccino back at the Sheraton, just ain't going to cut it, no matter who you are or who your daddy knows, because once a papers please, sir routine has been enforced by military police, or the screaming order of 'Halt, put your hands above your head' has been screamed by a soldier standing, rifle butt firm in the shoulder drawing a bead on your head, then you ain't going anywhere fast. And since there was only one main route into Iraq and up to Baghdad then it would be the easiest papers please, sir to enforce in modern warfare, and like most things in life, there's no point in coming second, by that I mean, there's no point following the scoff wagon in a war. We the Maverick Team, had to be right up the front, almost in the face of the Iraqis, to break quality news.

On my third night back in Kuwait, I got a call from the Sheikh, who passed me some real-time intel and to this day, if I knew just how crucial this was to the Sky team, I would have asked a King's ransom for it—agggh! Sheikh said his government was going to order the closure of the MSR at Mutla Ridge to all civilians, and that included news crews but not the nomads of the desert, the Bedouin or Bedu, because not even a war would stop those folk roaming, and the closure was going to happen within thirty-six hours. Now, that may seem a long time to get one's kit together, but in my experience living and working in the Middle East, time don't mean a lot. They could close the ridge as soon as they woke up from their afternoon kip, or they could close it at midnight, it's the way of the Kuwaiti,

and I don't say this in a bad way, it's just they have a different way, and it's kind of endearing... well, sometimes.

Mutla Ridge is a large rocky outcrop which sits on a flat barren desert wasteland, and runs east-west across the only northern route twenty k's out of Kuwait City and some sixty k's from the Iraq border. The ridge is a place well known to all those journalists who covered Gulf War 1. It was the area the US Air Force pulverised the retreating Iraqi men and machinery intoa mush of mucus and mangled metal. Pictures of this truly horrific carnage were sent all around the world; a gridlock of hundreds of burnt-out tanks, military vehicles, a few Rolls-Royce and Ferraris to boot, all looted from Kuwait. And of course, those desperate photos of thousands of dead Iraqi troops and civilians clearly defined the moment. If anyone wants to know if modern warfare has changed for the better, I would argue not; the images of mass beheadings are just as gruesome as that of the Mutla Ridge photo, which was dubbed the last turkey shoot. If you spoke to the Kuwaiti back then, they would talk about Mutla Ridge with great relief at seeing their retreating invaders being vaporised through a clusterfuck of bombs, but much of the world looking-on, moralised about overkill, so it came across to many less schooled, as immoral slaughter. War is war, it's utterly disgusting, and history keeps telling us that.

What little do our politicians and people know about war these days! To understand war, one has to stand the line, form the British Square in the face of the enemy, then deal with whatever comes at you, not watch it from some flank or an armchair. The best way ahead for any soldier in combat is to focus on what they have been trained to do and not to moralise about what he or she can or can't do. There are many dead soldiers who moralised for far too long in the face of the enemy. A split second, that's all it takes, and that's it, BANG you're, dead! You have to have been in combat to fully understand all of war's nasty hidden subtleties. Back in '91 a good friend, Scots Guards, Kev Gorman was working with the Graves Commission for the British Army during the clean-up operations on Mutla Ridge, and he knows all about war's nasty hidden subtleties too—he pulled out hundreds of them, all dead Iraqis and buried

them in mass graves. They were never claimed by Saddam Hussein and are still interred where Kev buried them.

Time for an immediate reaction. I suggested we make haste, break for the border and drive up to a place called Abdali, which is the most northern settlement in Kuwait. It's like a one-horse town; one petrol station set in amongst small, unkept and dilapidated flat roofed flatland farmsteads. It's the sort of place tumbleweed blows through, and it was to be the only official border crossing into Iraq, albeit closed since Gulf War 1. Nick agreed, so he and I immediately went to see the Sheikh to stay up at his farm. The farm was in an ideal location, just a mile short from the border. A deal was struck, money changed hands, and in just a few hours, JY and I picked up the fresh rations; stuff like bottled water, tools, dried biscuits, anything we thought we would need to see us through the war, we'd sourced the day previous. Short of bullets and bombs, we managed to get everything we needed.

Getting anything done in Kuwait is very hard going. It's the temperature and the dust which gets to us Westerners. It grinds us down, both physically and mentally. The sand gets into every orifice, clogs you up and the heat tires you out very quickly, and for those who forget to drink lots of water little and often, it gets to them the most. They are the first to go down. Four litres or a gallon a day is the absolute minimum you should throw down your neck until you get acclimatised. A 55°C dry heat ain't no joke. It's like living in an oven.

First light, saw us all met up behind the Sheraton, by the old church out of the way of prying media eyes and headed north. I had received no more intelligence other than Mutla Ridge was still open, but I was mindful things could change by the minute, and like I said, the Kuwaiti thought process is just, well, so different from our Western one!

With a quick brief from JY, telling the team to start switching on as we were now operational, we set off north in a three-vehicle convoy. I was designated lead as both the Sky vehicles were towing single-axle trailers. I was solo in my Grand Cherokee Jeep 4x4; JY in a Toyota Hilux, which wasn't the ideal model because it was the manual freewheeling hub model, so

you actually had to stop the truck, get out and turn by hand the hubs on both front wheels to engage four-wheel drive. An absolute nightmare if you had to escape an attack across country, and of course, you couldn't keep them engaged all the time as they don't like it; one or both of the CV (Constant Velocity) joints could come loose, or worse, snap off.

Nick and the team members were split between JY's Hilux and Des the comms man, in his Toyota Land Cruiser sat-wagon (satellite communications vehicle), which was basically a fully integrated outdoor broadcasting unit. The going was slow; the roads were still covered in thick layers of sand which made the steering shudder at times and made braking even harder, but thankfully traffic was very light outside the city limits and there was absolutely none heading north and why should there be— apart from mad dogs and Englishmen.

At about forty minutes out we passed the rough town of Jahra, the last inhabited area we would see for a very long time, then the road opened up on to beautiful smooth tarmac. Jahra is just one big scrapyard, the only one in Kuwait at that time. It's made up of several companies dealing in vehicle write-offs and war scrap. I've made a couple of visits to it over the years. Scrapyards have always fascinated me; even as a kid I'd go around them with my dad to look for a part for his Morris Minor.

The land either side of the road past Jahra was covered in a white sand and tabletop-flat for some miles, it then rose gently, and far off in the distance I could see Mutla Ridge. The ridge stretched from left to right in front of me like some giant sleeping polar bear. We made it to the ridge unnoticed; it was quiet, too quiet. I slowed down as I approached the Police Post and readied to stop if signalled to do so, but it wasn't unmanned yet the barrier was up. Just keep going I said to myself out loud. That's it, keep going, don't look back, I mimicked in the mirror urging JY to do the same. He knew the score, and he knew we'd just had our first piece of luck. All the police vehicles were neatly parked up alongside the pull-in lanes, very strange! We'd missed first prayers by a couple of hours, so were they taking a kip? Who knows, who cares, but just in case they attempted to

come after us, I floored the big old V8 and put distance between us and the threat.

After Mutla Ridge the land turned into a featureless plain of unforgiving desert. The wind would whip across the open land carrying a fine dust, which gave our vehicles a quick sandblasting, stripping off paint in the process. We passed the odd car wreck, but that was all we passed to indicate signs of any human life. In peacetime nobody lived between Mutla Ridge and Abdali, it was the forgotten land and the only sign of the tens of thousands of coalition troops were two discreet turn-offs along this route north, just a series of tyre tracks leading off into the desert; one on the left to get to the Americans, andone on the right if you wanted to visit the British. That was to be the order to march into battle: Yanks on the left, Brits on the right.

In the two hours it took us to drive to Abdali we met no vehicles, no army, no Kuwaiti, no Bedu, only camels, but it took us another thirty minutes to locate our camp and get a brew on. The camp was getting on for a three-acre plot and two massive sheet-metal swing gates were the only visible entrance from the dirt track it paralleled. The camp was surrounded on all sides by a fast-growing rugged Australian hedging shrub. Kuwait imported millions of these after the 91 liberation to quickly bring back a bit of colour to a war-ravaged, looted Kuwait. We would have to make an additional escape route through the hedge at the rear just in case! There was a massive forty-foot-long Arabic horsehair-style tent, the type a Sheikh would use for entertaining which I immediately commandeered for my basher (army slang for a place to sleep), two mobile Portacabins, which Nick grabbed for his team, and a water tower. JY slept in his truck. The camp was a hidden oasis. It was the perfect spot and no one would guess we were here. The gates were tight-fitting and kept padlocked. We would be safe.

The fast-ball drive up to the border turned out to be brilliant tactical move because I heard later, the BBC and another UK news network got turned around at the Mutla Ridge police checkpoint. In fact, one BBC team was caught sniffing around the border region by the police even before Kuwait closed the ridge and were kicked back to Kuwait City somewhat unceremoniously. I could only imagine the tone of conversation the BBC producer would offer, 'Do you know who we are?' Well, that really is not the way to appease a Kuwaiti policeman, I can tell you that. I know the Kuwaiti thinks well of us Brits and Americans, and indeed the BBC, but trying to pull rank willnot work with an Arab, least of all a Kuwaiti policeman. If they had begged a bit, thrown in some pleading and acted subservient, they might just have bluffed their case. See, local knowledge, again is invaluable. I did hear both networks complained bitterly to the British Embassy in Kuwait, demanding to know

why they weren't allowed up at the border. You gotta have the right fixers and pay them well. It was obvious to me the MSM were so ill prepared for their task ahead, they didn't even have the right warster, Kuwaiti slang for connections in high places.

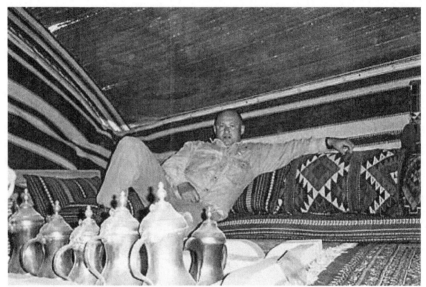

Me in the Sheikh's tent up at Abdali on the eve of the war.

This story put a slightly smug smile on my face, because while I was in the UK, I'd got in touch with all my media contacts, The Sun, Sunday Times, The Express, The Times,you name it, I hit them all. I even tried the BBC, letting them know I could be their man on the ground. All rejected me, giving the distinct impression they were so well connected from Bombay to Baghdad to Timbuktu, and all I received back was, 'Sorry, we have it covered, thanks.'

OK, I wasn't known for my photojournalism, but all of them had failed to recognise my local knowledge of the ground and my knowledge of war, and that was their biggest mistake on the day. None of them, including the BBC knew very much about war or how to operate a news crew in one. Indeed, even the BBC's most famous correspondent John Simpson, got his approach to the war spectacularly wrong. He decided the best way to cover it was by entering Iraq from the north. Epic fail. He missed out on one of the biggest stories, possibly of his

career and was almost taken out in a blue-on-blue, a friendly forces attack, an American air strike incident which tragically killed eighteen including his translator.

I was getting pissed off with rejection, so to hell with the editors sitting on their inexperienced arses back in London. I even had a well-known and respected director/producer colleague say, 'Every angle will be covered. The networks have a massive budget and have been at it for many years, and even if you did make it across the border, chances are, you're gonna get arrested by the Americans or British, or worse, end up getting killed.'

'So, you'd back a shiny-arse pen-pusher over me, then?' I threw back at him.

'You're mad Nigel.'

'And you're wrong Ed. I doubt very much if any media are trained in NBC [Nuclear, Biological and Chemical Warfare]. Check out blister agent casualties!'

I left him with that very gross image. I knew I could carry this off. I would use my knowledge of war to get me through. It was patently obvious this was an area the UK media, apart from Sky News, had forgotten to address. They didn't have many proven war correspondents and the ones they did have, were embedded; a truly bloody hopeless position to be in if you wanted to break news; if you wanted to be first, and if you wanted that scoop. Equally, it was so obvious to me the only way to cover this was to be free of any restriction.

Using all my field craft skills would see me through, and the stories would come, because I would be there to see and to report them. The well-used phrase Who Dares Wins sprung to mind, and the Maverick Team understood this all too well. Nick certainly did. Just as a side note, I had to sue a certain red-top newspaper when I got back to the UK, as they started to piss me off about saying they didn't receive my copy. What a joke excuse. They settled out of Court.

Even to this day I can't understand how we survived for so long up on the border without being discovered. After all, every time we sent a report back to the UK, we transmitted data and thus left an electronic footprint. It would have been quite easy to track us down, and worst-case, confiscate all our kit then kick

us back to the UK, consigned to watching the war unfold in the prone position on the sofa. But of course, the reality was, the coalition forces were engaged in far more pressing matters than releasing a couple of patrols to go search for stray media types, and once Mutla Ridge was closed not even the Police ventured north.

Hiding out in such isolation and so close to the border did have its drawbacks. We wouldn't be able to gauge precisely when the coalition forces would launch their attack. I was certain it would be a first-light advance, and we would certainly hear them coming, but not see them until they were right upon us. All their vehicles would be on tactical lighting or probably no lights. With troops driving using PNG's (Passive Night Goggles) they could take us out by mistake and we may become the first blue-on-blue of the war!

I had a limited knowledge of the coalition assault plan but between myself and JY, we agreed it would be one rapid mass advancement of thousands of tanks and vehicles heading north, preceded by hours of artillery fire and aerial bombardment aimed at predetermined targets, and under this aerial bombardment, would be our sign to break camp and creep forward towards the United Nations buffer zone, and towards the falling shells.

The buffer zone was defined by a fifteen-foot-high sand berm, a wall of sand pushed up years ago shortly after the 91 liberation by United Nations bulldozers. It ran the entire length of the Kuwait/Iraq border. I'd been up there many times in the past. The berm marked the Kuwait side of the official seven-mile-wide DMZ (Demilitarised Zone) between them and Iraq, but in truth, it was only a couple of miles wide. My Kuwaiti friends own small farmsteads around Abdali, so I've spent many a weekend up at Abdali. On occasions, I'd gone up to see the berm. I'd walk it with Kuwait Army friends. It was a spooky place because the Iraqi Army would occasionally make night raid attacks across into Kuwait to steal a couple of sheep, and at night when the farm guard dogs barked could well be a sign of Iraqi plunderers. The Kuwaiti farmers always carried rifles and

wouldn't hesitate to shoot dead a marauding Iraqi. It wasn't lawlessness; it was just common sense.

The plan, post breaking camp, was going to have to be made up on the hoof. I knew the Yanks were behind and to our left, and the Brits directly behind us and to our right, but how they were formed up and how they were going to execute their advance, I had no idea. I had a vision of the coalition force commander ordering, 'Ladies and gentlemen, start your engines,' and advancing in one vast extended line, stretching one hundred miles and literally charging right through our camp.

Most armies attack during just before first light, certainly the Americans and British do, so it would still be pretty dark when or if they came stampeding through our position, guns all a-blazin', zapping everything that moved. No, that's not how the British Army operates, but still, moving in line across the desert at dark early hours would bring its own problems of command and control, let alone creating a massive dust cloud. Luckily, when the advance did happen all the coalition ground forces moved along the only metal road, the MSR, mainly for speed, as the SAS adage of Speed, Aggression and Surprise always dictates an attack. However, the element of surprise, a major necessity in any attack, had long been lost. Still, I was worried we were not seeing what was happening other than to our front, which was just a vast, open, flat, featureless desert. We were blind, so someone had to leave the safety of the camp to carry out a recce, a reconnaissance, to find out what was happening in and around our immediate area. It's basic tactics when you're in such a forward position as we had put ourselves in. Myself and JY donned dishdashas and folded yashmaks around our heads in the Bedu style, jumped into my Jeep and headed off to sniff out our local piece of desert. I drove slowly and deliberate thinking I might just bump into an army patrol. The area was still devoid of any human life. The local farmers had been told to evacuate southwards days earlier. I knew this area very well but it's really easy to get lost too, so we had to stay fully switched on. Normally I'd focus on recognisable features such as a water tower at a crossroads or a certain building, then there was a fair chance of staying

on track and not getting lost, but up here they were few and far between. There was just not that many recognisable features and the ones I did recognise from a distance always seemed to disappear when I got up close, like a mirage. It's all to do with that bright, piercing sun, shining on sand, well, that was my excuse.

We came off the desert track by a large billboard peppered with bullet holes advertising local bottled water, turned right on to the MSR and headed north towards the border. No vehicles. Not even signs of the military. It was all very eerie. Three hundred thousand troops and their equipment hiding in this vast desert and not a single sign of their presence. We drove for a couple of minutes at a fairly fast pace, because no Bedu I've seen ever drives slowly, and we weren't to know if the Brits or Yanks had covert ops out covering the MSR. I sure would, if I was in charge!

The road stretched flat out in front, just a straight line with only a heat haze rising from it. Then some distance ahead I caught a glint of a vehicle on the other side of the road. It appeared to be heading towards us.

'Fuck! A Land Rover?' I screamed.

'Fuck it,' JY confirmed.

As we closed in, another similar vehicle came into view, and behind that one, another. Three Land Rovers!

'No one drives a friggin' Land Rover in Kuwait, they all drive Toyotas!' I replied sarcastically.

'Mate, they're Brit Army,' JY exclaimed, 'really hope they don't stop us!'

It sounded strange, JY referring to the British Army as Brits, as if they were somehow outsiders, the enemy.

I gripped the steering wheel tight and looked for my grab bag (a small, handy rucksack to carry survival kit) which contained water, food, a knife and other such pleasantries). JY picked his up from the corner of his foot-well and placed it on his lap.

'Just in case we have to do a runner, escape route fifty metres, right!' I commanded. I tried to stay calm. I was stating a well-rehearsed SOP for such an event, which was fast approaching.

'Roger that,' JY replied, eyes still fixed on the targets ahead.

'Bombed-out building,' I sounded off another.

'Seen,' JY firmly replied.

'If I turn off, they may just ignore us.'

'Roger that,' he replied again. No need for small talk.

Ahead and off to the right was a track which led to another old bombed-out single-storey building, a legacy from Gulf War 1. JY slowly raised his left arm, pulled off the windscreen his personal rear-view mirror and threw it in the glove box.

'ERV [emergency rendezvous]?' JY prompted.

'Fuck knows,' I hesitated. 'That billboard where we turned on to this road?'

'Roger that.'

Should we need to de-bus and do a runner, (more about de-busing later) it would only take us twenty odd minutes to reach, and if we did get split up then we both knew of a last known point to head for.

When moving across country in a vehicle or on foot you should always be pointing out ERVs, known places where you can regroup if the proverbial ever hit the fan and you got split up. I kept the V8 purring over at constant revs. The air conditioning motor was working overtime as we'd both windows open. Hot air meeting ice-cold only added to the tension. JY and I had been together in other wars so we both knew the intricacies of polite conversation when cool heads are needed. No need for small talk in a pending crisis; that only leads to confusion and sometimes death. We were both SAS-schooled in unambiguous conversation in these scenarios.

Another hundred metres later, we passed more bombed-out buildings. ERV bombed-out buildings, I ordered.

'Roger that. Vehicles slowing,' JY stated.

'Seen.' I slowed too, then all three Land Rovers made a sudden left turn and came to an abrupt halt in the middle of the MSR's sand run-off strip blowing a furious cloud of dust up in the air. It was clear the commander deemed a non-tactical halt to be OK in the desert on the brink of a war! I was unimpressed with him going non-tac.

'Escape route,' I paused, 'fuck it, what's the fuckin' point! Hang on, I'm gonna wing it.'

'Roger that,' JY replied with a touch of cynicism.

I kept driving. At about the fifty-metre point I could see two of the Land Rovers had mounted 7.62 GPMG's (General Purpose Machine Gun) while the last was sporting a fifty-cal. Troops started to dismount, and the good thing for us was, they didn't seem to be in that much of a rush and appeared not to have seen us heading their way, yet I could see by the way they had positioned their vehicles, they were definitely setting up a VCP. I now increased speed. Two of the soldiers were taking their helmets off and putting on maroon berets. One was taking a swig out of a water bottle. We were almost parallel with them now.

'Fuck! They're Paras,' JY muttered with a touch of irony, not really wanting to believe what his eyes were telling him.

'Shit, and they're 3 Para. The dozy fucks,' I replied. And we both laughed our heads off.

As ex paras looking at uniformed paras, you always immediately look for the colour of the DZ (Drop Zone) flash as it denotes what battalion one comes from. It's always worn on the top of the right arm, up by the shoulder. I could just make out a green DZ flash. Both of us had served in 2 Para and we wore blue. 1 Para wears red, and 3 Para wears green, and incidentally, the Parachute Regiment is the only regiment in the British Army who STILL have all three battalions; other regiments have been reduced to just one battalion apiece because of defence cuts, and through utterly incompetent planning and naivety I may add, all due to our glorious leaders with a Globalist ideology where they think all the World is made of chocolate.

When we were serving in the Paras or the SAS, we'd done exactly the same as these 3 Para guys were doing now. We'd done it a hundred times before on numerous operations. Timing counts for a lot in life, and sometimes you just have to risk it. You gotta risk it a bit in life, otherwise what's the point of living? JY sensed my mood. He, like me, takes risks, calculated risks.

'Going for it, mate?' JY stated the obvious.

'Sure, why not,' I replied.

JY turned to me with a serious look across his brow. 'Fuck it. Yeah, do it, who dares fuckin' wins!'

The V8 went from a purr to a burble to a roar. Hell, that engine sounded sweet. I've always had passion for anything with an engine in it, and on this day and heading into this danger, the Jeep's V8 didn't miss a beat. I had timed my speed with almost exact precision so we could pass them before they had a chance to set-up properly, but it was close. You know, when you're driving, and you see police check-point up ahead? The coppers are waving some vehicles through and perhaps they will pull, say, every tenth vehicle over, and you think you're going to be the tenth and you don't need the hassle today, you may speed up and not make eye contact. A copper tries to wave you down but realises they are far too slow in their attempt at the pull-over wave as they realise you've deliberately sped up while purposely not looking at them. Well, that's how it happened on this day. I could see a para just about to call us to halt with an authoritative gesture. We were his first customer, his first suspect target, but he hadn't quite perfected his technique yet, so I put up a sort of lazy, American front-facing, left-handed lazy salute, pretending to say, hi. His semi-authoritative halt-gesture then dropped and a grimace of disbelief crossed his face. Did he just see two unshaven Western faces dressed like Bedu driving a tidy Grand Cherokee Jeep in British Racing Car Green, giving an American salute with the left hand, and heading towards Iraq!

Right, I'm going to generalise here so if you're a PC type please don't get too woke offended, but if you're a swarthy, black-haired hairy white boy you can get away with dressing up as a Bedu but if you're like myself and JY this Arab garb only works from fifty metres away. You get up close to me and no matter what I'm wearing on my head, I'm only ever going to be an Anglo-Saxon white boy, and by the look on this para's face he could see that too. He probably thought we were either SAS running covert operations, or a pair of fucked-up white guys gone bush, either way, we had bluffed it. I took a glance back at the lone para who just kept looking at us, but I couldn't see any dust clouds made by Land Rovers charging up in hot pursuit.

'That was close. That was friggin' close. That was one fucked-up VCP,' I said.

'Roger that. Fuckin' 3 Para cocks,' JY laughed back, as he went about adjusting his windscreen mirror back into position as if all in a day's work—which of course, it was.

In this business one always has to have a bagful of excuses and big balls to bluff your way through. It's not an easy thing to do as it doesn't come naturally to many. It's something you learn as situations come along. I'm not sure it's something you can get taught. You've either got it, or you haven't! If we'd been pulled over, then the most obvious cover story was to say we were a two-man SAS team carrying out a recce of the local area. Of course, both JY and I knew the lingo and we would have been able to bluff our way out it, I was sure about that. Even if they had radioed through to check our story, soldiers know the SAS operate with impunity and very rarely would their base HQ have knowledge of any SAS patrols operating in the area, but they would merely cover any eventuality stating on their Patrol Orders, 'Be aware. Possible SF call-signs working in your area.' Crazy, I know; it's a recipe for a blue-on-blue, but there's always a need-to-know issue and the powers to be are never going to change that. I had the feeling, blue-on-blue would become a very familiar phrase among folk back home, just like the acronym IED (Improvised Explosive Device), unheard to those outside the British Armed Forces until 9/11.

I wasn't sure whether we should keep on with the recce, but we did, albeit really mindful the British Army were now out and about sniffing. Getting caught and being hauled back to Kuwait City and leaving the team not knowing what had happened to us just didn't even bear thinking about. That would be truly embarrassing for JY and not good for Nick either, as he would have to explain the cock-up to London when and if he eventually found out about our demise.

We continued on our recce only slightly fazed by the risk of being captured, and as we drove north towards the border, the desert started to turn into a sort of scrapyard. There were bits of vehicles and relics from a previous war scattered all over the place. The Kuwaiti driver brings a new meaning to the image of a car crash. Apart from the odd fender-bender, Kuwaiti smashes are often full-on impact at speed, and fatal. You really haven't seen anything like it, because in Kuwait, or indeed from what

I've witnessed around the Gulf region, many of the vehicles are unidentifiable after a full-impact crash, and how they get into such a state only God knows. But here's my theory; back in 2003 the population of Kuwait was under one million plus a million and a half expats, most of whom didn't drive as the government would not allow them a licence or didn't recognise their licence as most came from Third World countries where getting a driving licence is all about who you know and not what you know. I reckon if you were to carry out post-mortems on the dead drivers involved in these RTAs (Road Traffic Accidents), the local rice dish of machboos would be a contributing factor. Why? Well, Mr and Mrs Kuwaiti would often have their lunch around two in the afternoon when the sun is high and still bloody hot, and I don't mean Costa Brava hot, I mean hotter, much, much hotter! They then get in their Mercedes or Land Cruiser and off they go for a drive, declining the option of the daily siesta. Air conditioning on, the outside hot enough to cook an egg, with a belly full of rice and feeling a bit tired, they floor the Merc as they don't know where the slow button is, then BANG! They run straight up the arse end of an articulated truck carrying forty tons of Saudi Arabia's finest-quality dates, the driver of which is underneath his parked truck on a NAAFI break cooking up his own pot of machboos. Back then, three people a day died on the roads of Kuwait, now I'm told it's seven. Death by impact or even death by machboos is a very sad statistic.

Having had enough excitement for one day we returned to our little oasis and I came to the conclusion, that we, our little band of brothers, were probably the furthest most forward people in Kuwait, notwithstanding the SAS or the American Special Forces. Behind us by some miles lay an army in waiting, and to our front, an army that could easily muster one million. But would they stand? Would Saddam Hussein's Revolutionary Guard stand the line? Only time would tell.

That night over dinner we told our brave tale of escape and evasion. It's the done thing in the SAS, if you go out on a recce, you should always bring back some positive news for the other patrol members, as they will be waiting in belief and

anticipation of your return. Even if the reality of what your recce had discovered is doom and gloom, always sprinkle a little goodness over it, as it really does keep the team's morale up. I must say, it did worry Nick and the team, we were so far forward and out on a limb; and it worried me and JY too, but our job was to reassure.

'What would have happened if the Paras had stopped you?' Nick asked. He was agitated. He had good reason to be.

'I'd have bluffed my way out of it with some truths,' I replied.

'We're both ex-paras, Nick, so ain't no reason to worry,' JY interjected.

'I just hope they don't come snooping around here,' Nick sighed.

'Needle in a haystack. They got more important things to be on the lookout for,' I assured Nick.

The key to a bluff is to always have the bluff, based part on truth. The more truth, the better the bluff. I would let the paras know JY and I were part of the airborne brotherhood too; they might even have heard about one or both us from our time back in Battalion. Throw in a couple of names of blokes they might know too, sort of establish a common bond and hope they wave us on and say, 'Have a nice day,' and that was exactly the same MO (Modus Operandi) I used to get all my press passes. I knew the military system and just brazenly bluffed my way through the paperwork. I knew a war was pending and the military were at full stretch, and if the officer in charge of the stamp was presented with a plausible case, the correct language, a show of a British passport and an NUJ (National Union of Journalists) card, I would get my passes, and I did, because without these passes, I wouldn't have made it to the rear echelon, let alone the front line, and I certainly wouldn't have seen my 3 Para brothers in action either, ha-ha!

4. Gas! Gas! Gas!

Camp routine was to keep out of the sun as much as possible, move around as little as possible and to conserve as much of our rations and water as possible. There was no local corner store to pop round to and pick up a bag of sugar. What we were carrying, we had to make last. For how long, none of us knew. Most of our time was spent either sleeping or listening-in to the other news networks desperately trying to get an angle on what was happening outside of our piece of desert. To cope with the inevitable boredom, JY and I started putting together a series of one-hour training periods every day. We would take the team through the what if scenarios, referred to in the army as actions-on. For example, actions-on getting shot in the vehicle from the front, actions-on getting shot from the rear or side, wounded man drills, abandoned vehicle, vehicle with puncture. We took them through the complete vehicle anti-ambush package. Comms down, man down, action on mines, how to react, how to mark mines. We tested them on every conceivable scenario we might encounter. We even took them through a basic combat medic's course, showing them how to put a drip in. This really helped break the boredom and the daily training hour turned into part of all our conversations. If we weren't talking about the pending war, or our route in, we were discussing the finer points of anti-ambush drills and swotting up on useful Arabic phrases.

Sometime earlier whilst on my trip down to the Hilton Hotel, I'd managed to swap a British Army ration pack with a US Marine for a dozen of their Iraqi Visual Language Survival Guide. This was actually a very useful piece of kit. It was an A4 sheet, in colour, waterproofed, which folded down in a concertina style to top pocket size. It featured basic maps of Iraq, pictures of Iraqi weapons, tanks, radar—anything you might encounter in battle, and of course, essential Arabic sentences under the title Survival Phrases. The one we all found most amusing, and the one we really didn't fancy having to use

because we would have been in the wrong place at the wrong time, and not even our Arabist Ali could properly translate it, was, drop your weapons–Theb-buu Es-lah-kum.

Equally, and on the most serious topic, a topic which always gets lost when the invasion or liberation of Iraq is mentioned, is any reference to gas. A gas attack was deemed imminent every single day when we were in Kuwait, and the threat was only to increase when we started the advance. Blair and Bush thought Saddam had nukes, WMD (Weapons of Mass Destruction). They knew he had chemicals because he had used them during his war with Iran, and then against his own people, the Kurds, but the WMD threat became Blair's excuse he gave to the British people to go to war. Bush used it too, but he later came clean with his people and said he wanted a regime change, and didn't play the WMD card so hard. Blair on the other hand stated Saddam had WMDs that could attack us within forty minutes! Remember that one? And then later, when he took our country to war, that became his favourite defence. I hope one day very soon, Blair, and his entire February to March 2003 Front Bench and Powell, Blair's chief bureaucrat and his wretched spin doctor Campbell who made the decision to go to war, will be hauled up to the Court for England and Wales and put in front of twelve good men and women and tried for high treason and war crimes.

We couldn't do anything to protect ourselves against WMDs, but we made damn sure the team carried their gas masks everywhere they went, and if they were not carrying them, they were within a hand's reach. It was now part of our own SOPs, just like army.

We drilled them in a gas attack. 'Gas! Gas! Quick, boys!' We made sure they all knew the alarm for a pending gas attack: hit something metallic with something metallic hard shouting gas, gas, gas at the same time reaching for one's mask. We taught them how to put on their masks correctly within the ten second rule, we showed them how to check their mask's fitting using the buddy-buddy system, and to carry out the proper blow-out procedure. We had all been issued the latest British Army S10 respirators with a spare filter, and NBC suits. The NBC suits

came vacuum-packed in the size of half a shoebox, and they had to be punched out first in order to put them on. It was no good going into battle with them still vacuum-packed as it took several minutes to do the unwrapping and punching out, by which time you would be dead or suffering a horrendously slow, agonising death due to blister agents eating into your flesh! JY and I were constantly jumping on the team's case. If we saw them walking around without carrying their Kevlar helmet or grab bag near them, we'd bollock them, and they had to get used to putting on their NBC suits, as awkward and uncomfortable it was in spite of the murderously hot climate. They had to learn to work and survive in it. Practise, practise, practise putting it on, I drilled into them.

'Get used to the discomfort of wearing it. It will save your life,' JY impressed. He kept enforcing the issue until they were sick of him telling them, but they got the message.

During the day, the camp area was stiflingly hot, with really no wind at all, just direct sunlight with temperatures always hovering around 55°C. The evening was cooler, with a very welcome slight breeze, which made the atmosphere just about bearable. The flies never ceased. They would continuously hover-land, hover-land all bloody day and night with no respite. They were more aggressive in the evening, and as regular as the outgoing artillery barrages. This gunfire would last for an hour, sometimes two, and with hundreds of rounds fired off every evening with the sole aim of softening up Iraqi military targets such as gun emplacements, army barracks, vehicles and tanks. Then there would be silence. Then we would hear and sometimes see the small, unmanned reconnaissance drone buzz overhead. It would fly directly above us, slow and menacing, reminding me of the doodlebugs Hitler sent over to blitz London during World War 2.

These massive unmanned flying bombs were launched from France and had just enough fuel to reach London. Their engines made an unmistakable droning noise as they flew overhead, and when they ran out of fuel there would be seconds of deathly silence as they dropped indiscriminately earthwards and whistling as air was forced over their stubby wings in an attempt to reach terminal velocity, followed by an enormous explosion

as it detonated, more often than not, in the densely populated East End of London. As a young child I vividly remember my late father telling me his doodlebug stories. 'When I was your age...' he would say often recalling his London war time experiences. I do miss my old man.

In this war the drones were still very much in their infancy and had limited range and capability, only being used as spotters for the artillery to identify if shells had hit targets or not. After only a few minutes over the target-area the drone would fly back right over our heads along the same flight path as it had come. Then, within minutes, high-flying jets would be heard dropping their payloads on yet more Iraqi targets. Shortly after that, the night would fall silent again for an hour or so, then the artillery would start up once more, this time with harassing fire. This pattern of fire continued for many days and it steadily increased right up until the early hours of March 20, 2003. More air traffic than usual, more drone sorties than usual, and more artillery than usual. It was obvious something big was about to happen. And it did.

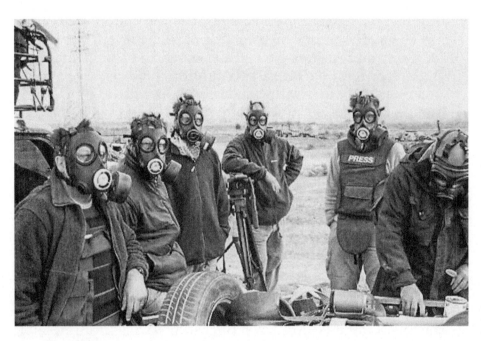

Gas! Gas! Gas!

5. First in Iraq

At 0300 hours I awoke to the noise of vehicles moving; the squeaking of thousands of heavily armoured vehicles and tanks, like they had surrounded my position. It was dark and it was eerie. I was up and at it within seconds, straining my ears and eyes and quickly taking in what my brain was trying to process. An ever-so-slight wind was playing tricks on my senses. I was not surrounded yet the noise was very close and heading my way, and I knew one thing, there was no chance Iraq attacking from the north. The American artillery and air force had made them all crispy many days before. No, there was only one attack, and that was heading right my way, as predicted from the south.

We immediately broke camp and waited by our vehicles in great suspense, but the noise of an army moving forward now sounded as if it was moving over to the west. Were they using the MSR as their route in? Yes, they were. So, as we waited for that amazingly bright sunrise one sees in this part of the world, I got a brew on, because moving north in the dark to join the party would have been suicidal. Getting blasted by friendly fire or crushed by a tank in the midst of the advance were just two very good reasons to stay put and drink tea until the dust of this first wave had settled. The tea gave me strength and comfort. I felt so alive, like I did when I did my first parachute jump—stomach churning, body full of adrenaline. As the sun warmed my face I drifted back in time. It was a frosty winter morning, yet the sun was shining through a cloudless blue sky.

'Up eight hundred feet, four men jumping,' the RAF parachute jump instructor roared out to the cable winch man. I was standing in a metal cage the size of a small garden shed with an old barrage balloon attached just above me, rigid with fear with almost uncontrollable bowel movements as it started to lift off. Up an up I went. It was quiet, so quiet, not even the rustle of wind. So unnatural, so fucking scary!

I knew I was on the cusp of something very special, something quite unique. I felt it more in a soldier's way rather as a photojournalist. Whatever any of us felt, we all knew it was going to be fraught with danger and maybe, I wasn't coming back. After all, we were the northernmost un-embedded up on the border poised to join the advance, and that meant being in the line of fire. I still wasn't confident some of Nick's team actually knew what kind of shite a war zone can throw at you. Nick had done his time in Bosnia and seen some shitty stuff there and in Africa too and Sky weren't going to put a complete dick on the ground, no, Nick was one hundred per cent, but I did have my reservations about a couple of his team. Des was ex-Royal Signals, so as expected, he always had his shit squared away and he too was one hundred percent, and Kieron and Laurence seemed switched on, but I was unsure about the nonchalant way our man on camera Ross acted on the build-up. Had he been to war? I doubted it, but I was sure Sky wouldn't have risked this operation unless they knew he was up to the task. Look, he was a chirpy and a much likable bloke but still, I had a nagging doubt about him. I hoped I was wrong. Either way, I wasn't going to mention it to JY as the team hadn't yet had its baptism of fire, and JY was an experienced operator, so he would have sensed what I sensed.

We could hear an Army firmly off to our left but there was still no show, which confirmed they were indeed using the MSR to infill, and none of us could wait for the sun to fully rise, so just after first light when we could see a hundred metres in front, we moved off. Our plan was to head north until we hit the DMZ. I told JY we should turn left when we hit it, that way would take us directly to the MSR and to the old border crossing, which by my calculations, would now be the new border crossing and would be full of coalition forces roaring through it, and if we were sharp enough, we could mingle-in with them before the military police started setting up snap and permanent VCP's and erecting signage and razor wire all over the damn place. JY agreed, so we set off in the same order-of- march with me as point and Des and his sat-wagon bringing up the rear.

I was keeping the speed down to about twenty mph. The desert was flat but I had to negotiate a lot of mini rubbish tips and all sorts of old bits of scrap and desert flotsam. This part of the Kuwait desert is nothing like the clean, sandy-looking desert with beautiful rolling sand dunes, like in the movie Lawrence of Arabia. No, this desert was part rock and part sand and full of man-made rubbish and it would just about piss me off if one of us got a puncture in this shit pit, and there was of course the real possibility of hitting a mine too, as this area had been heavily mined, indiscriminately by the Iraqis back in 1990. Most responsible armies draw up mine-laying plans and I know that may sound a bit contradictory, but war never lasts, and when peace comes, mines have to be lifted and accounted for, otherwise vast tracts of land, just as in Kuwait and many parts of Africa and the Falkland Islands too, have to be placed out of bounds until they are cleared. The cost and the danger of clearing minefields means they rarely get cleared.

Initial thoughts were, we'd misjudged our move because we hadn't seen a single military scout vehicle, then I spotted a break in the berm, a deliberate break made by big machinery, a bulldozer for sure, and certainly done by the coalition forces when out recceing for possible border crossings. JY pulled alongside.

'Shall we go through?' I asked.

'Fuck it' yeah,' he replied.

'Could be mined?'

'Probably not. The Brits done that for sure.' He paused, 'let's do a recce anyway,' he replied pointing toward the gap.

We both got out and took a careful look around the opening keeping an eye out for the enemy, trip wires or mines It looked as if it had been breached within a couple of weeks because the dozer tracks had only been partly washed away by the recent storms.

We couldn't see any signs trip wires or of mine-laying and could think of no reason why the army should lay them anyway, so we drove on through into the DMZ, which then opened up into a vast nothingness. It was very flat and void of any features apart from the Iraqi Jabal Sanam (Safwan Hill), the four-hundred-foot pimple which laid some ten K's off to our two o'clock and was the only high ground between us and Baghdad.

The Iraqis, rather stupidly, had a unit of infantry and artillery spotters stationed up there, that was, until the Americans clinically neutralised it. It was pretty obvious that would be the first target to get smashed, so why did the Iraqi Army think it was such a good position to dig-in on? The naivety of leadership!

I drove slow, real slow, very much aware we were technically not in Kuwait nor Iraq but in no man's land, so, as long as I headed west with a touch of north, we should meet up with friendly forces before we encountered any enemy. Then all of a sudden, right out of nowhere, three US Cobra helicopters appeared in line on the horizon and within seconds they swooped down upon us. I came to an abrupt halt. JY pulled up close by, but kept his distance. Des hung right back. The Cobras then went into hover mode and held steady at about five hundred feet. Were they looking for someone or something? Was there enemy nearby and were they trying to warn us? They then moved forward to a point where they were so close, I could make out the pilots. The middle Cobra broke ranks and crept even further forward to form what looked like an arrowhead formation. I was guessing the lead Cobra was the boss. It then dipped its nose in a commanding aspect and held that position, which I took to mean, just stay right where you are, buddy.

I screamed across to JY.

'Don't get out the truck.' Again, 'Don't get out the truck!'

Of course, he knew this; it was more of a confirmation to the others than a command to JY. They took note and stayed put. Rule one: whilst driving in hostile environments, *don't get outta the vehicle*, never get out of the vehicle if you don't have to. You see, in the situation we now found ourselves in, it could mean you're trying to escape, or in a firefight it's dumb thing to leave a place of cover from fire, and in a hostile roadblock you should just crash the fuck through any way you can, and if there's no option in reversing back, what the heck! If you can ram the boot end of the blocking vehicle, not the engine end if you can help it, then all the better, as this may give you a fighting chance of spinning it out of the way. But if you find yourself in an ambush

which had been set correctly, then nothing should get out of it. Nothing should survive.

The Cobras stayed put. I was having a real troubled feeling about this one. I started to move slowly and deliberately and tried to squeeze as much of my body out through my door window, leading with raised hands in surrender mode; something I've never had to do on any operation before. So, I'm half out the window, still with arms aloft and very conscious of mumbling these immortal words: 'Please, please don't shoot, don't shoot, can't you see I'm not an Iraqi, you friggin' Yankee twat?' All the time keeping eye contact with the pilot. The lead pilot edged his Cobra further forward, then lowered his nose again like a snarling monster sniffing out its prey, ready to strike. Now, to my untrained eyes, the Cobra's angle looked far too acute to fire off a Hellfire missile; maybe it was going to test its guns out instead and spray us all with a burst of 7.62, and maybe we were going to be its first kill of the war and itwanted to save the Hellfire for a more deserving target! It was probably the most helpless, wretched situation I had found myself in for many a year. With this hovering nemesis in front of me, I visualised the headline! No, there would be no headline. A casualty of war, yes, a statistic of war, when or if they ever found us, would we be marked down as missing, a sort of civvy MIA (Missing in Action), and a medal would be awarded to our families, or perhaps we would just be ploughed into the desert like those eighty thousand Iraqis back at Mutla Ridge by a different Kev!

All civilian press vehicles were ordered to have a red cross painted on their roofs to identify them as friendly vehicles from the air. We, on the other hand, didn't. Yeah, we were different alright, we were sure stupid and thought we were being clever. I had a large Union Jack flag taped over the entire roof of my Grand Cherokee and JY had the Stars and Stripes over his. It was truly a gut-wrenching moment as we waited motionless, facing possible death. Bile filled my mouth as I anticipated my pending dispatch from this earth through vaporisation. Would it be as quick as the term suggests, or would I smell my flesh burning as I suffered an agonising exit? Would my life flash past me? It's never flashed past me before when I've been_

close to death, or would the pain be so great to focus on anything else other than forgiveness? The Cobra hung there, taunting, like the Lord High Executioner, teasingly rubbing an edge to his blade whilst neck rests on oak, evaluating, contemplating, salivating. I can't ever recall when I had stared death so intensely in the face for so long, and feeling so bloody helpless. Normally, there's always something else happening all around, like the noise of soldiers in battle. Here, there wasn't a thing; I can't even recall the whoosh of the rotors, the tension was so great. It must have been obvious to the pilot we were the friendly guys—surely to God it was! But then again, I felt certain I was only seconds away from the end of life. We're just a bunch of friendly, happy Brits! I had to do more than just hang out of the window like a right dickhead with my arms up in the air. My body angle wasn't going to cut it with the pilot. The voice in my head screamed, *don't get outta the vehicle, don't get outta the vehicle.* Those images of the Mutla Ridge crisp critters still roasting in their vehicles came to mind, but I slowly eased my left hand down and popped the door handle and cautiously eased it open anyway. *Don't get outta the vehicle.* CLICK! Fuck it. Unintentionally, my Kevlar helmet dropped forward over my brow skewing my vision, and at the same time my door suddenly swung open, leaving me half in and half out of the window. I regained my footing while using my left bicep to straighten my helmet, and rather propelling my body through the window like an amateur acrobat, I somehow managed to regain my balance and sort of stumbled out on to the desert floor still with hands held high.

I could faintly hear JY screaming, 'Don't get out, don't get out. He's nae sure,' he's nae sure.'

I'm now fully out of the truck with hands still very much aloft, I shot an icy stare up at the pilot. 'See, mate, I shouted, I'm a Brit, you fucker, you fuckin' stupid dumb fuck Yank. For fuck's sake please don't shoot!' I was reaching full panic mode and shooting off a torrent of the most unpleasant expletives.

I threw a glance across to see where JY was. He too had slipped out of his vehicle, hands raised high.

'What more can we do, mate?' I yelled.

'Fucking Yanks. Too gung-ho,' JY screamed up at the Cobras.

I knew what he meant. It was just pure enragement caused by a frustrating situation. JY's aggressive harsh Scots accent seemed to penetrate through to the pilot. Had he heard what JY had screamed out? Could the pilot lip-read? Did the Americans now have special directional mics fitted to their choppers so pilots could hear ground conversations? No way ha-ha! But just as if on cue, the lead Cobra dipped its nose twice as if to intimate, OK buddy, have a nice day, then the three of them did a well-practised 180- degree and flew off north before turning east towards the city of Basrah and the sea.

I have to say, at this stage of the proceedings, I had a slight feeling of, Fuck this for a game of soldiers, I was shaking, and sweat was just pissing out of me, the collar and the back of my shirt was wringing wet, but I knew it would only be a passing sensation, and once that knotty stomach feeling had dissipated, I would be back firing on all eight cylinders again. I knew this feeling would only last for about two to three-minutes, max. It wasn't macho or anything like that, it's just the way I am. I'll learn from it, log it, and move on.

Team vehicles at Abdali just after the Cobra incident.

Some people let themselves get beat up by these situations. They wonder why, how, what if? Glass-half-empty stuff. I can't

bear all that psychoanalytical thinking, especially while still in a Shitsville situation. Apart from all that negativity and personal self-exploration stuff, it wasn't good for me or the team's well-being. Bollocks thinking like that will always end in a premature death for some poor bastard and it's normally not the doom-and-gloom merchants who get it first. You better believe it!

6. Baghdad or Bust: Enemy Contact

We had survived the first hour of day one, survived and still intact, which was a bonus. Was it a dumb thing to get out of the vehicles? No! We were unarmed civilians being challenged by known friendly forces. If we were unarmed civilians being challenged by unknown forces, we would have failed the test. Whatever the rights and wrongs of our actions-on, we were all alive, free and in good health, and what's more, we were all in full agreement, if the team was to progress forward to the second hour then we should immediately turn left and head towards a new sound that rumbled away in the distance: the familiar sound of mortar fire coming from an area around the Abdali border crossing point over to the west.

Fifteen minutes later we arrived at the border crossing, and it was then I saw just how massive the war effort was. To read in newspapers about thousands and thousands of military vehicles in extended line is one thing, but to actually see them all lined up, row upon row with their huge diesel engines growling, and to smell the fumes of war, had to be a military anorak's dream. But why weren't any of them moving? So, unchallenged, we went ahead of them and crossed on to the MSR, turned right and headed through the DMZ. This was a good move because we were now ahead of the game, but why was nobody taking any notice of us either? Up ahead was a line of traffic; USMC (United States Marine Corps) vehicles and two Abrams, the American main battle tank. We were now halfway across the DMZ. Slowly, slowly we drove north towards the Iraqi town of Safwan, a real shitty place with a reputation for smuggling and killing. I then saw and heard the reason why the convoy was at a halt. A US Army captain in a Humvee (High Mobility Multipurpose Wheeled Vehicle or HMMWV) came screeching up alongside, frantically waving us down.

'Can't go any further. Iraqi mortars,' the captain ordered. 'Follow me over here.' He was pointing to a ram-shackled building, the old Kuwait Customs buildings. Ahead of the

customs and tanks a lot of air activity started to happen just after I heard more mortar rounds being fired off, then Cobras and Hueys appeared, flying in low sniffing out targets. Yes, the Marines were still flying the old Huey Gunships, Vietnam era— amazing, and still nice to see. Then bursts of sporadic gunfire cut through the sound of a loudspeaker system on a loop playing instructions in Arabic. It was ordering the Iraqis who were lobbing mortars in our direction from a nearby mosque to cease firing. The tape was also telling the folk of Safwan to, 'Please go to your house and stay away from windows.'

I was waiting for the captain to give us an update when a couple of Iraqi mortar rounds landed smack-bang on the tarmac road about three hundred metres ahead. This sent three of the Sky team who, f o r s o m e u n k n o w n r e a s o n had dismounted, scrambling for cover. Never get out of the vehicle! A couple of Kuwaiti police who were operating the loudspeaker system laughed at the Sky boys doing a swift dive back into their vehicle, then two more rounds landed, this time much closer, raining bits of secondary fragmentation; rock, twisted shards of metal and tarmac. Welcome to the Iraq War. I really didn't need another wakeup Cobra call, but I should imagine two life-threatening incidents in such a short time would certainly wake up the Sky team. 'Stay in the fucking vehicle,' I shouted to anyone who cared to listen. We were far too close to the action, and as if on cue, a kind of instinctive, no-need-for-discussion moment, we did an about- turn, and affected a tactical withdrawal back to the safe country of Kuwait. I headed for the only major structure overlooking Iraq, a petrol station. In days gone by I've refuelled there many times. It was the only petrol between Abdali and Kuwait City, and between lay that inhospitable stretch of desert. If you happened to get caught out here with no water, you would if you had it, sure give a million dollars just for one bottle. It's amazing what the human mind and body will do to survive.

I've been up here in the summer when to feel 55° plus is the norm. I've seen gusting forty-knot sandstorms which will rip into your hands, neck and face; sharp frosts in winter, and in spring, I've seen this desert covered in a pinkie-purple flower the Kuwaiti call Shegara. I can tell you; one should really avoid

breaking down on the road back south, but if you did, you sure better have plenty of water, warm clothes as per the season and a sense of humour. Even FM radio didn't penetrate out here. No comms either. Mobile phones were dodgy at best and there's hardly any road traffic either, so getting help could be hours away.

We pulled up in the petrol station forecourt.

'Hey, you got a leak,' JY said, pointing to my Jeep.

'I hope not,' I panicked then looked underneath and could see a slow drip of oil. 'Twat!'

I popped the hood and spotted a half-broken oil feeder pipe. Mortar rounds were still dropping up in the distance, signalling the war had started, and here I was ready to go, now with an oil leak. Just my friggin' luck.

From the relative safety of the petrol station, I repaired the oil pipe the best I could, then climbed up on to the flat roof of the petrol station and joined the others to watch a really impressive show of US supremacy by way of a 21st century firepower demonstration. Contrary to the popular perception how the Americans like to be gung-ho, well over the top and trigger-happy, they were, from what I saw and heard during the Battle for Safwan, really restrained indeed. Instead of just flattening the town, which as a military target was a rather weak Iraqi position slowing down the advance, the Americans only dropped a few bombs of HE (High Explosives) just to the west of the town in unoccupied desert. This had two effects: first, an enormous fireball engulfed the surrounding area and made the earth all around shudder; second, the mortars in the mosque ceased their pathetic attempt to scare the giant.

It was on the roof of the petrol station overlooking Safwan, the Sky team got their first for the liberation of Iraq. They were the only network to catch this amazing footage, in real time, of air strikes, bombs exploding and troops assaulting. Of course, there must have been a few media types up at the border with us too, but I didn't see them because they were embedded within the units and were restricted in how forward they could venture. No restriction on us though! So, we seized the moment, and without orders, we moved out and once again entered the DMZ

then raced ahead for all we were worth, speed and boldness being the order of the day. We advanced so fast into shitty Safwan we had to pull up because an Iraqi lad in his teens came towards us holding aloft white rag wrapped around a pole. Wow, our first prisoner.

Our first surrendering Iraqi in the border town of Safwan.

'Mate. Fuck off,' JY bellowed out, sergeant major like. The lad took one look at JY and ran off.

'No need for that,' someone commented.

'Suicide bombers! You wanna give this little fucker a lift?' I said to no one in particular.

'Yes, suicide bombers. Start fucking switching on troops,' JY ordered.

For the second time in almost as many hours we made a retreat back to the outskirts just short of the DMZ and the security of the Marine Corps, where we found ourselves looking around the mosque the Iraqis had been firing from, before the Yanks gave them some JDAM (Joint Direct Attack Munition) to think about. The light was now fading fast and we were all a bit knackered from our first full day of war, so we decided to pitch camp just outside the mosque. It was relatively flat, away from much of the main town and right by

the road where the American war machine was still thundering north. We would be safe here.

We parked the three vehicles in a tight triangle formation, in a similar way the early American settlers did with their wagons in the great Wild West. JY got on with writing out the stag list (guard roster) whilst the rest of us began to get scoff on and ready to settle down for the night. I knew the constant friendly gear changes attached to the hundreds of turbo diesel engines trundling on past on the highway to hell would not stop me from getting a good night's kip. I can get to sleep on a knife-edge and wake up on the sound of a snapping twig. After scoff we quickly settled down, and with big fat bellies and brews in hand started to discuss the day's events, all far too hyped up to even contemplate sleep, when a lone voice, an agitated, screaming voice, cut through the thunderous growl of trucks and heavy plant still pushing through. It wasn't an agonising scream, as if an Iraqi had just been run-through with a bayonet, no, the voice reminded me of that old Second World War saying which used to be screamed out by air raid wardens when a light was spotted on in a house, fearful of it attracting the deadly attention of a Heinkel bomber crew:

'Put those lights out! 'Screamed the voice.

A lone American soldier appeared, shining a torch around and catching me square in the face.

'Who the fuck's in charge here?' The voice commanded.

'Mate, please keep that light down?' I asked politely, 'you're fucking up my night vision!'

'Who the fuck's in charge here?' Again, the voice commanded, ignoring my plea.

Mindful we were just guests in this war and knowing it would have been so easy to kick our butts back across the border. Nick rose, and in a subservient tone, offered himself up as the boss.

'Sky News,' Nick said. 'We have permission to be here if that's what you're asking?'

As the American soldier made his approach, he shone his torch directly into Nick's face. Nick quickly put his hand up to shield it.

'May I ask who you are?' Nick enquired.

'No, you may not. Is that your vehicle?' The major said replying to a question with a question.

I was on my feet by now, and I could see the soldier was an American army major armed only with a hip-slung pistol, dressed in a MOPP (Mission-Oriented Protective Posture) suit. I know the acronym's a bit of a handful, but it's their equivalent of the British NBC suit. Anyway, he was pointing over at Des' sat-wagon where another American soldier was standing guard, this time with a rifle at the ready. Then I immediately knew what the major was on about.

'Yes, it is, Nick said. 'It's our sat-wagon, who else could it have been!'

'Well, cover the damn thing up. Cover it up now!' The major ordered, followed by a few choice expletives, something to do with Limeys and tea. He was one pissed-off major. The sense of irony wasn't lost on me either. I threw a grin across at JY, he smiled and let the major vent off whatever combat nerves he had, but I'm not sure this major did irony, yet he did have a point.

The sat-wagon had a large four feet wide satellite dish on its roof and when not in use the dish is folded down horizontally, parallel to the vehicle's roof. But on Des's particular model you couldn't fold back the antenna, the long, pointy bit in the dish's centre, all the way down, flat level with the roof, so it protruded at a thirty-degree angle and not dissimilar to the barrel of a standard anti-aircraft gun, and silhouetted against an Iraqi dusk, yes, it could have quite easily have been mistaken for one. Yeah, I very well remember thinking, the major would have had a point if the Battle for Safwan was still in full swing, but his army had won that battle hours earlier, and hundreds of troops and marines had passed by our sat-wagon and said nothing. In addition, there were many destroyed Iraqi gun emplacements and burning artefacts of battlefield detritus scattered around. Otherwise, the major would have been quite within his rights carrying that sort of attitude into battle. Uhmmm, I hope I wasn't going to meet too many nervous jobsworths over the coming weeks, but I did pray the major would get a grip of those nerves as the war progressed, and that he had a safe war.

I slept lightly that first night with the thought of Cobras covering me, and strafing A10 Warthog attack aircraft, and the major's rant still fresh in my head.

7. The USMC: Task Force Tarawa

It felt good to be in Iraq and it felt good to be back in a war. Please do not think this a trite statement in any way, I'm not trying to play the big I am, but I did feel good, and war can do that to some folk!

The following morning, I wanted to move as far in-country as possible. I was fearful of getting caught by the military police and being escorted back across the border, so we moved inland, putting distance between us and the border and getting friendly with the Marine Corps and Army units we passed. I like to call it doing hearts and minds. The Marines liked us and kept taking the piss out of our accents yet were friendly enough, so I asked them if they would protect us from any military police if they tried to deport us, and they said they would. They liked that idea, as they didn't like military police either. No Marine or soldier likes the military police, no matter if you're a Brit or an American, we just don't like them—period! They also thought we were just clean off it, mad, wanting to piggyback with them on their way to Baghdad, and that sort of resonated with them too.

These marines were part of a group called Task Force Tarawa, of the 2nd Marine Expeditionary Brigade, named after the Battle for Tarawa where they fought and won a vicious battle against the Japanese during World War II, and from what I could gather, they were a diverse bunch of marines and sailors, and all the ones I spoke to were just so energetic, professional and really helpful. I'd worked with the Americans: Delta, SEAL Teams and SF before, and it always struck me just how professional and patriotic these men and women are, and a complete contrast to what is generally believed by the masses back home in the UK, who are more often fed the line of how gung-ho the Yanks are, especially by our lily-livered liberal media. It's a falsehood and I'll defend the USMC and American Armed Forces every single time.

We pushed on through Safwan. Such a shitty town of flat-roofed shacks, mud huts and festering pirates. 'Nothing but trouble,' my good friend Brigadier Abdul said to me back in Kuwait about the Iraqis. 'Bastards, the lot of them, and the fuckin' Palestinian traitors who sided with them, Bastards too.' You see, Abdul's elder brother was murdered when Iraq invaded Kuwait. They shot him dead at a VCP for no reason. The VCP was manned by Palestinians who used to work in Kuwait but changed sides as soon Iraq invaded. They shot many a Kuwaiti dead for no reason!

Nick's plan was move across country to see how the Brits were doing in Basrah and then hook up with Sky News anchor man Jeremy Thompson, JT for short, who was embedded with the British troops, so we followed the road heading east. A few miles outside Safwan we came upon half a dozen scared looking prisoners, well, Iraqis dressed in civilian clothes waving white flags. I kept my distance, suicide bomber-wary and half expecting to receive a burst of 7.62 short from a hidden AK-47. I pointed over to an American Army unit which was clearly visible and told them in my broken Arabic I couldn't help them, and they should go talk to the Americans. It didn't register with them; still, I drove on thinking that was really weird, a second incident with prisoners as it hadn't even crossed my mind about receiving possible surrenders.

Three miles further east we were stopped by a British Army VCP. They had captured twenty or so Iraqis in civvies and had them all lying face down in a circle with their hands on their heads. A couple of the soldiers came over to have a chat, but I stayed in the Jeep. As a young soldier with 2 Para fighting against the IRA (Irish Republican Army) in Northern Ireland on VCP duty, I can recall many similar situations having to wave a vehicle down. You just don't know what the reaction of the driver is going to be. If the vehicle stopped, as in most cases it does, then you approached with extreme caution, it certainly isn't anything like a cop pulling over a suspect speed merchant scenario. I used to treat every vehicle as if it were a car bomb or packing an armed terrorist, or both. It's the only way to operate. I would keep my eyes on the driver and any passengers and didn't want anyone to get out of the vehicle unless I ordered

them to, as that's the quickest way to lose control of a situation, unless of course the driver decides to floor it, then that's an entirely different ball game. Your open fire if your life or your mate's lives are in danger. In all my years in this business I've never been trained to shoot to wound, it's always shoot to kill. Shoot to wound could get you killed!

The soldiers looked fairly relaxed. I didn't care much for small talk. I had Iraqi prisoners to my left and British soldiers all over the place who may at any time decide to arrest me and the team and escort us back across the border, again, game over. I could see a couple more soldiers chatting to JY then I saw them pointing towards Basrah. I turned my attention to the two who had now moved up to my window.

'You gotta be stupid if you carry on down here,' said the first soldier.

'Why, what's the problem?'

'Iraqi tanks,' the other soldier interrupted.

'T72s,' I inquired, educated.

'Yeah, both dead. The place is swarming with enemy.'

JY and Nick came across to my vehicle.

'Don't look good,' I said.

'Nah!' replied JY.

'What do ya want to do, Nick?' I asked.

'I say bin it. Too risky,' JY interjected.

'Baghdad it is then,' I said eagerly.

'Yep. Plan B, the Palestine Hotel, Baghdad,' Nick ordered.

'Baghdad or bust it is mate,' I mused.

The T72 tank is a 1970's built Russian main battle tank. It was a complete mismatch against the American Abrams or the British Challenger II, but is still very effective against my Grand Cherokee Jeep, so that was a good enough reason for us not to go to Basrah. We made another about-turn and headed west with a touch of north to catch the marines up. I was quietly chuffed as I really didn't want to miss the Baghdad story. The Palestine Hotel was where all the world's media had been embedded for weeks under the strict control of Saddam's media men, and looking at things realistically, in terms of a hard news, I knew

the Brits in Basrah story wasn't going to cover my costs of this adventure—just not sexy enough for the world media.

Tragically, several hours later the ITN journalist Terry Lloyd, with whom I'd shared a chat and a coffee back in the Marriott Kuwait Hotel some days previous, was killed on this same stretch of road whilst trying to get to Basrah. He was killed along with his Lebanese interpreter, Hussein Osman, as it turns out, not by the enemy, but by American friendly fire. A French cameraman, Frederic Neral, was also with Terry, is missing to this day. He's officially missing, presumed dead. I knew this affected the team's morale as Terry was a very popular guy, a character amongst the media folk, but they would have to get over it. As tragic as this incident was, it was a stark reminder of just how close we had come with the Cobra gunship incident, and how dangerous our mission was turning out to be.

I said they wouldn't stand.

Heading north, we hitched up with the US 3rd Infantry Division. We would travel with them for a few hours and when they were ordered to stop, we drove through them and hooked up with the next unit we came up behind. For miles on the eastern side of the road we passed burning oil pipelines; they lay way off into the distance with masses of thick black smoke stacks rising up, and right alongside we passed many deserted Iraqi Army gun positions with discarded army boots and uniforms all just left in a heap, and pots of still warm rice as if the owners had run off naked into the desert.

On the western side of the MSR, we paralleled a deserted four lane highway, travelled only by the odd local riding a donkey and cart, a set-up not changed since biblical times, except for the addition of rubber tyres. Above every bridge was an Iraqi OP, which had been taken out by missiles fired by USMC Cobras. Scorch marks and bent railings told you the Cobras had neutralised their target. We tagged along with several more units, and carried on piggybacking off each one in turn, until we found ourselves a couple of miles short of a city called Al-Nasiriyah. It was at this point we re-joined Task Force Tarawa, and then my war really started!

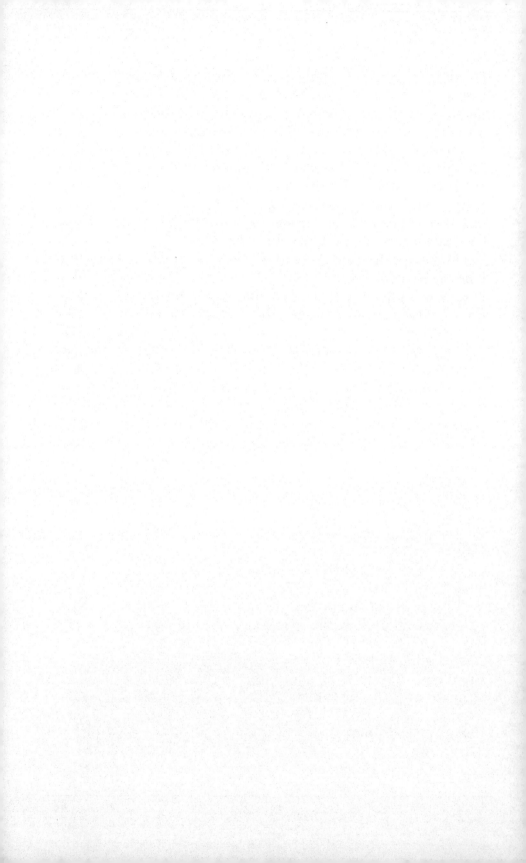

8. The Battle for Al-Nasiriyah

Southern Iraq. The coalition forces and the Sky News team were under attack. An electric storm of thunder and streaked lightning battered down on our defences, causing ferocious flash floods which turned the desert into mud and rivers of quicksand. Come first light the storms died and the piercing hot rays of sun now baked the mud dry. It baked it as hard any kiln could, rock hard. Come night, the storm came again and repeated its bombardment. We were stuck on the side of the road in amongst the backlog of marines. For seventy-two hours we couldn't move forward or back.

On the first night I chose to sleep in my Jeep, but Nick and the others decided to pitch tents during the day, so as I couched up, snug in my dry, lightweight blanket listening to giant raindrops pounding off the roof above the crack and hiss of the electric storm, I could just make out the sodden expletives of Nick and his men abandoning their tents and rushing to clamber back into their vehicles in absolute utter discomfort. First light saw Nick and his team sloshing through flood water and quick sand trying to salvage what they could of their kit. It was a sorry state of affairs to witness from the comfort of my Jeep.

'Come on lads give us a hand,' Nick shouted across to me and JY.

'No. Fuck off,' we both shouted back laughing in floods of tears at the now indignant look Nick was wearing.

For days we had nothing to do but sit tight. I spent most of the time huddled under my light-weight blanket by the side of the Jeep just keeping out of the sun, expending as little energy as possible and killing time. Every so often one of the hundreds of dust devils, mini tornados, would come spinning across the convoy and sandblast those unlucky to be in its path. Ali, who I thought was turning out to be a damned decent chap given the short period I had known him, said the bad weather was God

showing his anger. Anger at what, he never said, but I suspected it was anger over the invasion.

On the fourth day the storms died down so we got the order to move off again. Just as well because I was getting restless. I was acutely aware of the passing days and lost time. We moved only a couple of miles further up the MSR until we were ordered to go firm again and basher down with our latest USMC host just on the outskirts of Al-Nasiriyah. As we moved into position, I could see a group of Iraqi civilians huddled, looking scared behind what I presumed to be their house, a series of mud huts, and were frantically screaming at a little girl to run to them. She looked about five or six and I could see she had frozen scared stiff at sight of the marines. She wasn't going to move and no members of her family seemed happy about breaking cover and going to get her. I pulled up hard got out the Jeep, *never get outta the vehicle*, made eye contact with JY and ran over to the petrified little girl. I crouched right down beside her and uttered some real rubbish Arabic; it must have been rubbish because she immediately stopped screaming. I reached into my pockets and pulled out a hand full of sweats, unwrapped one and put it in my mouth then offered her the rest. She took only one, all the time her family yelling at her, 'Yallah, yallah' come, come. I was understanding about the Arab culture of not touching a child's head, so rather than pick her up, I offered my hand, she took it, 'impshee, go,' I said and I led her quickly to her family and it was only then I could hear the close crack and thump of small arms up ahead. The battle had started.

Al-Nasiriyah sits on the banks of the great Euphrates River, is the fourth largest city in Iraq and home to well over half a million people. The surrounding sandy soil is very fertile, and fields of green surrounded us and the marines. Everyday helicopters were landing and dropping off supplies. One could almost picture being on the set of Apocalypse Now, and like I've mentioned previously, the Marines were still flying Hueys, but even odder, they were still flying the twin rota Ch-46 Sea Knight chopper, affectionately nicknamed the Phrog, pronounced frog, and some say it got its name because when it comes in to land it sits back on its rear, somewhat like a frog. It's like a smaller

version of the massive twin rotor CH-47 Chinook. The Phrog first went into battle in 1965 during the early days of the Vietnam war and was famously photographed lifting off from the top of the American Embassy during the fall of Saigon at the end of the war, back in 1975.

USMC Phrogs resupply during the battle for Al-Nasiriyah.

We spent several days around these fertile fields as the Marines battled hard for the city. We dug-in and lived side by side with them in our foxholes, swapping rations, sharing war stories, and they all had the feeling Al-Nasiriyah was going to be their Tarawa, their Okinawa, their Khe Sanh. This was their time and they told me so. They were up for the fight, big time, and we surely must have made a funny picture; several civilians and my green Grand Cherokee Jeep parked up in the middle of a marine defence position. I used the word battled cautiously because, contrary to popular belief at the time, the US Marine Corps forward elements actually stretched fifty miles further north, way past Al-Nasiriyah towards Baghdad. Yes, there were many individual battles in that city and it's now regarded as the site of the fiercest fighting for the liberation of Iraq, but the Marine Corps were definitely NOT stuck in Al-Nasiriyah and fighting

for their lives as some leftist armchair media types wanted the world to believe. They were closing-in on the enemy and killing them in vast numbers.

Because the city evolved along the Euphrates, human nature being what it is, the progressive urban sprawl pushed out across the flatlands, so Al-Nasiriyah had a couple of main bridges spanning the Euphrates and you had to cross either one of them to get to Baghdad. This posed tactical issues for the Marines, whose mission was also to get to Baghdad. One had to be crossed at all costs and the Iraqis knew this all too well.

The vicious battle for the city saw the PFC (Private First Class), Jessica Lynch incident. Lynch was the American logistics soldier whose convoy took a wrong turn in the middle of the city then got ambushed, tragically killing nine of her fellow soldiers. Lynch was captured but sustained life-threatening injuries. What a horrendous situation to be caught up in. It's almost beyond imagination; utterly frightening! I managed to interview the doctor who treated her for several days before the US Special Forces rescue mission. They raided the hospital she was being treated in and I conducted my interview in the same room she had been rescued from. The doc said he did all he could for her and nothing funny ever happened to her under his care.

'We looked after her very well,' he pleaded.

He told me had been an Iraqi military doctor stationed in Kuwait back in 1990 when Iraq invaded Kuwait, and when the Americans came to liberate Kuwait, 'I was wounded,' he said sincerely, 'and the Americans looked after me very well, they are very good people.'

I believed him, but listening to the horrendous rumour control about her being raped and tortured circulating amongst the marines, would surely not help the hearts and minds campaign of this war.

Al-Nasiriyah was also my baptism under fire by Old Spooky. One night our perimeter came under attack from two thousand fedayeen, Saddam Hussein's own militia, later to be known as insurgents, firing RPGs (Rocket-Propelled Grenades), and thousands of small arms fire. Incoming rounds impacted all around us. Flares and tracers lit up the night sky. An RPG flew

low right across our position then exploded into a sandbank, so the marines returned with a firepower demonstration worthy of the world's most powerful nation.

Me and JY in Al-Nasiriyah Hospital.

All through the attack Nick managed to get a live voice link, up back to London, which allowed Ross to give an incredibly vivid

commentary of what was happening all around us. Every now and then an explosion would occur and Ross, who was cowering under the sat-wagon, would look up to myself and JY for some clarification such as, what was that? so he could then voice a graphic picture back to London as things were happening in real time.

'Incoming and outgoing small arms. AK-47 and five-five-six,' JY shouted.

'Yes, we are being attacked,' Ross nervously shrieked back to the voice in London.

He repeated exactly what JY had said, then all of a sudden there was a massive explosion from inside our camp.

'I heard an explosion. What was that?' asked the desperate voice in London. Ross delayed and peered up to me for guidance.

'RPG seven,' I screamed.

'RPG seven,' Ross screamed back down the headset.

'A Soviet-made, shoulder-fired, rocket-propelled grenade launcher,' I said, giving Ross more information, so he relayed that back too.

He had his helmet tied so tightly down on his head it looked like he was chewing his chin-strap, and every time he lifted his head from the lower reaches of the Land Cruiser to glean more information, he banged it on the truck's chassis. The noise from incoming small arms fire was really close, then JY screams, 'RPG!' And seconds later, as if in slow motion, this death ball of HE flew in through our camp several feet above the ground and exploded off in the desert. The attack lasted a couple of hours and in terms of closing with the enemy, two hours is quite a long time in today's modern combat speak!

As midnight came the enemy fire stopped as quickly as it had started, and all through the early hours of dark I listened to one of the most comforting sounds an infantry soldier in the field of battle could ever want to hear. A sound coming a close second to that of those 105's fired by the 29 Commando Regiment, Royal Artillery on to Wireless Ridge to soften up Argentinian targets before I and the rest of 2 Para put in the assault during one fierce snow-stormy night during the Falklands War of 1982.

It was the steady, comforting, droning sound of an AC-130 Spectre Gunship, a descendant of the AC-47 commonly known to the troops in Vietnam and the marines as Puff the Magic Dragon or Old Spooky, flying above us. Suffice to say it's a flying tank. Every now and then the steady droning would be interrupted by the hum of its autocannon engaging ground targets and then a single thud as it discharged a 105 howitzer round out of its port door. It looked after me, the team and those marines really well that night. God bless that AC-130 crew and God bless America.

First light arrived quicker than normal and the day looked to be a hot one. The camp was still abuzz from the night's activities but had it taken casualties? No, it hadn't, thank God, but it was the team who sustained the first casualties of our war. Just as the sun began to rise, four of the Maverick Team decided war was just not for them and wanted out. Kieron, whose wife had recently given birth was understandable, and Laurence our other cameraman too, and Ali and Ross. What a shock that was! I understood fully young Laurence, he had a go and it wasn't for him, but I was surprised at Ali; he appeared on the surface to be one of those rare, hard sort of Arabs, and it was a big blow for the team because he was the main link between us and any aggressive or desperate Iraqis we may encounter. He could talk us out of a shitload of grief. He who speaks the lingo will save lives. He said he didn't realise war could be so scary and he too had a young family back in Jordan. I guess I got him wrong. Trouble was, he was a cracking chef, he was designated the team's chef from day one and I would dearly miss his vegetable machboos.

I tried, Nick tried, JY tried, to coax them out of their decisions, but they weren't having any of it. Of course, one had to empathise with them all, but Ross, well, he wanted out really bad. Actually, it was quite embarrassing. Yes, we had taken incoming and yes, it was a bit shitty getting fired at and bombed, but no one got hit or killed and if the truth be known, it was especially shitty for me because I didn't even have a gun to hold close for comfort. As an old mate of mine once said with a big grin on his face, as we both struggled to take cover during a

firefight down South, 'Nobody said it was going to be easy.' Nothing worthwhile seldom is.

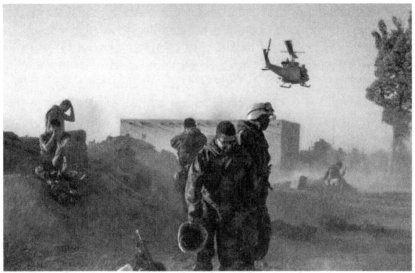

Marines dug-in, morning after the night attack.

JY and Nick had another quiet word with Ross; we needed him to stay the most, because anyone of us could have manned the camera or sound boom, but Nick's pleading didn't work. JY explained to Ross he had too been in similar situations when he first started out in the Paras. Unpleasant first-time experiences which take you out of your comfort zone aren't a reason to jack at the first hurdle. Normally, a bit of coaxing from a senior tends to work, and as you go through life one tends to learn to deal with these shitty experiences, but not Ross, he wanted out, period. Last night's party had made them all readdress their own personal priorities, but to be fair to Ross, after several hours of reflection, changed his mind and wanted to stay. Nick said no.

'What happens when we get further upcountry?' Nick said privately. 'No, I can't take the risk. Not for Ross, not for the rest of the team.'

I don't like putting folk down in these situations, but Ross could become a liability and Nick called it right and I told him so. We couldn't chance him bottling it again, but equally, we

couldn't take the risk of progressing further without a correspondent. At the moment, we weren't as yet, beyond the point of no return, so Nick called London and ordered up replacements. The replacements were going to take five days to get to us. That was no real problem because we and the marines weren't going anywhere fast, anytime soon. The city was still full of fedayeen and we'd been ordered not to move until the route through the city and to the north had been relatively cleared of snipers, and more importantly, IEDs.

9. British Guns

The next five days just dragged on, and once again I was getting impatient. I wanted to push ahead, but in my heart, I knew it was foolhardy, pointless and very dangerous. I was concerned other journalists were now ahead of me but was put at ease by Colonel Reed Bonadonna, a sprightly and cheerful marine who had the job of writing up Task Force Tarawa's history as it unfolded, and who became a good friend to the team. He was acting as our unofficial liaison officer and he would often come across to our little camp we called home, surrounded by marines living out of their foxholes, have a brew and keep us up to date on the combat picture and any pending move. Every time he came across one of us would always ask him if he would he like a nice cup of tea? It was a standing joke which played on the stereotypical Brit and Yank tea v coffee thing!

On one occasion he answered, 'Damn. Why would you Brits ever serve up a crap cup of tea?' He had a point, and we all laughed. Then the obvious.

'Any news?' I'd ask.

'Still no move for you guys. No point, we're still taking out enemy positions. Mainly snipers now. Possibly in a couple of days,' he replied.

'War is long periods of boredom punctuated by moments of sheer terror,' I muttered sarcastically.

'It sure is. Anyway, who wants to go visit the Brit gun line?' Reed said cheerily. JY and I immediately raised our hands like a couple of excited ten-year-olds. 'It's gotta be an overnighter so get your kit together,' Reed finished off.

Nick had to stay put to keep order as there was still that embarrassing tension hanging around where a team is let down by those who decide to jack—throw in the towel.

G Battery, 7RHA (7th Regiment Royal Artillery, as it was back then, but now 7 Para RHA), were ordered to be detached from 1 Para (1st Battalion, the Parachute Regiment), who they had

been supporting, to go north and carry out fire missions in support of the US Marine Corps at Al-Nasiriyah. I spent an entire night with these guys, digging a shell scrap and watching them put down accurate fire on sniping fedayeen.

Twenty-one years earlier the second in command of this detachment had been a young marine with 29 Commando Regiment Royal Artillery, so two veterans from a previous war in a previous century meeting for the first time in twenty-one years on another battlefield, made for a pleasant night! We each pulled up a sandbag and swung that lantern, metaphorically speaking of course. We talked about how his 105mm howitzers pummelled and ripped up the feature of Wireless Ridge. I was one of the poor bastards in 2 Para, cowering, shivering almost uncontrollably in the peat bogs through a howling snowstorm, waiting to attack that ridge immediately after his artillery barrage had halted. We assaulted upwards and fought to the death. When we got there, we found the enemy utterly pulverised. Artillery shells had carved out twenty-foot slithers of razor-sharp rock which stood up like ancient tombstones; other shells landed in peat bogs creating huge pools of iced water. Parts of human remains were strewn all about the place. Dead Argentinian soldiers bent double, some literally sliced in half by shards of this razor rock. Those who could sense or see the British artillery coming ran off the ridge back towards Port Stanley and relative safety, leaving their compadres to a hideous death. The ridge held no survivors that day. The guns were not that forgiving. Accurate artillery rarely is.

This had been the first time I'd been behind a gun line while it was firing in anger! The gun targets were across an open desert in and around massive oil storage tanks the Iraqis had deliberately set on fire. Thick black smoke spewed up it into the clear blue sky creating an eclipse of the sun, a global warmer's nightmare. War is no respecter of global warming. The years hadn't softened me up as they might have done. I didn't give a moment's thought to those bastards getting a pummelling. I'm not sure it's for folk back home to understand the well-used phrase, it's you or me, but I felt angry at the fedayeen, I really didn't give a rat's arse about them, I wanted them dead so I

could move onwards and wrap this war up in double quick time. War can make one selfish and heartless.

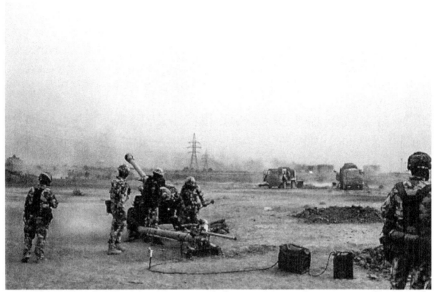

British guns firing in support of the U.S. Marine Corps during the battle for Al-Nasiriyah.

A day later Reed came racing across the camp; he was a man on a mission, and this time I got the feeling he didn't want a nice cup of tea.

'We've got the bridge totally secured so a convoy's going up to liaise with A Company on the other side. It's leaving in a few minutes,' he said, 'any volunteers for a trip to the bridge through Ambush Alley?'

An adrenaline rush hit me like a sucker punch to the head. I could see Nick's face flush a bit.

'Can't, Reed, sorry, mate,' he said. 'London's put a halt to any movement until the replacements are sorted.'

'Damn!' Reed replied.

I can tell you there was no covering up the look of disappointment on Reed's face on hearing Nick's rejection, as this offer was for one minute only and you don't get a second chance to cover the biggest story of the war so far.

'Really sorry,' Nick quietly said.

'We've been sent into a war to report on that war. It doesn't make sense,' JY added.

'Something to do with health and safety,' Nick replied.

'Fuck off,' JY sounded disgusted.

'Insurance issues too,' said Nick.

'I'm sure,' Reed replied, slightly unconvinced. But it was the truth.

'Well count me in,' I eagerly declared, 'can't sit on my arse all day doing diddly-squat,'

I knew it sounded crass and like I was having a pop at the team, but that's just banter. It wasn't because the team were scared, it was orders from London, and Nick was thinking about Ross's mental state and his ability to react calmly in the face of adversity should something happen on the bridge.

'OK, buddy, grab your kit, let's go.'

'Roger that.' I paused, 'do I get a gun?' I asked with a smile.

'Civilians with guns in a war zone? Give me a break buddy,' he smiled back. Then he paused, 'Got a Glock for ya, any good?'

'Nice.'

'It's a Goddamn joke, Nige. You'll ride with me and I'll be your security.'

'But what if we get attacked?'

'Pray we don't.'

My kit is always packed but I quickly double-checked it as Reed was on his starting blocks: cameras, notebook, pencil, grab bag, body armour, helmet, NBC suit, gas mask, scoff, water. I stuffed it all back into my Bergen like I've done a thousand times before, said my goodbyes to all with a bit of backslapping and hoofed it from the safety of our little camp right on the heels of Reed and into no man's land once more.

'Don't take any unnecessary risks,' Nick said.

'I'd better stay here then!' I shouted back with a broad grin.

This was going to be my toughest assignment yet. Was I slightly crazy? Probably yes, but not that detached from emotion because that knotty rush of adrenaline feeling was creeping back into the pit of my stomach again.

Most of our lives are so staid so we only occasionally experience that rapid rush of adrenaline which I think makes a person so much stronger; it makes one more aware of one's

surrounding and concentrates the mind, makes one switch-on, stops one from flipping out and going soft.

The route selected would lead us straight on to the MSR and the only main thoroughfare through a city of open sewers and rat runs, across the main bridge where most of the fighting had taken place, then up into A Company's HQ. The marines said these rat runs, and streets were just like Mogadishu, and that Iraq was like Mexico without the chickens.

'How long's it going to take?' I asked.

'It's a straight route across the main bridge. Fifteen minutes if all goes well,' Reed replied.

I rode into Ambush Alley in the back of what the Marines call an Amtrac (AAV, Amphibious Assault Vehicle). It was loud, smelly and hot, and sweat was pissing out of me it was so humid. Every now and then the twenty-nine-ton machine would lurch left then right as it dodged or just ploughed over the burnt-out wrecks of Iraqi hardware which forever littered the highway. We passed a similar Marine assault vehicle on its side, burnt out, and I can tell you it didn't fill me with much confidence. It had been hit by something much heavier than an RPG, possibly a T72 tank! Then a message was passed to Reed through his personal comms set, he leaned over to me and screamed above the noise of the engines, I just couldn't hear him through the high whine of gearing and piston, it was impossible. He mimicked firing a machine gun. We were taking incoming— nice! What could I do? Nothing, absolutely nothing but sit tight and try not to think about how bloody helpless I felt.

Again, I found myself drifting back many years when I was in Northern Ireland, riding around in the back of a similar type of vehicle which we affectionately called a Sarry, but its proper name was a Saracen; a six-wheeled, eleven-ton armoured troop carrier, when all of a sudden, we came under attack from a lone sniper who made a very lucky hit on the driver's thick glass vision block and smashed it to bits. SOPs dictated this block should always be closed in hostile environments otherwise some slag may try and shoot you through it, which indeed they did that day. The driver had it open just a touch to draw in cool air as it was so damn noisy and stuffy inside from the heat being

produced off its Rolls-Royce-built engine. The driver survived and was taught an invaluable lesson.

My Amtrac roared and shuddered as it slowed under the torque of its whining drivetrain. I cracked my helmeted head on something hard which brought me back to the present time as the driver pulled a sharp right. We came abruptly to a halt and no sooner had we stopped, it lurched forward again, then suddenly braked hard again like a learner driver still not sure where the accelerator pedal was. We surged off again, then minutes later a violent hard stamp on the brakes brought us to our destination and the rear doors flung open. I stepped out into one big cloud of dust. I had arrived at some sort of walled compound comprising of several buildings with marines taking up fire positions behind every wall. Immediately I sensed these marines had attitude, an attitude I'd seen and felt before, and that smell of burned cordite and spent ammunitions and ordnance, a smell not dissimilar to the morning after Bonfire Night. It was the smell of war, the aftermath of a victorious battle. marines, many with rifles in the aim pointing outwards and those not were cooking up food in mess tins. All wearing dirty combats and by the way they held themselves, steadfast and sure, told me they had just fought a big battle and survived. Off to a flank and sat on their own were another bunch of soldiers, not Marines; US Special Forces, probably Delta or Navy SEALs. They were joking about, relaxing; a couple wearing those black Pro-Tec-style parachuting come skateboard helmets. I was fairly confident they had been part of the Jessica Lynch rescue team.

'This way, quick!' Reed ordered. There was a sense of urgency about him, for an older soldier, and by that, I mean, he could have been any one of these marines' father or perhaps grandfather! For all that, Reed was a fit nimble old soldier. He led me to a structure which had taken a direct hit. He could see me looking all about and could sense I was feeling a bit uncomfortable.

'An Iraqi police station. Don't worry, we've had a team clear it for IEDs.'

'They find any?' I asked.

'No, we hit this place so hard they bugged out really quick.'

'That's good then,' I said looking for reassurance.

'Sure, but still got snipers about.'

Reed was met by a marine. 'This way please Colonel.'

We were ushered through more bombed-out buildings then finally into a small room with a marine sitting at a table surrounded by several other marines. It was a tight squeeze. The man by the table stood up and introduced himself as the battalion commander, Lieutenant Colonel Rick Grabowski, the officer in charge of the marines who had justwon the Battle for Al-Nasiriyah. He was probably a little bit older than myself; early forties, looking every bit like the endearing caricature ofa USMC colonel.

Reed made the introduction. 'Colonel, Nigel Ely, Sky News,'.

'Sky?' The colonel replied unsure if he'd heard of Sky or not.

'Part of Fox News,' I interjected. I lied slightly. Sky News and indeed, the Sky Company wasn't that well known back in 2003, or at least not in the USA. In order to break the ice with any of the Americans I would always mention Sky News first then quickly tell them it was the UK arm of Fox, which wasn't really that far from the truth.

The colonel shook my hand. 'Welcome to the United States Marine Corps, Nigel.'

'Thank you, Colonel, for inviting me.'

'Just you?'

'Yes,' I said. 'The others were scared.'

Well, it was the only thing I could think of. His men had risked their lives to deliver me to his brief, so I had to say something, and I didn't want to embarrass Reed since he'd organised the trip. I couldn't tell the colonel our war correspondent and half the team had bottled it the night Old Spooky was up doing the business, now, could I!

'Sorry Colonel, I was joking. London only allowed one of us to attend.'

'And you pulled the short straw?' the colonel replied.

I inadvertently let out a slight nervous cough.

'Well, something like that but I consider it a great honour, Colonel.'

Then, a couple of seconds of unwelcome silence, Colonel Grabowski started his brief. I could feel tension and

apprehension, as if I were intruding on their victory and about to ask a stupid question about the battle and their losses, but I was wrong to feel that way as the colonel received me as courteously and as professionally as he would a guest in peacetime.

I stood there listening to his account and frantically writing it all down as fast as I could. I'm not trained in shorthand, so much of my writing was a scribble, and this wasn't good because even I have trouble in deciphering it most times. I was using one of those orange pocket-sized Silvine memo books; I still do, as they are just the right size for any pocket and robust enough to see you through any war, and if it ever took a soaking, the paper is surprisingly easy to dry out and save, especially if one writes in pencil. It burns easily too if you think capture is imminent.

The colonel's account was a construct of concise, unambiguous sentences, with many military acronyms, culminating in a deep respect for his men, living and dead, under his command, and just how professionally his marines had executed the mission to secure the bridge for the rest of the US war machine to push on to Baghdad. He then finished as abruptly as he had started; he was a busy marine, a marine with purpose.

'Any questions?' he said firmly and a prompt for me to keep quiet. My time was up.

I shook my head and thought, no, I was all done. After all, it would be a bit embarrassing having to re-question or raise any points. He said what he said; it was fluid and succinct. End of. But I was tempted.

'Colonel, there is one.

He turned as if in mortal combat mode.

'One request please sir,' I uttered.

'Go on.'

'Is there any chance of seeing the bridge? Can I go and see the bridge?'

'You've just driven over it! It's too dangerous for journalists on foot.'

The colonel turned to one of the marines, who nodded, and then turned back.

'Colonel Bonadonna tells me you're ex SAS?'

'Yes, Colonel, and airborne' I replied firmly. This seemed to connect with him. 'I've worked with Delta and SEAL teams,' I added.

I wasn't going to mention the Delta thing I'd just seen them outside—elephant in the room and all that, but on the other hand it might just help my case.

The colonel stayed quiet then said, 'OK, you've got your request.'

'Thank you, Colonel.'

'I'll take you,' he finished off with.

It took us five minutes to drive back to the bridge and I found myself stepping out on to a wide concrete structure which spanned the mighty Euphrates. It had a pedestrian path running along both sides, hemmed in with a green-painted metre-high railing also running the entire length. An Abrams was standing guard over the open ground of Ambush Alley.

The colonel was off, zigzagging across to one side. I gave him a second or two before following. There were marines lying down tucked up close to the sides as they could get, weapons at the ready, in fire positions trying to make themselves as small a target as possible. I crunched down some distance behind them. I was taking pictures on the real understanding that I knew I was a target, and I knew these marines knew I was a target, a snipers' target, because these Iraqi snipers are the type who cowardly snipe from behind the cover of women and children and would be attracted to a target with a camera rather than one with a gun. It was difficult to get close-up shots of the marines, they didn't seem keen on me and I certainly didn't want to spook them either. Their stare was fierce and their faces haggard. Again, I'm very much aware soldiers and marines in combat have a great mistrust and antipathy towards any journalist who enters their field of battle, so I kept a humble distance, and they seemed to be tolerant of that.

We stayed on the bridge for twenty minutes. It was a long time but it didn't bother me as I wanted that time to get a feel for the place. The colonel took this opportunity to go around and have a friendly chat with all his men. You see, a colonel is like a father figure to his troops, and when you're a young man in war it's a great comfort to have an officer like this colonel as

your boss, to come and say a few words of encouragement. It's one of many traits I've taken from my mentors over the years,

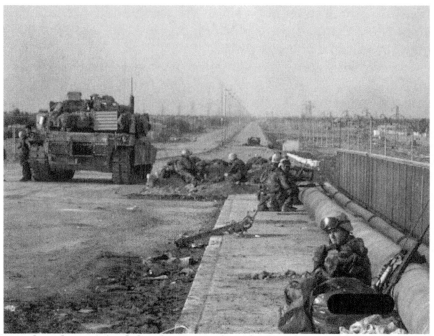

On the Al-Nasiriyah bridge just after the battle.

and it's one I pass on when appropriate. It's so important to keep the troop's morale up, and that goes for everyday life too, not just in war.

On that bridge, lying down in the prone position amongst the detritus and the smell of war, the colonel told me a heart-wrenching story which I've never written about until now. Although I've told it verbally over the years, I've never put pen to paper, something I should have done, but respect for the occasion stopped me and I felt uncomfortable only writing up half a story. He said whilst fighting to secure the safety of the bridge, which cost the lives of thirty-three marines and soldiers, he wasn't sure where some of them had fallen such was the fierce street-to-street and house-to-house encounters. The Marines have a code, they never leave behind any of their mates on the field of battle, they always find them and bring them

home (a code portrayed by the actor Kevin Bacon in the film Taking Chance).

Colonel Grabowski did find all his fallen marines. After the fighting had died down to only the odd stray Iraqi sniper, a small mixed group of Iraqi men and women dressed in civilian clothes moved slowly and cautiously towards the bridge waving a white sheet wrapped around a stick. You have to remember, the marines had been exposed to all manner of incidents; IEDs, suicide bombers, snipers, mortar bombardments and rocket attacks while still keeping the bridge open, so seeing thisgroup approach, the marines were well guarded. At two hundred metres the marines ordered the group to halt. A woman started speaking broken English, she knew where a dead marine lay, so, after a bit of a stand-off the Iraqi civilians led the marines to their fallen comrade. The Iraqis had looked after the dead marine, and in Islamic tradition had buried the fallen hero within twenty-four hours of him being killed. These touches of humanity are so rare in war. Later, the marines recovered another one of their fallen buddies whose lifeless body the fedayeen had dragged through the backstreets of the city. Quite a contrast, and the word savages springs to mind.

I arrived back at the team's base still full of tenseexcitement and very bullish knowing I'd achieved another first and survived, and the irony of the Hereford Old Bridge wasn't lost on me either, but I was brought right back down to earth because Nick had received orders regarding the replacements.

'Do you want the good news or the bad news?' he started off.

'Good, please,' I said. 'I like good news.'

'The replacements will be here tomorrow. They're in Kuwait now and will cross the border early dawn and we'll have to go pick them up at checkpoint Charlie.

'And the bad?'

'Someone's got to drive with JY back a hundred clicks for the drop-off and pickup. Can you go?'

'No probs,' I said. 'Should do it in a day if we leave early enough.'

So, early next morning JY and I took two vehicles and tactical withdrew once more back south. We made the RV (rendezvous) in good time, dropped off four, picked up two and returned. Yes, it was a bit of a pisser having to drive back, but the route was so

secured by the Americans, we had no security issues at all. It was safer than the streets of Cardiff for an Englishman after England having smashed Wales in rugby. We dropped off Ross, Ali, Kieron and Laurence, and picked up correspondent Lisa Holland and cameraman Andy. No interpreter.

As we neared Al-Nasiriyah I saw a man off to my leftcoming out of the huts I had led the little girl to safety some days earlier. I waved across just out of politeness, hearts and minds, and all that sort of stuff, not knowing if he'd remembered me or my vehicle. He beckoned me to stop. I stopped. He went back into the hut and appeared a few seconds later and came across carrying a dozen or so of those large round flat roti breads the size of an extra-large pizza but real thin and floppy. He couldn't thank me enough for helping his little girl. He even offered me a couple of AK-47's but I had to decline. What a lovely warm gesture from him to give me some of his bread ration as there was a massive shortage of all food stuffs in Southern Iraq, but this is the Arab way, even in war time. Today, as I sit back and write up this vignette, that little girl must be in her-twenties now!

10. Exposed and Alone

Mount up and move out. We left Al-Nasiriyah to its newly found freedoms. I was very happy to leave that dump but not Reed or his marines, because they had treated and protected us like one of their own. Unfortunately, they were having to wait for orders and it was more than likely they were heading off to Al-Kut which wasn't in the direction we wanted to be heading. Reed gave us one last piece of intel.

'Look,' he said, 'Command is tightening up on the press. There's been reports of un-embeds writing up stuff they shouldn't and sent back to Kuwait. You be careful.'

It was sound advice, as I'd earlier been told by Andrew North, the BBC Radio 4 embedded correspondent, that some embedded folk were getting pissed off with us un-embeds having such a free rein, including himself. That made me feel even better, and said, 'BBC complaining again, Andrew?'

He wouldn't comment. I felt his professional envy, but he was safer embedded where he was, and he knew it.

'Why don't you come along with me?' I asked him.

'Love to, but can't, Aunty would have a fit, and I'd get the sack,' he replied.

I liked Andrew, but I never saw him again until several months later I got a call from him. Back in Al-Nasiriyah he'd lent me a charging cable which he'd signed out from the BBC stores and now the BBC wanted it back, so we met in London for a coffee and gave him back the cable! Once again, similar war stories, it reminded me about equipment and accountability. During the Falklands War after the battle for Goose Green my unit was at a place called Fitzroy. We were test- firing weapons into the estuary, and when we'd finished the officer in charge ordered us to pick up all the empty cases and put them in the back of a Snowcat. (A Snowcat is a small tracked utility vehicle which can carry half a dozen troops at a push). We all thought this was utter madness because we were at war and we'd just expended tens of thousands of rounds fighting to

take back the settlement of Goose Green, and no one said we should area clean the battlefield of brass then! It was like clearing the ranges back at Aldershot in the UK. Anyway, reluctantly we all started filling up sandbags of empty cases and stacking them in the back of the Snowcat when all of a sudden from out of nowhere, four Argentine Skyhawks flew up the estuary and dropped bombs on the two RFA LSLs (Royal Fleet Auxiliary Landing Ship Logistics), RFA Sir Galahad and RFA Sir Tristram, which had surprisingly been at anchor like sitting ducks for the past day, turning the Sir Galahad into a burning wreck and killing forty-eight Welsh Guards and crew in the process. Instinctively, we all fired back at the Skyhawks, but it happened so quick it would have been such a lucky shot if we had downed one—an impossible shot really. I could see men abandoning ship, jumping from the burning decks of the Sir Galahad into the water, whilst others lowered lifeboats in a frantic race to get off the exploding ship. We all felt desperately helpless at the catastrophe unfolding. Anticipating the arrival of many wounded, we started grabbing the sacks of brass and throwing them off the back of the Snowcat to make way for the casualties, then my mate Dick jumped in it and sped off down to the shore as life rafts were heading our way, followed closely by the rest of us.

This was a sight impregnated in the memories of all who bore witness. The screams of burnt men and burning ships; those poor Welsh Guards and the Chinese and European crew. I shall never forget their faces as they came ashore. My point is, some years later I went back to the Falkland Islands to film a documentary and I found that exact point where we pulled those sandbags back out of that Snowcat. How? Because they were still left where we had dropped them, but now, those sacks of shiny brass casings were now just a weathered dark brown heap, bleached by the sun and frozen by the ice, their hessian sacks long rotted away, yet the casings were still there, as bold as brass!

We had to make speed and get back on the road to Baghdad. Reed kindly got us hooked up with a marine unit heading towards the capital where we found ourselves back to our old

tricks again and were making up for lost time by weaving in and out of the marine convoy, pushing ever forward. We passed hundreds of Abrams, Humvees, tractor units, you name any vehicle the Marine Corps had in their armoury, we passed it, and always with a smile and a wave.

So often, we were called to a halt. 'Incident up front,' a marine would report, so that was the order to get a brew on or get some scoff down your neck. Many occasions we would hear an explosion somewhere, usually always seemed to be close by, then we would hear the Cobras and the Hueys, then they'd appear overhead or to a flank, their rotors screaming and so low you could see the pilots grimacing. Seconds later there'd be a huge explosion, a burst of cannon fire, then we would be on the move again.

A couple of miles ahead we would see what the hold-up had been. Sometimes it was a hidden Iraqi tank sitting silently with no visible damage all but a scorch mark across the turret, indicating it had been hit by a tank-busting high explosive round, which had pierced the tank's armoured plate, making a small hole upon impact and would let off a fierce, whirling explosion inside, killing the crew almost instantly; a visible contrast with the tank-busting rounds they used in Gulf War 1. Back then I saw T72 tanks after they had been hit by Allied rounds, but their turrets had been blown off askew, or the entire tank smashed. That's the clinical advancement of modern missiles on the battlefield today. Same outcome, just a neater kill!

Other times, we'd find the mangled wreck of a car once driven by a suicide bomber. Occasionally, we would pass the still-burning wrecks of Humvees and soft-skin vehicles. The Iraqi attacks were mainly on soft targets as the military like to call them, but the Americans were not without their concerns because during more than one of these encounters we passed the upturned wreck of an Amtrac which was wearing anti-RPG deflection armour designed to prevent an RPG attack! Possibly a very lucky RPG strike or, more worrying, the end result of a dug-in Soviet-made anti-tank bar mine.

Every day we scrounged fuel, rations and any kind of intelligence from the Yanks at every opportunity. In return,

Nick allowed them to use the satellite phone to call home. It was one of the major factors that allowed us to advance so much more quickly forward than other un-embedded correspondent. A touch of genius through bribery.

One time, the tarmac road fell away to hard desert floor and the marine unit who were hosting us at the time had orders to go firm; it was still only midday so rather hang about for them to get their marching orders again, as it could have been in an hour or in a day or two, JY called the team together for a Chinese parliament (SAS-speak for an informal discussion) about whether to push on without an escort.

'Well, I say let's go. We could be stuck here for days,' I said.

'Look, we got no idea of what's out there apart from several hours' hard driving,' replied Nick.

'I dunno,' JY threw in. 'Nige is right, we could be stuck here for days.'

'Maybe the marines won't let us go it alone,' Nick replied.

'You have point,' I said, 'allow them time to think about it, then they may just order us to embed with them, and then we're fucked.'

'For our own safety, no doubt!' Des replied sarcastically 'then we'll never make Baghdad.'

We had only minutes to make a decision. Stay or leave, stay or leave, decisions, decisions! The longer we stayed prating about, the easier it would be for the major in charge to come to the sensible decision and order us to embed with him for the duration. But I managed to get some hot intel off one of the marines on the forward most wagon, apparently, there was another Marine convoy which was about an hour ahead of us, so JY and I felt it safe to push on. We mounted up and slipped away before they noticed and drove hard and fast. We were against the clock and we desperately needed to catch up with the convoy's rear element as we were burning daylight, fast, and I knew, if we had to spend a night out with no guns it would mean certain death for some, and that wouldn't have been fair on the replacements!

The land was rolling, hard-packed desert with many natural obstacles making the going hard on the vehicles, and that meant many ideal places to get ambushed. A vehicle on the move, even

if it's creeping forward makes for a much harder target than a vehicle stationary. Our vehicles performed well, and it was the first time since crossing the border we had managed to hit the fifty mile an hour mark. We drove for three hours and saw no sign of the convoy and met no one to ask. I did see some bodies up on some high ground but put them down to Bedu. This Mad Max dash across the desert was a crazy, yet a calculated choice. Lesser folk would have stayed in the safety of the group, but for us, the Maverick Team, the mission was to get to Baghdad, and my mission to be the first into Baghdad, was a very powerful driving force, and if that meant taking a risk here and there, then that's what I had to do.

Time was running out fast. Light was fading and a couple of the team were beginning to show signs of panic. My panic hadn't yet set in, but it wouldn't be long before it came a' knocking. I've been in many a tight squeeze before, and I know it's not the situation one finds oneself in, no, it's an individual in the situation who first starts apportioning blame who is the killer, not the enemy. You know what I'm getting at. The, *I told you we should've stayed merchant*, but we were lucky, bloody lucky, because Nick, who was in the lead wagon, suddenly pulled up and pointed to a massive cloud of dust rising up in the fading light; a sight only a convoy trucks could create. My eyes were so red and tired from all the heat and dust yet I could just make it out too. It was chugging away about two miles ahead. We had been averaging speeds of thirty to forty mph compared to the average convoy speed of about fifteen, so we hadn't been given duff information after all, only the timing was out. We took the risk on face value and now, it looked like our risk had paid off.

On seeing the rear of the convoy, the marines acting as tail-end Charlie would have certainly seen us too, and were probably thinking, who the fuck's coming up fast behind us? We had to make our approach slow, real slow, as the marines would not be happy to see us, I was sure of that. Rapidly fading last light with three unknown civilian vehicles following you in the middle of a war, one looking like it could have anti-aircraft gun on its roof, is a deffo case of fire first and ask questions later!

We slowed down and I saw two Humvees break away from the main convoy, drive off to a flank and come to a halt in anticipation of us keeping our same heading so they could observe. I adopted my Cobra surrender position and shoved both arms out and held them high as the Jeep slowly lurched forward under its own tick over. Nick and Des did the same. One Humvee broke off and came alongside.

'We're Sky News, Fox News,' Nick shouted across in a pleading sort of way.

'You crazy fucking fucks, we were just about to engage,' a marine yelled back.

'Sorry, old chap,' Nick replied. Again, the moment really didn't need Nick's smart reply, but it put a much-needed smile across my face.

Our Mad Max dash was another experience I would have to rank as number two on my list of my most concerned periods so far into this job. Meeting the Cobras was still number one, but being exposed in every conceivable way to the enemy and the elements comes a real close second. And no matter how many times I rewind this incident, it still gives me goose pimples even to this day. Makes my teeth tingle.

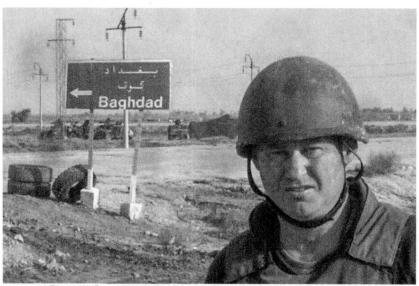

Me on the road to Baghdad

NIGEL ELY

11. The Awesome Might of the USMC

The days now just rolled into nights as we pushed further and further north, snaking through the massive green monster which was gobbling up everything in its way as it crept slowly towards Baghdad. We drove all through the day and rested up at night. Night and day, day and night. We kept this pattern up for days. Sometimes we would have to stop and rest up for a few hours while the Marines dealt with the enemy, then Nick would fire off copy, a news piece, a progress report, and in return London kept us informed about what was happening across the bigger picture, and to our delight they kept confirming the Maverick Team was always the furthest forward of any of the un-embedded by one hundred miles, and no one was looking like anywhere close to us. We were the leading news network of the entire war, so to that end, JT, who was still down in Basrah covering the British, wanted to join us. I wasn't surprised one bit because our stories were being picked up and viewed all around the world. We got orders to slow down so JT could catch up. He and his small team were making a similar mad dash across the desert. JY chose a safe place for the RV, a camp in the desert the Americans had just constructed.

Now here's a thing, if anyone has ever underestimated the fearsome might and professionalism of the American war machine, well, just take on board what I have to say next. The entire USMC I was travelling with hadn't veered off the MSR (now officially named Tampa by the Americans) since crossing the border. Because we had made such good time, it appeared the Marines were now in the slightly embarrassing predicament of getting ahead of themselves. Lines of communication and logistics are so vitally important, they are the lifeline to keep the war machine moving, were perhaps at the point of being tactically stretched. Remember, this force of eight thousand plus vehicles guzzling up two hundred thousand gallons of fuel every day needed constant resupplying, (each Abrams does gallons to the mile, not miles to the gallon. It uses several just

to start up) so consequently, the Marines decided to just chuck a right off the MSR and pitch camp in the flat open desert. In simplistic terms, that's exactly what they did. But it really happened like this. I waited on the MSR along with thousands of marines while Cobras and Huey gunships flew low up the column, made a right turn and did their aerial recce of the proposed campsite. A few Hellfire missiles engaged suspect targets and then we all had to move our vehicles over to the left side of the road, marines included, to allow massive six-wheel drive tractor-trailer units to pass, each carrying American-built Caterpillar bulldozers. There were D6s and few of the massive D10s, they could have even been D11s, many with bulletproof cabs fitted, some with single big rippers on the back; a big hook-like claw which rips six-foot-deep furrows into the ground.

They immediately set to work pushing and piling up thousands upon thousands of tons of sand into lines of high protective berms, ripping rock and constructing areas for each Marine Battalion. Then after a couple of hours, a convoy of similar six-wheel drive trucks hauling more heavy plant, some with massive rollers on their front, some with big square teeth on front rollers which were used to vibrate the desert floor solid. Others were fitted with a conventional smooth roller. Graders, diggers, massive diesel generators and fuel tankers. Hundreds must have passed by me. This construction went on for several hours but before last light, the team and I, and all the marines, and there were thousands of us, made the same right turn off the MSR and into the safety of this incredible desert camp they had just constructed. As we slurped tea and prepared for last light, Hercules C-130 transport aircraft started flying in and out, offloading tons and tons of stores. I felt very privileged to have witnessed this military construction, and I'm sure all the marines involved will one day look back with absolute pride and realise just how formidable and special all their skills were to have constructed such a camp in such a short time. It's an event which happens only once in a lifetime. Old Spooky and now this, I certainly was one of the privileged—and these were surely crazy times!

Situation Change. We spent only one night in this camp. The marines decided to pick up the pace, so we were now travelling

through the night. The going was slow, as slow as a snail's pace along most stretches. At night, we averaged ten mph; by day faster, but not much faster. The Jeep was now experiencing some sort of oil loss. That drip back at Abdali had now turned into a dribble. I was aware of becoming a burden to the team, like a wounded soldier left to fend for himself as the mission has to go on. No way did I want to abandon my Jeep and ride with the others. Ever since I was a kid, I've been fascinated with engines and cars. Back home I have several projects, old British classic cars and tractors in varying states of repair, so I knew how to keep a sick engine ticking over, and I knew the nectar to any engine is oil, and if I kept a constant check on the oil pipe repair and the oil in the engine all would be fine, and that's what I did. Every few miles or when there was a forced stop, I would quickly lift the hood, pull out the dipstick and do my checks. It became a habit, even though I knew I didn't have to do it as often as I did, and it brought a new meaning to *don't get outta the vehicle.*

Because our vehicles were not fitted out for tactical night moves, we had to prep them, for example, masking-tape up all lights, front and rear, cover up brakes, indicators andreversing lights too, leaving only a slit on each headlight lens which produced hardly any light by which to drive on. All interior light bulbs were taken out. At night, the marines were driving in total blackout using only their personal PNG's to see where they were going. On one very confused night stage we found ourselves at a road junction with a mass of military vehicles blocking all routes, total gridlock. It was a classic, does anyone know where the fuck we are?

JY was in the lead vehicle but he eventually managed to get us clear and out of the traffic jam. Several miles later, the vehicle he was following, chose to do a right turn and veered off into blackness. JY followed, then he stopped suddenly. I pulled up alongside him.

'Did you see where those trucks went?' He asked, slightly embarrassed because he was point and it was his responsibility to keep up with our escort. But in JY's defence, it was a pitch-black night, low cloud base, no stars, no nothing!

'No, mate,' I replied, tempted to try a one word, one-lineron him, such as, twat!

'Fuck it.' JY was pissed off. I would log his fuck-up and use it as my defence when I fucked up next. We all fuck up, no one's infallible.

JY ordered the team to stay inside the vehicles while he and I carried out a very cautious look around. We knew the marines were about someplace but since we daren't use a torch we had no choice but to stop where we were. We found ourselves in some kind of wide re-entrant, an old riverbed of sorts but couldn't figure out where the heck the marines had disappeared to, so we decided to stay put for the night and sort it out in the morning. Ten minutes passed when all of a sudden, the skies lit up with hundreds of screeches and flashes of bright lights. It was a massive artillery barrage. I ran up to a high point and looked down to where the shells were landing, then I caught my first glimpse of the Iraqi capital as it was being lit up. The barrage stopped, then low-flying jets screeched overhead, dropping bombs. Baghdad was getting a right pummelling. SOP's, I started to dig a shell scrape just in case the Iraqis had enough fight left to launch a counter attack.

I woke the following morning, half in and half out of my shell scrape. I looked around to gather my bearings only to find we had parked up not far away from a Marine comms tent, which looked similar to the standard British Army 12 by 12. It was only a hundred metres away. I could see JY and the team had slept out in the open too and were just rising from their slumber. I took a wander over to the tent. One side was open, the tent flap being tied back by a length of para cord and I could see the duty marine signaller sitting by a small desk working on a laptop. He raised his head and smiled.

'Mornin', sir. Can I get you a coffee, sir?' He asked in a perky southern drawl.

He said it in such a straightforward way and didn't even bat an eyelid. I almost expected him to say, 'What the fuck are you doin' here?' But he didn't, he was really polite.

I was bloody starving too but I stopped short asking him if he had any of that blueberry pie like mother used to make! It was a fantastic cup of coffee, the best I'd tasted for years.

So, we'd got lost the previous night, or at least detached from our escort—it happens! It was no setback as we would easily pick up the trail again after breakfast. What a start to another crazy day. I felt a touch of nervous wind rumbling around in the pit of my bowels again. We were closing with the enemy while the coffee caused me to let rip a squeaky stagnant fart as my constitution beckoned—more tea, vicar!

Me in my shell scrape.

12. LOGOF: Looters Galore
and the Battle for the Diyala Bridges

Some 340 miles from the Kuwait border we approached the Baghdad city limits. The ground was starting to change from a barren desert landscape to a coarse undulating terrain covered by a series of ramshackle small towns overflowing with heaps of stinking rubbish, scrap iron and a militia of snarling mange dogs at the ready. The entire landscape was now orange and black, ablaze from the result of war. Blown gas pipes creating toxic black smoke spewed fiercely upwards. Smouldering Russian-built APCs (Armoured Personnel Carriers) and T72s and the much older T55s all now scrap. Roadkill was visible; dead animals; goats, dogs and Iraqis. Some squashed as flat as a pancake, some lying in the gutter, but all dead. We then arrived at the town of Salman Pak, which later became world famous for its covert Iraqi blogger. It was the first biggest town I'd seen since Al-Nasiriyah. Without exception, it looked like none of the buildings had ever seen a lick of paint or had any refurbishment since the day they had been built, which was probably back in the 1930s. Many of them were still made from mud and timber like those in the south. I've seen better African towns and villages still at war with each other in better states. It never ceases to amaze me the destruction war brings. How can we humans keep this up? Why? Recently it's been our, dangerous self-proclaimed political elites who wage and profit from war, but they and their families are never affected by war. They are never the ones on the ground to see and clear their mess up, but they should; they should all be made to, they should all be dragged by the scruffs of their necks to the battlefield, to the hospitals, to the gravestones.

For a thousand years this indigenous population of Sunni and Shia shared such a tribal hatred for each other, feudal fighting was the only life they knew. They knew nothing but war and hardship, but anyone who took the time to listen to the Gulf

Arab would understand it was Saddam who was the latest leader who was holding these two factions apart. Now, without a Saddam, Iraq would be totally lawless and this was obvious to most in the region, apart from Blair and Bush

I entered Salman Pak to a face full of noxious smoke billowing off a pile of burning tyres someone had kindly lined the street with. The place reeked, it chucked up so bad the acidic fumes ripped down my throat. But no sign of an effective enemy, only the pop of a single shot here and there. It seemed many of the Salman Pakers' were on a mission and it wasn't firefighting, it was looting! Looting of anything moveable or fixed was rampant. Anything that could be carried away, was. Anything that could be smashed into a thousand pieces for whatever reason, was. I saw a dozen brand new Bobcats being driven up and down the streets, their drivers acting like kids on fairground dodgems. You know Bobcats? Small-wheeled front-loaders which are used in confined spaces for lifting sand and stuff around. Then there were rolls of steel cable on huge wooden drums being hastily rolled away, no doubt to a secret location, by men using wooden poles to prod them, frantically trying to keep them straight on track, while other men were screaming trying to shove the men with the poles out of the way, in a sort of looters mugging looters situation.

Rolls of carpet, panes of glass, furniture, sofas, chairs, kitchen sinks and hundreds and hundreds and hundreds of boxes of tinned tomatoes being carried on heads like ants in file off to build their nest, hurriedly disappearing down back alleys. Yes, tinned tomatoes! It seemed every looter got a box of tinned tomatoes just for looting, the first ever LOGOF, Loot One, Get One Free! They didn't seem the slightest bit interested in their town burning down or in us passing through. No, they were far too busy. The loot was coming out of the local Iraqi government building complex, only an hour earlier occupied by the ruling Ba'ath Party. I couldn't blame the locals one bit. They were the liberated and they were going to take back what three lost generations under Saddam had taken from them, so what the heck if they looted!

Salman Pak flashed by and was now just a distant memory, but there has to be some cause for concern because, how one can so easily forget the utter misery for so many of the people who lay behind me. Was I feeling a sense of guilt, or just numbed to guilt? I had to stay focused; it was the team and myself I should be looking out for, not the looters. I wasn't blind to the human suffering and I was sure I'd feel their pain soon enough.

We now pushed on well into the sprawling Baghdad metropolis. I came across civilians, children, some ragged wretches but most with smiles. I would throw out handfuls of boiled sweats as they came racing up to my Jeep. The streets were littered with all sorts of household rubbish which looked as if it had lain there for months if not years. Did the inhabitants ever clean their areas where they lived? Evidently not! Everywhere I looked I had to assume every building as a potential sniper hide and at every road junction, obstruction or culvert a potential IED threat, but still we kept close to the marines, and at a half-decent speed we could certainly be sitting on the balcony of the Palestine in time for tea and tiffin.

Deeper and deeper, we dared towards the centre of the capital. At about fifteen miles in, the convoy eventually slowed down, came to a crawl and then ground to a halt. I knew the going was too good to be true. Something didn't seem right, then news came down saying we had halted just short of a battle which was raging across the Diyala River. The Iraqis had blown up one of the two bridges which spanned the river. Now, the Diyala, in river terms, wasn't so significant, but strategically the two bridges were all-important as they marked the south-eastern boundary of Baghdad and was our only direct way into the capital. For the Marines to turn and go find another crossing was not an option, however, speed and aggression was. I managed to flag down a marine.

'What's happening up front?' I asked.

'Fuckin' chaos up there. Iraqis blew the bridges. We got Combat Engineers repairing them.'

'How long?'

'Hours, maybe a day or so,' he said cheerily.

I got the feeling he was quite a happy marine. He didn't mind staying around here for a day or so, but I certainly did. The road to the bridges had forced us all into a bottleneck and as a consequence we had formed a long winding snake which slithered back for two miles, lying up in a choke point just ripe for an Iraqi counter-attack.

'Any enemy about?' I asked in a sort of inquisitive tone.

'Intel says no. We killed most of'em, and the rest, well, they've all run away to the other side of the river,' he replied quite matter-of-fact.

As night time closed in I prepared for a come-on. I hated being out of the loop. It made me tense and slightly scared not knowing what was happening up front. We were so close to Baghdad so I didn't fancy sitting around for one hour in the open, let alone one day. I stretched out in the back of the Jeep and with a tight stomach I started worrying about life, family, and stuff like that. The previous night I had one of those real thought-provoking times we all go through once in a while. The trouble was, I was having mine in a war zone, and feeling so bloody helpless. I sucked on boiled sweets and listened to the odd angry shot and watched tracer rounds light up the night sky. First light couldn't come quick enough. I willed it in with the power of my mind. It's amazing how the majestic sight of a rising sun can change one's entire mood. The beating myself up period had come to an end for now, until the next time. Get it sorted, I told myself, just crack on with the day and worry what's down range.

I was entering another hurry up and wait period, and I came all over goosepimply and really fancied a coffee. I rarely drink coffee, but thinking back to the marine in the comms tent, I made myself a strong one, half water and half condensed milk, that thick, glue-like stuff that comes out of a tin. I got to know this milk whilst operating in the jungles of South and Central America and the Far East. It came as a single item in the special-issue jungle ration packs. It's massively high in calories and tastes like extremely sweet milk. Go try it for a treat! Half a pint of coffee, sweetened by this stuff is just the job to get your constitution going. It really does sort out any blocked-up stomach issues!

It had been three days since I last had a Number Two, and was dreading the next one. The previous week we'd had an overnighter at an area the marines were looking to construct a refuelling stop where I'd managed to have a good look at the Jeep's oil pipe and bodge a temporary fix with some heavy-duty USMC masking tape. I also had to visit the boys' room as my bloody farmers were giving me some sort of gyp! I recalled the first time I ever visited a US military toilet; it was over in the States at Fort Bragg. Their cubicles have no doors, which always made me think of us Brits being a little on the prude side, but

hold that thought of no doors. Anyway, the marines on the march-up took the no-door policy to the next level. They dug holes in the open, no cubicles, no top cover, just you and the elements, the odd Iraqi goat herder and a thousand marines in full view. Holes are dug, and small timber frames are placed over the holes, sort of like a communal seating area mainly constructed from scrap ammo and ration boxes, a bit like a series of small coffee tables all in a row without the flat bit for resting your cup on, just the frame and legs for you to squat on.

When we first set-out I brought along fresh rations for a bit of roughage, but they got used up within the first couple of days at Abdali, so I tended eat the MREs (Meals Ready to Eat) US Forces daily issued one-man ration packs mixed with my own choice of tinned fish, tinned processed cheese and biscuits. They really were OK and I certainly didn't mind them. In the field, hot food is hot food and one can't be too fussy. The MREs came in several varieties but they're all designed to block up your regular constitution, because squatting in the field is time-consuming, uncontrolled, and can be messy and fairly un-tactical if you're in an op or a hide, so the MREs move your bodily functions into a three or four-day cycle and when you feel it's time to go it comes real slow, slow and painful, and if I may, I'd like to describe it as the, showing or retreating of a turtle's head. I'm sure you get the picture! Twenty or thirty minutes is not uncommon for your stool or bits of stool to pass into the dessert of Iraq, and in that time, you can strike up a long-term friendship with guy next to you.

'It's like giving birth,' one marine sat next to me once said. Not sure how he could make the comparison, but I will tell you

it is excruciatingly painful to pass rock-hard stools some the size of golf balls while keeping an eye out for snipers and suicide bombers.

I assumed drinking the coffee would send me running to the nearest boys' room, but all it did was make belly rumble and grumble with no sign of bowel movement at all! Just as well, because we were now on the move again. We moved up to the bridge and were halted by another traffic jam. There were two bridges built right next to each other, the one to my right was the blown bridge, now spanned by a newly erected pontoon bridge allowing vehicles to across. The other, was a single-track deck girder type, which was all bent and mangled by badly placed Iraqi shaped HE charges, because it was still passable on foot.

We were held up again while the road across the bridges and beyond were secured. I took this as an opportunity to have a look around and take a few pictures. The place was swarming with marines; they had just fought a hard battle and I didn't know how many of them were killed or wounded—not the sort of thing one asks just after a battle, ever conscious of intruding into their world. Their faces were ashen and drawn. I call it the ten-metre stare, a stare which cuts right through you, not vacant, just hard. They had just stormed the bridges and they looked exhausted. I asked a couple if I could take their picture but all I got was a blank stare. I took them anyway and half expected a, 'Fuck off, buddy' but it never came. I later found out they had lost two of their buddies, so their blood was up, they were as angry as I had been back when we were lined up ready assault Goose Green many years earlier, having just taken Darwin Hill and passed through the battle field where our dead and wounded lay. It's an explosive anger which is calculated, controlled and contained, and only detonated by an order. Let loose the Devil Dogs.

Four hours later, the marines had cleared the route across, so once again we set off. Now only five miles from the Palestine Hotel, our marine escort was taking the wide-berth route and we were now heading north with a touch of west, skirting the city centre and picking up Baghdad's answer to the M25 motorway ring road and heading in an anticlockwise direction.

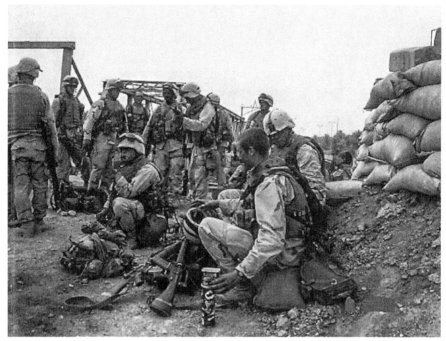

Both shot just after the battle for the Diyala Bridges.

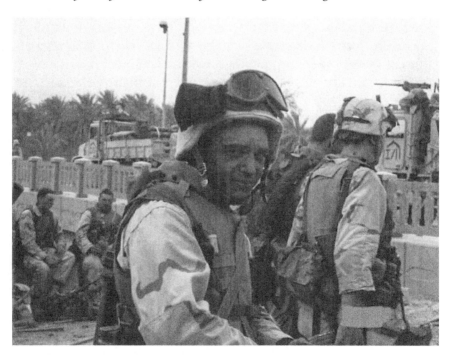

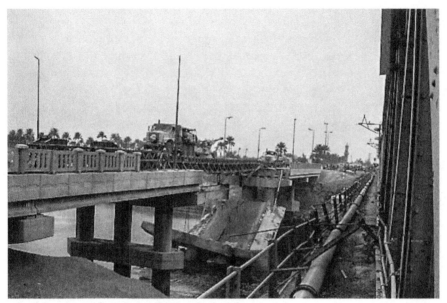

The blown and repaired Diyala bridges.

As we approached Baghdad central, I saw the pathetic defences the Iraqi Army had constructed. In brief, they totalled a series of long, thin trenches just wide enough for two soldiers to pass. It appeared to be a design based on a First World War trench system with very little top protection, and by that I mean, cover from view, and absolutely no cover from enemy fire. Back in the Paras when we built trenches, we built them for cover from enemy fire and cover from enemy view, but these trenches were just sandbags holding down sheets of corrugated iron to give some overhead protection, but in effect it was just cover from the sun and view from a distance, and nothing else. What had Saddam and his generals really told the grunts on the ground? I was truly shocked at just how inadequately Iraq had prepared for battle, prepared to defend the capital of their country.

All through the war I saw thousands of Iraqi soldiers just hanging around all along the side of the MSR. They had been so scared of what the marines would do to them most of them had discarded their uniforms and boots and now pretended to be civilians. A marine major who had spoken to a group of these Iraqi grunts told me they had been briefed by their officers the Americans would show no mercy to any Iraqi they caught; they

would rape and slaughter their women and children. Well, one can't help thinking in such a depressed and controlled society where only the elite had access to the outside world, one could understand the thought process of these poor excuses for soldiers and one only had to look at their trench defence systems to know their system wouldn't even stop a charge of a dozen chariots, let alone one Abrams.

Fair play to the Americans, and from what I saw, they were friendly to the defeated soldiers, they told them, 'Go find your boots, and go home to your families.' I found out later most of the Iraqi soldiers stationed in the south had in fact been shipped down from the north of Iraq. There were thousands of these now ex-soldiers streaming north and surely this was a security problem just waiting to happen! With the amount of defeated Iraqi soldiers on the move, I was sure the Americans were thinking about a counter-attack. Would the Iraqi soldiers get brave, regroup into a militia and wage a guerrilla war? I certainly thought there was a big possibility of this happening as it was clear to me (forget about the feudal Sunni versus Shia as it would most certainly be Saddam's defeated Sunnis who would be the problem. The Shia would take revenge when time permitted) a proportion of them would wage a freedom fighters' (now called insurgents) strike- back campaign. I certainly would have, if someone invaded my country, but I'm moving off the story now, sorry!

Back to the defeated Iraqi Army. Some marched in military column formation, quite defiant, but not like any defeated enemy I'd seen in previous wars, while many shuffled along in groups of four or five, hobbling, carrying all their possessions in one scraggy, unbranded plastic bag, their rifles long discarded. They were a mixed bunch, some harmless, but far too many displayed defiant attitudes and I sensed this far too often.

Before I'd even entered Iraq, I knew a bottle of water was something of an anomaly south of Baghdad, in fact any type of consumer product south of Baghdad was an anomaly; my Kuwaiti friends told me so. Every now and then as the American fighting machine passed this beaten army, they would toss over

to them bottles of mineral water, then a Humvee would pull up and drop off a case of MREs, even cigarettes. It was such a gracious and humane move on the part of the Americans and something I'd never witnessed before in war, as all the defeated armies I've ever seen all looked the same: dazed, sullen and scared. It's a pitiful sight to see men women and children in such a distressed state, but was it all just a ploy! Were the Americans unknowingly fattening up religious fever?

13. First to Baghdad

It was midday on the 9th April when the Maverick Team crawled into the centre of Baghdad. We were behind our escort and it appeared they were heading for the airport way over to the west, but then, for reason our escort did a complete about turn. I knew the area around the airport was getting a right old battering, so I guess that was the reason! We now found ourselves moving around towards the east of Baghdad. Light faded fast in this part of the world and an unease started to creep in as I knew we had to get off the streets and into a safe area very soon. Sniper fire, an RPG attack or even kidnap wasa massive concern as we entered the tightly packed houses along narrow streets. It would be so easy for the enemy to pop up, fire off a rocket and disappear—it's that easy, I know because I've done it. Then, and not before time, our marine escort reported our destination for the night would be the Republican Guard barracks. The Republican Guard were Saddam Hussein's elite fighters. A battalion of marines had, and I'm being polite here, kicked them out of their barracks during the day and now made it their HQ, then, almost immediately after that, received orders to head for Baghdad Airport at first light the following morning. Problem being, the Palestine Hotel was in a different direction. The airport was not the story. We had to work out a plan to escape from our new hosts, and fast.

As we entered the barracks, I could see the marines had set up a very secure perimeter with their Abrams and Amtracs as cordon protection; it felt secure, so just out of curiosity I went for a forage around. Most army barracks are of similar design: accommodation blocks, HQ block, armoury, stores and a cookhouse all sited around a big square where soldiers carry out their drill, get inspected, get awarded medals, get disciplined, and according to the marines, the hanging of civilians was another common disciplinary measure practised by Saddam in these barracks too.

Army stores contain uniforms, webbing and nice shiny expensive things, so JY and I headed for the stores. It's not unusual for a retreating army to booby-trap nice shiny things. Earlier, a marine search team had cleared the stores but not the armoury, which was over the other side of the barracks and well out of the way. Nothing is failsafe, so I was very much aware of missed or secondary devices as I moved about. I didn't take much, a few Republican Guard cap badges in the shape of the Iraq eagle, oddly not dissimilar looking to the American eagle, pressed-out of a cheap sheet metal alloy and a few cloth shoulder-patches just for souvenirs. I didn't venture off the concrete floors and was very mindful of trip wires. The Iraqis were still schooled in non-electrical detonated IEDs such as pressure plates, mercury tilt switches and pressure release pads.

Dark o'clock and hunger closed in, so we made our way back to the vehicles where I saw JT, Jeremy Thompson putting a framed picture of Saddam Hussein in the back of his truck. See! It's not only old soldiers who like a bit of war souvenir-hunting! Later JT dropped the bomb shell, the marines ordered us to be confined to barracks until the fighting had died down. Earlier, a unit of marines had pulled down a big statue of Saddam in a place called Firdos Square, right next to the Palestine Hotel and this appeared to have pissed off some pro Saddam supporters which only added fuel to an already volatile situation. Also, the Iraqis had been planting IEDs all over the capital ever since they realised, they were going to take a hiding. Bombs were going off all over Baghdad and snipers stalked the roads, but still, we couldn't stay cooped up here for the duration. Nick called a Chinese parliament, it lasted all of five minutes and we agreed on an escape plan out of the barracks. Nothing was going to stop us getting to the Palestine Hotel.

In the very early hours of 10th April, I was lurking just out of sight of the marine main gate sentry post. I was on my own with engine running. Adrenaline was up. Behind me in their vehicles were JY, then JT, and Des, as per norm bringing up the rear. The gate was heavily manned by marines. I was waiting for that moment when the barrier was raised to let out a marine patrol. The aim was to confuse the guard into thinking we were part of

that patrol and to naturally slip out behind them. It reminded me of a WW2 movie set in which prisoners waited for the gates to open so they could jump into the back of the laundry truck to make their escape. A big bluff, yes, I knew that. We might make it through or we might not, yet it was a chance we had to take.

At 0410 hours, a three-Humvee marine patrol with one of the 6x6 wheeled trucks bringing up the rear crawled up to the barrier. The 6x6 driver was not in stealth mode because he brutally revved down through the gearbox. If the enemy were asleep then they were awake now! A few early morning niceties passed between guard and driver, the barrier raised and the Humvees and truck slipped out into uncertainty. Iimmediately took a position behind the truck, almost bumper to bumper. My timing was perfect: the guard waved us all through, and we were now officially MIA (Missing in Action) or AWOL (Absent Without Leave), and no longer confined to barracks. The bunch of marines in the rear truck saw us so started frantically waving us away. In anger, two of them raised and pointed their rifles at me. I assume they didn't want us to attract any more attention to them, and I felt a bit empathetic towards them too. If I were tail- end Charlie I wouldn't want a bunch of fucked-up media types following me either. I would have released a couple of warmers into the tarmac just to send a message: *Stay the fuck well away, you fuckers!* But I wasn't about to play chicken. I slowed down and let them know I'd got the message. The distance between us and them increased and so did our chances of getting killed. Strength in numbers was my motto that morning, but now we were left exposed in the most dangerous capital in the world.

The marines pull away but I was still following. I had a street map of the capital laid out on my lap and I had the route engrained in my head before I left. JY made everyone study it. If we got hit on-route, the Palestine Hotel was to be our ERV, and our RV, not ideal to have them both at the same place, but we were dealing in limited options. To get from the barracks to the hotel was a straightforward route. It would be a three-mile sprint through the crappiest and most dangerous place on earth, a right turn, a left turn, then a right across a bridge, then across a staggered junction roundabout affair, then on to Al-

Sadon Street which would take us all the way to the Palestine Hotel; piece of piss!

The marine patrol turned off left. Shit! According to the map we needed to keep straight so now we were totally alone. I drove hard and fast, constantly checking to see if the other vehicles were still with me, they were, and were tactically spread out as per the brief; keeping a good four car distance between us. Again, not ideal using rural convoy drills in an urban environment because the team is spread over a greater distance so you have to rely on comms as well as sight. It's a tactical trade-off when one isn't armed: no point two vehicles getting taken out by one RPG if we could help it.

Later on, as the war progressed through the weeks, then months and then into years, the Iraqis developed more modern forms of IED detonation. As I've mentioned previously, they started off with non-electrical and suicide bombers, but detonation by radio signal would soon become their preferred choice. Less risky as you can stand off from a long distance or from the other side of the world on a beach somewhere and fire off your bomb from the hotel pool, so the boffins back in the UK invented this invisible system called the Bubble, which jammed any radio signals and potential detonation of IEDs, and so it was introduced into Iraq by the Allies which allowed vehicles in convoy to travel really close together; in fact tailgating was necessary if you wanted to be in the, invisible fifty-metre protection zone the Bubble offered. Of course, the insurgents got to know this, so they reverted back to the old-school methods of non-electrical detonation.

Baghdad made me recall so many similarities to my Northern Ireland days. While on foot patrols one of us was made to carry this box of tricks which looked like a radio but with a big six-foot whip antenna. It was designed to jam any radio frequency in range that could detonate IEDs. (Back in the '70s and '80s the IRA were far more advanced than these 21st century Iraqis). It made a distinct noise like a Geiger counter, and the theory was, as you approached an IED this thing would make a noise like Star Trek's 'Beam me up, Scotty' hand communicator increasing as one neared danger. We used to pick straws as to who would carry it; as any infantry soldier will

agree, it's always the radio operator who gets it first. Take out the communications, you then can't call in for backup. The boffins named this piece of kit the Joker, seriously, that was the technical name they gave it, and we all thought it was a great name because we all thought it was a joke piece of kit. Troops who used it found it to be another utterly useless piece of shite to lug about the cuds with, and no doubt made some one in the British Establishment a very wealthy person off the back of tax payer.

The streets of Baghdad were deserted and just ripe to receive a burst of AK-47. Break hard, left turn, another right, the Jeep rolled and the V8 growled. Oil! What about the oil? I didn't want the engine seizing up on me now, didn't fancy cross-decking onto another vehicle in full view of the enemy. Not far now, a mile to go, keep pushing on, look left, look right, keep checking who's behind—have we lost anyone?

Much of the tarmac road had been chewed up by Abrams. Street lamp posts deliberately flattened like matchsticks by these sixty-ton monsters. I entered the bottom of Al-Sadon Street and any folk looking from the adjacent buildings would have seen a lone Grand Cherokee Jeep being chased by three more crazily driven civilian vehicles, one looking very much like it was supporting an anti-aircraft gun on its roof albeit by now Des had covered it in a camo net. Up ahead I could just make out several Abrams. They were all mustered up by what looked to be the tallest building in Baghdad. It towered over all others. It was the Palestine Hotel.

Al-Sadon Street ran straight for a few hundred metres, and this part of Baghdad reminded me of some low-class neighbourhood you might expect to see in any French city, minus the cobbles. Only the grey shabby-looking flat-topped buildings, peering over the deserted streets covered with the debris of war told you something different. The Abrams were a giveaway too, plus the shards of secondary fragmentation from exploded ordnance and pieces of brick and concrete which had been blasted off buildings were strewn over both sides of the street. Obstacles dictated I drove slowly, too slow for my liking, so I was continually going through the what if drill, and always conscious of a tyre blowout. Sure, the Jeep's drivetrain was

powerful enough to drag me along if any of my tyres did get chewed up, but that wasn't the point; I doubted there was a Baghdad Jeep dealership where I could order up a replacement set of rims and tyres, and I would have put my mortgage onmy Jeep being the first ever Grand Cherokee in Iraq, let alone the capital. Sod it! Driving this slow was stupid, so I floored it. I had no time to swerve around the small slivers of metal shard, only the big bits I tried to avoid. My front and peripheral vision were so focused on any possible movement. RPG the left? Sniper fire, right? Team vehicle down? Where are the other three vehicles? All sorts of scenarios kept me focused, while at the same time having to concentrate ahead.

You can only partly teach this sort of driving; the rest is simply experience, sixth sense and luck. How none of us got a puncture on this crazy race to the square was pure luck, and my own Jeep battle bus performed above and beyond the call of duty. As hard as granite, robust as a tracked vehicle and as reliable as any Toyota Hilux, I just couldn't praise it enough, and to think I'd a broken oil pipe on day one, just confirmed to me how well engineered the Jeep was. Of course. it was the Sheikh's Jeep. Sheikh had many vehicles and didn't mind if this one got smashed up a bit.

'Take it,' he said, 'and when you get to Baghdad, sell it. See how much the Iraqi will pay,' he added, laughing.

I was in two minds as to why I should be taking this V8 into a war in the first place, understanding the coalition forces used diesel as their main fuel, but I was wrong, petrol is also used and I always got fuelled up, so it wasn't a bad choice after all.

Suddenly, I saw JY's Hilux veer sharply off to the left to avoid a burnt-out car. He closed the gap and was now thirty metres behind. I could now clearly see Firdos Square, and as I made my approach; I saw a crowd of Westerners half right outside what had to be the Palestine Hotel, all of them cheering and waving at me. I looked up and saw smoke slowly drifting out of one of its upper-storey windows. Was the hotel on fire? I couldn't quite make it out. There didn't appear to be any shell holes or strike marks, just plume of black smoke rising into the morning sky as if someone had popped a smoke grenade in the room and was deliberately blowing the smoke out through the window. Ifthis

was back home, the Fire Brigade would have evacuated the hotel plus several blocks around, but here in war torn Baghdad I was betting there were still morning showers being taken, teeth being brushed and guests smoking shisha on a mezzanine floor.

In the art of fire-making this is called the chimney effect, for the obvious reasons. Air being sucked up from the lower floors was funnelling the smoke out of through the balcony window. But why was it still smouldering? Why hadn't the hotel staff put this possible fire out? Well, I later found out, a day earlier, an Abrams had fired just one shell into the fifteenth floor of its eighteen storeys, which tragically killed the Reuters cameraman Taras Protsyuk and wounded three others. A man on the fourteenth floor was also killed; José Couso of Telecinco, the Spanish television network. I can't say who was at fault, call it the fog of war. Not a nice phrase, but now a very familiarone.

As a young soldier one can get it all so wrong in a split second. You're knackered, stressed, and probably fucked off as well. Maybe you've lost a mate or two during the long haul up. You're under constant fire, facing threats of suicide bombers and snipers shooting out from every culvert, alleyway, window and doorway. You've had few RPGs whoosh past you at a rapid rate of knots and always thinking about a face full of HE. Young kids running about the place, old folk cowering, eyeing you up like some pervert then reporting your every movement back via covert hand signals to a fanatical scrote yielding an RPG 7 ready to send you to your maker. So, with all this crap sloshing around inside your head, you're hyped up somewhat. Then, away up in the distance you see a guy aiming what looks like an RPG or some heavy machine gun from the window of a high-rise. You take as much time as is tactically possible to study the image, mindful of small arms pinging off your tank. The guy aiming at you has a couple of pals in tow, spotters for sure—100%, definitely. But there's another side of your thought process,the side politicians put there to protect their arses and will get you killed, the side which pushes doubt over common sense and fact. You can now see a man with a set of binos looking directly at you, then, a ray of sun suddenly glints back off the binos lens sending you yet another image very similar to that of a

telescopic sight of a rifle or a muzzle-flash, or are they spotting for an RPG'er to find targets? Is the target you? Yes, of course it is, the fuck's looking straight at you. It's time to take the threat out. You fire. Target falls when hit. Target is no longer a threat. Focus on the next target.

The view of the cameraman is quite different. He sees the American tanks entering Baghdad. He may well think he has the first picture of Americans entering the capital. He keeps his shoulder-held camera rigid and trained on the tank whilst his spotter looks for other fantastic scoop shots. This is going to be one big scoop, an exclusive, he may have said to himself, unaware of what his profile looked like to the advancing Americans. In my opinion the only thing I would point back at a tank is a bigger tank, but I've been doing this soldiering game for too many years now and everything I've learnt in my past has come in bloody handy as a freelance photojournalist in war. This was an extremely tragic incident which should have been avoided if the journalists had been better briefed. I now know media networks insist all their employees attend a fluffy named Hostile Environment course before deployment onto the battlefield.

With the crowd still waving, the three other vehicles draw up behind me, I then realised they weren't really waving at me but to JT and the Sky News Maverick Team. Crazy days, but it was truly a welcome sight. I pulled off to the left and allowed the three Maverick Team vehicles to draw up alongside and adjacent to the front of the hotel. They couldn't get any further because of the crowds, and other civilian vehicles blocking their path. I could see Nick stepping out followed by JT, as high-fives were dished out. Nick signalled to get the camera set up. It looked like he was going live back to London, and I could see JT making his way to a Westerner who was surrounded by other media-looking men and women. They shook hands and hugged each other. I moved and parked up just short of Des' sat-wagon; I wanted to keep eyes-on the Jeep. I didn't want some slag planting a bomb under it. I've had years of covert terrorism experience and I wasn't about to forget it now, not even through all this period of media self-congratulation. Don't become a

victim! Old-school knowledge sometimes gets pushed aside in this all-emerging electronic, cyber warfare, drone-filled skies of the fire-and-forget 21st century. I still haven't forgotten grey men, dead letter boxes and mercury tilt switches.

I got out of the Jeep ready to join in this joyous time. Why? Well, why not? I don't know who was who in this cache of correspondents but they all seemed to know each other. It just seemed the polite thing to do. I made my way to the edge of the maddening crowd, keeping one eye on the Jeep and the other on any suspect suicide bomber. I accepted a few handshakes and JT introduced to me to the Sky News Baghdad embedded correspondent, David Chater, and then to a couple of well-known American correspondents. I then walked slowly back towards the Jeep, but from a distance, looked under it, around the wheels and the back and offside. I saw nothing suspicious apart from the usual small pool of oil. If was parked up for any length of time I'd shoved a plastic bowl under it. Look, it was my small effort in recycling. Everything looked all clear. I then moved around the driver's side and saw nothing; all clear. I didn't expect to see anything, but who knows just how quick Saddam's loyal fedayeen could work. No point in taking chances. Anyway, SOPs had been instilled in my DNA. Working in this manner is who I am now, and annoyingly for me, it's what I've morphed into. Earlier, I'd manually locked the Jeep so I made a cursory check to see if it had been tampered with, it hadn't, all clear then, so I unlocked the door, opened it, paused for a couple of seconds to let the muggy heat out, then got in. Crazy, it was hotter than a greenhouse in an Indian summer. I reversed and parked in the shade alongside the hotel still in view of the entire proceedings keen on doing a spot of people watching. Doors locked, windows up and engine working that AC pump toits max. Curiously I rummaged around in the glove box for some food. I found a small tin of sardines in tomato sauce and washed it all down with a warm can of Diet Coke; sheer bliss!

14. The Arse of Saddam

People really do imitate sheep. They attract each other like a magnet. It's who we are. It's human nature. We see a small crowd, and on impulse we are drawn in to see what it's all about. The bigger the crowd the more people are attracted. We humans are a nosy bunch! The media massed in victory while a bloody battle still raged. I decided I'd had enough of this lunacy and headed for the safety of Firdos Square. I fancied a look at the statue of Saddam; I was rather drawn to it, I wanted to see what all the fuss the commentariat had kicked up about it. In their reporting they used specific phrases like, *the toppling of this iconic statue* and, *it symbolises the fall of the Hussein Government and his Ba'ath Party.* I fired up the V8 beast, and drove the 150 metres or so. No point walking in this heat and I wasn't about to leave the Jeep, it was special to me, it was my home and the only escape tool I had.

I made the approach with caution. It was surrounded by Abrams. The nearest tank was turretless, instead it had some kind of lifting gantry where the turret should have been. I later found out this was the vehicle the marines used to pull the statue down, an M88 TRV (Tank Recovery Vehicle). At first, I couldn't see the statue of Saddam but for sure it was lying prone somewhere ahead of me in the middle of the square.

A marine held up his left hand to indicate, stop!

'Sir, get out the vehicle,' he ordered.

I stepped out as ordered. I'd already moved to put my hands up. He sensed this. He sensed I was compliant with the Marine Code. He more or less knew I was one of the good guys, but as a professional, it was his duty to take me through the process. A process I'd been through many times before.

'Sir, put your arms out and up. Do not approach. Do not move.'

I like the way the Americans do their security stop. It's firm yet polite, and you're left in no doubt they will shoot you dead if you don't do as you're told. Same as in Northern Ireland, if you

didn't show strength and a get a firm grip of the situation and let the suspect know you mean business, then it will go tits up every time. This is the trouble the police now have in the UK. They tend to take a softly-softly approach with the bad guys, and of course, the bad guys don't give a toss, they know they can get away with pissing the police about. It's excruciating to watch, one almost feels sorry for the police, but it's the liberal-minded political class who now make the rules for a society they rarely visit, and one, the rest of us poor saps have to deal with, while the majority keep voting them back in office.

'I'm with Sky News,' then corrected my statement to give it more meaning. 'Fox News,' I confirmed. 'Sky News is the Brit side of Fox News. I just want to have a look at Saddam?' I was sort of pleading my case.

There was a reason why the square was surrounded by tanks. It wasn't only to stop the locals coming for a nosy about, the tanks also formed the forward most defence of this Marine unit. The marine stayed silent, and while he eyed me and the Jeep up and down, I carried on my plea.

'We came all the way from Kuwait with you guys, and we're the first into Baghdad.'

The marine stayed silent.

Some days earlier when I was begging more oil, the soldier in charge of the lubes (an American term. The British Army call it the POL point: Petrol, Oil, Lubricants), a nice chap from Tennessee, asked me where I was from. I said England, well, it sounds a bit more local then just saying the UK. He looked pleased.

'Is that anywhere near London?' he asked.

Well, I was gobsmacked; I held back the tears of laughter because I really needed the oil as the Jeep was losing about a gallon a day by then.

'Well, mate, it's near it,' I replied. I just couldn't believe what he'd said, but there you go.

They say only thirty-five per cent of all Americans own a passport. I know some folks say Americans are a bit of an insular race, but please don't buy that because if you've ever travelled round the US, and I have, then you will understand why the majority of them don't travel outside. It's a great

country, massive in size with everything one could possibly want, and of course it has freedom, and that's why so many folk want to emigrate there. Anyway, I digress again.

'Sir, approach,' the marine ordered.

I walked forward with a smile. He held out his hand. I took it. I pointed over towards the statue.

'Can I go and have a look?'

'Sure, but, be careful, there's still snipers about but we're ready for them with the fifty.' The fifty is the .50 calibre machine gun which fires slugs the size of your thumb.

'I'll grab my kit from the Jeep, OK?' I always carry a couple of cameras on my body but I never venture far without the kit in my grab bag. Another marine came from behind a tank and took a cursory look around my vehicle. He nodded to his buddy to indicate, all clear.

'We got eyes on,' the marine said, and then he motioned me to follow him on to the first step of the square like a police officer escorting a CSI (Crime Scene Investigator) into a murder scene, and just left. Bizarre, but that's how it happened, and as I took the first couple of steps up on to the square, small arms fire began to crackle off nearby, as if someone was telling me, hey, stop, don't go any further or I'll shoot. I carried on walking, but on my best behaviour!

Firdos Square got its name from the Persian word meaning paradise. The square was shaped as a circle, not as a square and was set in a large roundabout just like we have back in the UK. It wasn't particularly ornate or anything resembling paradise. It was a low circular plateau structure with a fourteen-inch step; unusually high for a step and it took a good stride to clear it. Was it done to stop people entering paradise, or was it was just a bad design! My guess, it was to stop drivers accidentally driving up on to it. The step was tiled in cheap marble squares, opaque green in colour, the type and quality one might find a low-grade Mediterranean hotel.

I made my way across to the rather odd-looking headless statue. Yeah, headless! Some fucker had nicked his head, lying harmlessly in the prone position. It lay exactly where it had been pulled down. The twenty-foot-high concrete plinth was

still intact, and Saddam's knees and feet were still attached to their iron supports which were protruding out from the top of the plinth. I was surprised at just how small the torso was, probably no more than twelve to fifteen feet in length. I had a vision of a monster-sized statue of the Monster, that's what the Shia in the south called him, but it wasn't small, yet it wasn't big either in comparison to the other dedicated works to the Monster I'd seen on my trip up.

I moved in closer, its aspect was that of head down, arse up. I took cover behind it, leaned back and took in the noise of war while watching a couple of marines take up fire positions some thirty feet away.

The tank barrels were silent but their machine guns would open up every so often in response to a burst of incoming.Both marine and Iraqi fire had very different yet distinct sounds. An Iraqi would snipe out a full burst from some window, say thirty-rounds, that's about a full magazine, but to let rip with a full mag is, in the words of professional soldiers, is a bit of a dickhead thing to do. Why? First, it's a waste of ammo and second,firing off long bursts without moving your position gives the enemy more time to locate you. How? Any rifle causes noise, sparks and smoke as the bullets are fired out of the barrel, it's called muzzle flash, and in part, or as a whole, these three factors will give your position away.

The marines on the other hand would return fire with a massive amount of interest. Why? Because they could! It was easy to see where the marines were firing at, especially when they let rip with the .50 cal. Entire window frames, sides of building would just disintegrate as these big old slugs smashed into the weak structure of the target area. What were the fedayeen or Republican Guard really thinking? Did they actually believe they could beat the Americans in a head-to-head fight? Didn't they know they were just pissing in the wind! Bringing a rifle to a tank battle is never a smart move. It was as one marine said to me about these staunchly loyal Saddam fighters, 'They like dying and we like killing'em.' And that just about summed up the entire liberation of Iraq. This enemy didn't mind dying as their religion told them Paradise was their final destination anyway.

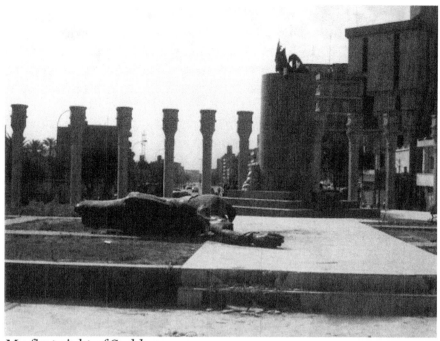

My first sight of Saddam.

I watched more marines sprint across the square and take up fire positions. I didn't want to take any photos of them just yet; I wanted them to know I was a friend first and not some fucked-up gung-ho journalist. When I was serving, any media type was anathema to the common soldier and I wasn't willing to take the risk to see if those times had changed. Then, two marines darted back to the left and out of view. Heavy machine gun fire was being directed from one of the Abrams on my left and acting as support to whatever was happening. To my right at about my 4 o'clock was the Palestine Hotel with all its mass of media still celebrating. Remember, this was still a war and there were firefights going on all over the place. Who's to say one of those many media types didn't have a bomb strapped to them? No! I felt safe and very comfortable squatting by Saddam, sun on my face, taking it all in. Surreal or what! Or was it just the norm? I've never been able to explain away these periods in my life, the fact I keep finding myself in such absurdly dangerous situations. Seriously, one or two is really

enough for any man or woman in their lifetime, so why did I get exposed to so many of these fucked-up situations is troubling. However, back then it made me appreciate life so much more when I was so close to danger. Now, I realise what a crap life choice it actually was, and have now profoundly changed it, before my lives run out for good.

Anyway, I was feeling up the bronze, it was well weathered, it had been baked dark brown by the midday sun and I was rubbing my hands over the rough hairline cracks. Were these cracks art or a design fault caused by cheap bronze and bad casting? Would the sculptor risk ripping-off Saddam? I think not! Then suddenly, I saw something which made me double-take. Well past the plinth and across the square on the road ahead signalling all stations south to Kuwait and sanity, I saw a bald-headed civilian; a man struggling to push what looked like an old makeshift wooden cart. He was carrying something heavy in it. What had that bastard looted? Curiosity got the better of me, so I moved off in his direction

The old man had taken temporary cover under a lean-to by some boarded-up shops not far from the other side of the roundabout. I made a move across the square and up past the plinth. I could see him much more clearly now. He was carrying what looked like a large head, snapped off around the neck. Could it be the head? Could it be the head of this Saddam? Fuck, surely not! I'd been around the Arab world since '83, and I knew all the sales tricks these souk boys got up to.

I waited for a lull in the firing. I didn't have to wait long, then made off at a rapid rate of knots towards the old man. He too had moved out from under cover and started to push his cart, somewhat awkwardly up the street and away from the square. I slowed down to a fast walk then realised I was out in the open so decided to trot a bit and attempted a couple of half-zigzags.

He was still about fifty metres away. I closed on him fast, knowing every step was a step further away from relative safety.

'Salaam wa alaikum. Marhaba,' I called out, showing off my best Arabic.

I could see a thick rope, a bit like a ship's rope, coiled around the old man's cart handle. He stopped, turned around and grinned as if to say, *Ah, I've caught a sucker.* Was this a trap to

lure me to my death? Quite possibly, but still I had to know, I had to satisfy my curiosity as to whose head was in the cart. He then did the oddest thing, he started to play around with the thick rope, miming hanging the head.

'Howdy,' he said, showing off his best American.

Howdy! Who the fuck was this old man? A lover of Westerns or just friendly! Did he think I was American? Cheeky bastard! And was he trying to make me drop my guard? Well, it wasn't going to work on me. He held out a hand in friendship, I took it. His grip was strong, his hand hard and bony. He was old, well, he looked old, certainly late sixties but probably a true age, mid-forties. He carried a heavy smell of body odour. He was chucking up with some sort of a pong. I knew it wasn't me because I was beyond body odour, I was three weeks in, using baby wipes, and I wasn't sure what that smelt like as I couldn't smell my own aroma any more, but I just knew I didn't smell like he did. JY would have pulled me up on it for sure!

'Please, is this the head of Saddam?' I asked, pointing back towards where the statue once stood.

'Yes, yes, Saddam, Saddam.' He started to whip Saddam's head with the tail end of the rope, and then spat on it. His solid, light yellow blob of mucus hit Saddam's cheek and slid slowly downwards. 'Yes. Bastard Saddam,' he replied defiantly.

I had no idea if it was or not. It certainly looked as if it was made of the same stuff. I bent down and touched it, yep, it was bronze and it had the same dark brown patina and was of the same texture. The point being, was it the one off the statue behind me? I'd seen a few of these Saddam statues on the journey up, and it would not have been beyond the bounds of imagination if some enterprising Iraqi had a head off another statue ready to flog it to some unsuspecting Westerner! I've heard a million rip-off stories, so my head was telling me, caveat emptor, buyer beware, but my gut was telling me, this WAS the real head of Saddam.

At the time, I didn't know the significance of this statue. Indeed, I'm not sure the man with the head did either. Was it for sale? Did he know the value of it? And if so, what's his price? This was the thing, back then, all the Iraqis I'd come across wanted food, water and the US dollar. For generations of Iraqis,

apart from the elite Ba'ath Party members, hadn't a pot to piss in, and I don't want to come across even faintly sanctimonious, but within a couple of months they would be assaulted with all sorts of shiny bits and pieces from the West. He had that trader's look in his eye. I was sure he wanted to sell it and why wouldn't he? He looked as if he could do with a good pay day. I pulled out a small bottle of water and offered to him as a sort of a gift, a sweetener before the bargaining started. He took it.

'For sale?' I asked.

The old man looked puzzled. He pulled a cheesy, well-perfected grin. I'd seen this supercilious look many times before. It's the look of expectancy; I'm only a poor, ignorant old man who is in much need.

'Fuluus?' I asked. The Arabic word for money immediately put a smile across his face. I noticed he was definitely in need, in need of a visit to the dentist. More gunshots in the air, not that close, but close enough not to be complacent. An explosion detonated up in the distance. I could see a plume of black smoke rising.

'Shoo fuluus?' I asked him again. How much? This time with more urgency.

Then a heavy machine gun opened up from somewhere behind me, its rounds smashing into a target high off to my left. The old man looked around; I wasn't sure what he was up to. Was he getting scared about being out in the open? Was he looking around for backup? Did he have backup? Was I about to get mugged off or even mugged—please no, not in Baghdad! Shot dead, yes, but not mugged. I wasn't going to have that! I looked around for his accomplices and could see no one. Incoming was still local, small arms getting closer. I kept looking at the head. I bent down and touched it again, it sure looked and felt like the head. The old man kept moving the noose over the head and pointing over to Firdos Square.

'Yeah, yeah, I get the message, fella,' I said. I then started to click off a few photos.

'Dollars,' the man said. 'American.'

I had about $160-odd on me. Some in my wallet, some in my trouser belt, a few tens and twenties sewn into my trousers and

I was walking on about $60 too. How was I meant to pay the fella? I would have to strip in the middle of Baghdad.

'Yes, habibi, shrukan,' I said; that meant, verbatim, Yes, my beloved, thank you.

Well, OK, it was a bit formal, but I just couldn't think of the right phrase to use and any bit of Arabic might just get me discount.

The old man looked up and said in broken English, 'You know Arabic?'

I smiled and slowly pulled out a fistful of $1 bills and deliberately flicked through them for maximum buyer impact, and to let him see the dollar bills didn't contain any Iraqi. No good having big denomination notes, the locals would have trouble trying to split them; also, they wouldn't have change either. Not in dollars! The Iraqi dinar was just about useless now the Americans had arrived.

The old man stared at the cash, mouth salivating, hand trembling at all that hard currency, the US dollar. Was I about to get the steal of the war or what? Ten dollars American for the head of Saddam, surely not, no bloody way!

I asked him again, 'Shoo fuluus?'

'Ashra. Ten! Ten dollar,' came his reply. He was mimicking taking photos.

What was he on about? Was he saying he wanted paying for the pleasure of me taking photos of him and the head? Really? The cheeky fuck!

He kept on. 'Ashra, dollar, ashra dollar,' he demanded.

Then the penny dropped.

'Ten dollars for snappy-snap? You can fuck right off,' I said, and just kept snapping off more and more photos. I motioned to the head. 'I want to buy the head and cart, shoo fuluus?' I said, pointing to the head and making a circular motion with my left hand around the cart. He mimicked my hand action.

'Of course, I want the cart you fucked-up old man. How else am I going to move the fucking head?'

Negotiations were getting tense.

Again, 'Shoo fuluus?'

And they were the last words I ever said to him, as something

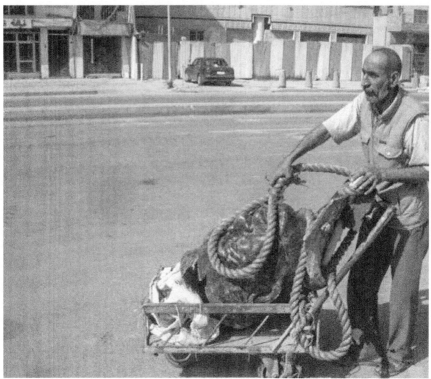

The old man and the head of Saddam.

fast and furious sizzled past my left ear. Again, and again and again, zing, hiss, zing, the unmistakable crack and thump of incoming AK-47 rounds taking out small chunks of concrete from a shop facade just off to my right, then I heard a voice calling out to me, I turned, and there was a marine waving frantically at something. I looked at the old man; he rubbed his eyes, he was unsure. He then mimicked picking food from the palm of his hand indicating I should give him some dollars so he could go eat. Fuck him! I turned and sprinted towards the marine. I took a final glance back at the old man, the cart was stuck in a rut and he was frantically trying to get it out; he then gave up and ran for cover too. Another burst of incoming torn up the street behind me. Seconds earlier I would have been a goner, no doubt about it!

So tight are the margins of war, nothing ever surprises me anymore. I'm a realist, so a great believer in when your number's up, it's up, and there ain't fuck all one can do about it. If you can get a bit of solace out of disseminating the, ifs and buts of life, then all well and good, but I just crack on with it and log it down as another close one. No point in beating yourself up. None whatsoever.

Marines were rushing around taking up fire positions with their weapons pointing roughly in my direction. I sprinted the best I could back to the marines, but the last few metres were a ball-breaker. I hadn't walked far in three weeks, let alone sprinted like a twenty-year-old soldier under fire. A marine smiled, grinned more like as he offered a hand similar to what I would have done years ago to some smart-arse journalist who had just been caught in a compromising act. Then silence. Then a marine barked what I knew to be a FCO (Fire Control Order) and the top right-hand corner of the target building stated to disintegrate under the heavy weight of lead being pumped into it. Splintered brick and debris dropped down on to the street below. The head was still in the middle of the street but there was no sign of the old man. I hoped he was safe. I wandered back over to statue and took up a position furthest away from the action. The old soldier in me wanted to have a piece of this Saddam, to keep as a memento of my time spent here. A spoil of war. Every war I've ever been in, I've taken a keepsake back with me. I've built quite a large collection but and they merited their own genre, so I coined the term, War Relic Art.

How was I meant to break a piece off? I felt around the shredded part of Saddam's neck where his head had once been attached. It was less than ten mills thick. Then' unexpectantly a splinter caught my thumb, dug deep into the nail and sliced the top of it off, leaving a piece of flapping skin. Blood flowed out as the ragged bronze edge was as sharp a butcher's knife. I got up and poked my head half inside Saddam whilst sucking the blood from my thumb then applied direct pressure. Twat! First battle

wound of the war, typical, marvellous. What to do? Yes, that head-in-a-cart was matching alright! Before I moved back up to see if the old man was still about, I pulled out a little sealed plastic bag of powered antiseptic and stuck my thumb in it then pulled a couple of thin strips of masking tape I'd purposely stuck on my waist belt and taped it up as a temporary fix until I could dress it properly.

Marines were still in fire positions, but silent. They were in a more relaxed state, some eating their MREs. The old man and the head were MIA. What a missed opportunity, but there again, in soldier's terms it wasn't my opportunity to take. I hadn't fought, spilt blood and lost friends in this war—it wasn't even my war, and it certainly wasn't my place to take such a trophy as the head of Saddam. No, that was for these marines to decide if they wanted it or not. I moved back to the statue and took in the atmosphere of the occasion and convinced myself I had no right to the head.

The sun was now up. The firing quietened down leaving only the comforting sound of a distant rumble of American howitzers disrupting the speed of an Iraqi retreat. That familiar smell of bonfire, barbeque and cordite was hanging in the air just as it hangs around all battlefields. Apart from my throbbing thumb, life felt good. I stretched out and lay against Saddam and contemplated my next move. A lull in the battle, I reached into my grab bag, took a slurp of lukewarm mineral water followed by a boiled sweet. I could have quite easily taken a nap there and then. It had been a long time since I had a full eight hours in the prone position. My thoughts drifted back to the safety of Kuwait. I wanted to go back. My business in Iraq was finished for now. I had achieved what I set out to achieve, so hanging around here only added to the risk of being killed. I then felt slightly isolated. That's what lulls in war do to soldiers. It's a forced time of reflection, that's what it is. Not good for the soul, not good for the occasion. Darkness can set in. Having been on so much of a high, an adrenaline rush, then anything can make one slightly paranoid and now it was happening to me. I do try to dodge these fucked-up demons trying to open my mind, trying to dislodge my train of thought, trying the old paranoia trick, trying to fuck me up? Oh, they tried to tempt me, and then

I realised for the first time my gas mask wasn't at hand. I'd left it in the Jeep. Fuck it! I'd broken the most basic rule of being in an NBC threat environment. Always carry your fucking gas mask. Too late now! Fuck it, I ain't no crow or Joe crow in this business. Switch on, stay alive. What a wanker! You don't think, you die. The demons were coming out to play!

All along the route up we hadn't been gassed, hadn't even seen any evidence of NBC or Blair's WMD's, (Weapon of Mass Destruction) although that threat was made very real to us with every uttered intelligence report. One last twist-of-the-rack by a fleeing tyrant! I would not have put it past Saddam. He had used gas against the Kurds up north of Iraq. He had used it during his war with Iran, where he gassed thousands of Iranians and his own troops ending in a million deaths on each side, so why would he not lob a few shells of mustard gas into Firdos Square? That would spoil the Americans' party! I gave myself a bollocking and told the demons to fuck off!

With the gas, gas, gas bollocking still simmering in my mind, a marine came over. He was carrying a crowbar and sledgehammer with his rifle slung over his shoulder.

'Sir, can you move? I'm gonna smash this puppy.'

'Sure,' I said. 'No problem.' I stood up and moved away from the headless legless torso. He turned to me.

'You wanna a piece?'

'Cheers, mate,' I said, really grateful for the offer.

'Here, take this.' He handed me the crowbar. 'What part do ya want?' he casually asked, resting the sledge on Saddam's back.

'I'm not sure. I hadn't really thought about it.'

He pointed to a piece which looked like it would fracture easily. I think it was part of the left arm but I was just grateful for any piece.

'Look, can I have this bit?'

'What! That bit?' The Marine looked incredulous at the bit I was pointing too. 'Buddy, that's his butt. You want his butt?'

'Problem?' I tried to sound sincere. 'It looks the easiest bit to break off!'

'No problem.' He then started to rain down hits on Saddam's arse whilst I attempted to help by levering the crowbar thebest I could. It was taking more muscle and effort than both of us had reckoned on. Sweat was pissing out from under the marine's helmet. He meant business. I wasn't sure at the time if he was treating this little exercise as a workout or an expression of built-up aggression or both! Every time he made the swing, the sledge came crashing down on the arse with a mighty whoosh, then nothing, it just bounced off. The sledge would just not break or make any penetration.

I heard small arms again. Close, real close, but it was outgoing, yet here I was in the middle of Baghdad with the war still in its infancy but at full rage, smashing the crap out of Saddam's arse with the USMC. It was crazy, then again, most things in war are just plain crazy, sometimes stupid, dull, dangerous and disgusting, but crazier than not.

Again, a few more swings and eventually a crack started to appear in the arse. I tried to use the lever where the crack was, and the crack just hadn't opened up wide enough. I then tried to bend up a small flap of bronze from one of the fractures, still not good enough. This was turning out to be a bit of a chore. I still only wanted a small bit and I couldn't even get that. I pointed to a straight welded joint along the top of the arse.

'Try here,' I said. 'Give it some welly across the weld.'

'Welly? The marine asked, not understanding the British slang.

'Yeah. Give it some shit.'

'You got it.'

The marine needed no more prompting. He started to pound down on an obvious foundry joint. You see the statue was made in sections and not as one big cast. Well, shows you what I know. I'd assumed a piece as profound and important as this would have been made out of the purest bronze to the highest spec and in one piece. I don't know, maybe all statues of this size are made using the section method! I just assumed it would have been better constructed.

The joint started to show signs of giving up. The sledgehammer took a break and I managed to get a bit of purchase and started working the bar back and fro on the arse.

A big piece was at last working loose. The sle(started up again and there was a bit more po suddenly the arse began to crack more, and then it off along the welded section and smashed to the grou... marines laughed and cheered.

'That was hard going,' I said back to them. 'You want some of this?' I added, pointing to the piece on the ground.

'No, we got enough. It's all yours, sir,' a marine replied. These marines weren't only polite but real generous too!

Marine Sledgehammer dropped his tool and sat down on the statue. Another job well done.

'That'll do ya?' he asked as he saw me bend down to pick up this rather large piece of bronze.

'More than I expected,' I chuckled back. 'Fuck me, I've got the arse of Saddam!'

I was sort of cradling it across my chest, like a fisherman holding a prize catch.

'Crazy Brit.'

It was heavy, say it weighed in at about twenty-five pounds, and about five-foot square in area, sporting a slight curve in a triangular shape. It was extremely sharp too, with vicious ragged edges. I sat back down and took a real good look at Saddam's arse, actually, Saddam's left buttock in the words of Forrest Gump, from the statue erected almost one year ago to the day, to celebrate his sixty-fifth birthday. Fucking outrageous!

I proudly carried off my spoils of war gifted to me by the USMC across the square and down towards my Jeep. I wasn't really giving the bronze much thought. Yes, it was a much bigger piece than I'd anticipated, but what the heck, I was more concerned about the amount of sporadic gunfire I could still hear and mindful I was still in a war zone, and on top of that my thumb started to throb real bad by too.

People were still being blown to bits and bits of bodies were still being blown off. War! What an awful fucking construct! Every now and again, which in my case is every second, you have to give yourself a reality check, make sure you know exactly where you are and who is with you. Always know who and what the threat is and where it's coming from. Always plan an escape route. Always know your escape route or routes.

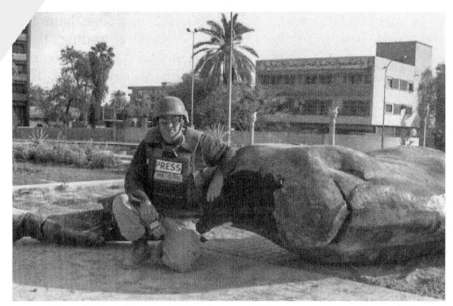

Me by Saddam after the shooting had died down. Picture taken on my camera by the late great Robert Fisk, described by the New York Times in 2005 as "probably the most famous foreign correspondent in Britain." RIP 2020.

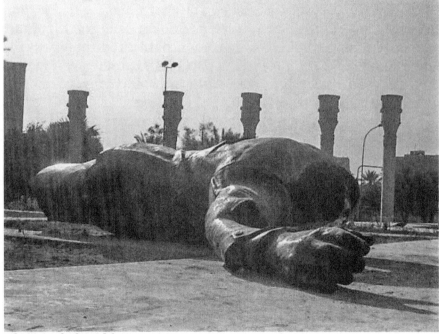

The toppled Saddam.

These are the focused thoughts that always bring me back down to earth. They aren't the thoughts borne out of a generation of war gamers, they are instincts attributed to, at this time in my life, twenty-five years of hard graft experience gained in the game of life and death of soldering.

I made it back to my Jeep. I was hungry and thirsty for a drink other than warm water, and of course, there was the rest of the day to crack on with.

'You got a bad oil leak, sir,' the marine guarding my Jeep said.

'Been pissing out since Safwan.'

'You need to get it fixed.'

'I know, I got about eight gallons of your diesel oil to get me back to Kuwait.'

'That should do it,' he laughed.

Eight gallons took up a lot of space in my Jeep. I didn't think I needed to carry that much, but I was running on a fifty/fifty refusal rate. Either the unit I asked didn't have any or they were too low to give me some, either way, they always pointed me in the direction of a truck which was carrying a load. Sometimes I'd be lucky and get an NCO or an officer's name to ask for, which was always a bonus as it saved a lot of confusion when soldiers in war have more pressing things to be getting on with.

15. Crispy Biryani

I managed to wedge the most pointed part of the arse under my seat while the rest, sort of ran up the back of it, and since I was carrying several full sandbags to act as bombproofing, the arse could only enhance my crude attempt to pacify IEDs and bullets. Better than no protection at all, that's what I say. I've seen too many weird things on the field of battle that have shown me, if you can give yourself a fighting chance of surviving an attack, then you best do it. Ain't no good having a, *oh, that won't stop fuck all, you're just wasting your time attitude*, or the doom-and-gloom merchant's vocab, *that won't protect you from jack shit!* I mean, you really wouldn't want these critters in a lifeboat, would you? And you really don't need them on the battlefield either. That's another thing that will get you fucked up.

I've seen some unexplained, spooky stuff in combat. I've seen aimed shots, the ones which are on target to kill you, get deflected by a twig from a tree—literally! I've had a big old bullet, a 7.62mm hit me in my thigh and get deflected by my own full magazine of the same calibre rounds, only to break the skin and give me severe bruising. I've seen secondary fragmentation from an IED get deflected by a stack of cased water. I've seen a guy get shot at almost point-blank range by a Colt .44 only for the round to hit his head, traverse across his face and exit behind his ear. Probably a dud round of course, but you get my point. Therefore, anything you can put in the way of the threat, is, in my mind, a good thing, even if it's a piece of arse!

I drove back over to the sat-wagon. The guys were packing things away. Nick saw me and waved me over. He seemed agitated. Was he was going to ask me about all that nonsense happening over at the square? He didn't!

'There are no rooms left in the Palestine,' he said, frowning. 'Apparently every media man, woman and their dog had pre-booked months previous. Bloody tossers.'

'No room at the inn, then?' I said, grateful for the fact I would now not be tempted by the thought of sleeping in a bed. 'No probs, I'll sleep in the truck.'

'No need to do that. I've got the heads-up on some rooms over there.' He pointed just behind the Palestine to a sign, Al-Rabie Apartments.

'I've sent a message over to book everything what's left.'

'That's good news, Nick. Sounds fuckin' lovely,' I replied with a touch of sarcasm. I knew he meant well, but I also knew I wasn't going to leave my vehicle.

'Stay local and I'll give you a shout when we're ready to move.'

'Roger that,' I replied, thinking I'd debrief him later on my Saddam's arse experience.

None of us were going anywhere until we had secured our vehicles and kit. It was the first time in weeks I didn't have to worry about escorts and convoys, so JY wrote out a stag list for the night. It was to start at last light, and until then everyone would be responsible for their own kit, then all the team would do an hour each throughout the night. JY and I would do two hours apiece and cover the drag hours. It didn't bother me, I would rather myself and JY do the early hours because if stuff's going to happen you can bet it will happen in the drag hours when the human mind and body are at their lowest state of alertness. JY and I have staged on all our lives, it's par for the course in the army wishing large chunks of your life away! I'm not saying the others weren't up for it or couldn't have done the drag hours, but we were used to it. It ain't easy staging on in the early hours; if you've never done it before, you could quite easily nod off. In some armies, that's a hanging offence, and in the British Army it's even a worse crime than having an ND (Negligent Discharge), accidentally firing off a live or blank round from your rifle. JY also told me the Marines had established a cordon around the entire hotel, Al-Rabie Apartments and Firdos Square area included.

'I did a recce earlier, and they've got tanks all over the place. It looks like Fort Knox,' he said confidently.

'I've heard that one before!'

'Mate, I guess we're pretty safe,' he said, 'so far, at least for tonight, then they may decide to move off tomorrow!'

'Yeah, rumour has it, next stop Tikrit,' I replied.

I could handle the fact there was a war going on all around us, but a bigger concern was, inside the cordon, the place was turning into a free-for-all, full of opportunistic Ali Baba types, cutting about and touting for all sorts of business. I come from the school of no fucker's gonna nick my kit, and if they try, I want to be the one to pass judgement! It's all too easy to feel secure in these situations. Folk naturally start to switch off when self-congratulations are administered in large doses. I've seen it a few times. Too much air-punching can set a man up for a fall. Stay alert, stay alive.

The Palestine Hotel wasn't the only large hotel in Baghdad; there was another just across the road, the Ishtar Sheraton Hotel. It housed a few journalists, the overspill from the Palestine. This hotel was where Saddam's fixers and PR men stayed during the invasion. It's where they held court for anyone who wanted to listen to the Saddam Hussein's version of the invasion. I can't recall anything of note ever happening over at the Sheraton now the Americans had arrived. I went across a couple of times, twice to check out the local cuisine; crispy biryani was the offered delicacy. I had it on both occasions as it was the only dish on the menu. On the first occasion, the restaurant was empty of guests, any celebrations and soul, and that was because it was outside of the Marine cordon. You had to make a timed run from the semi-secure area of the Palestine, through the Marine checkpoint, across a road, then wait out in the open-air car park for the hotel's security staff to let you in. It seemed strange to risk one's life on such a short trip for so little. That's why I only did it twice: once to check out the delicacy, the second to see if the chef just had an off day on my first visit, but he hadn't, you couldn't chew the meat as it was as hard and crisp, and just like the rice, it tasted shite.

Nick successfully secured a couple of large rooms in a rather uninteresting-looking building which made up the Al-Rabie Apartments. I can tell you I've stayed in much worse, and Iwas

very tempted to stay there for the night. The owner was a short, balding chap in his late fifties. He seemed pleasant enough and welcomed us all with a lovely style of pidgin English and a grin as broad as the Tigris. He even gave us each a complimentary can of beer; one of those really small cans of Heineken I've never seen back in the UK. It tasted bloody fantastic. I did wonder how, in this city of nothing, the proprietor of the Al-Rabie came to have a case of beer still in his possession! After all, these thirsty media types had been in Baghdad for weeks prior to the invasion. What a smashing chap.

As the day moved from the freshness of early morning intoa scorching midday, more and more journalists appeared in the celebrations; well over two hundred by high noon. I found out almost all of them had come in from the west via Amman, Jordan. They had run that Iraqi gauntlet and survived, and I could sense their journey was like some hallelujah moment for a lot of them.

'It was so exciting. It was a great personal experience for me.' I heard one adrenaline-filled young Canadian-sounding girl tell a fellow hack.

The only journalists I met who had come in from Kuwait were those who had been embedded with the forward units but then decided to jump ship and make a break for the Palestine, because in the media mind-set, that was where the action was. There was a voracious need for information. What was happening? Where was Saddam? Did you hear about so-and-so? How many dead? How many injured? Rumour control was rife. At one stage someone said Saddam was hiding in a secret bunker under the Sheraton, so an army of hacks raced over to check it out, completely forgetting about a possible Republican Guard come-on and the shite biryani. Then came another rumour, Saddam had been captured in one of his palaces nearby, so the media circus sped off like a scene out of Wacky Races, cutting through the Marine checkpoints with such arrogance they were lucky they didn't get shot by them. So blessed are the meek.

I'd been about the square for less than a day but my old instincts told me it was time to leave this theatre of war in double quick time. It was going to get very nasty, very soon, and

during the afternoon there was a scuffle on the steps of the Palestine. I took pictures of two Iraqi civilians having a finger-pointing exchange at each other, then fists were thrown, then some marines came in and broke the fight up—the Big Reckoning was starting; revenge, pay-back and consequence.

Dusk appeared on day one—the end of the beginning. A slight let-up in the crowds gave way to cameramen and correspondents hustling each other in the failing light as they retreated back into the Palestine to prepare for their evening news broadcast. Back then, not one of us could have ever imagined the daily clambering for the best backdrop of Firdos Square to send off the evening schedule, was to become part of the media routine for years and years to come. Handshakes, continuous backslapping and more congratulations were still the preferred manner of meet and greet. Not my style, all this touchy-feely stuff; never has been. I really don't want to come across as some kind of anal pontificator but I still considered myself to be on the battlefield, and that meant I could still get wasted.

None us, now believed Saddam had WMDs and all that Blair bullshit, but we didn't know for certain Blair's WMDs were all in his own mind. Still, I was only one of a handful of folk who still clung on to their gas masks, bar just one error of forgetfulness, and who were constantly prepared for the WMDs, or more probably, the crude but still a killer, mustard gas attack. What also made me feel very uncomfortable was, I knew I was standing in a classic suicide bombers' paradise. One just couldn't imagine the fallout from a Palestine Hotel IED incident. And little did these journalists know what fate had in store for them in the coming months and years ahead!

Whilst the British had recently fought a long, hard and bloody war on home soil against the IRA (we were really well used to the term 'IED' and the British press were pretty much versed to the meaning of, the terrorist threat), it was the rest of the Western world's media who, in my opinion, were not taking this threat seriously enough. If I were to come to their defence, I could protest they really didn't know any better. That was clearly the case, but ignorance of war ain't no excuse as those

who don't learn from the history of war are surely doomed to repeat the same old nonsense.

This bravado on this first day frightened me. Not in the sense of being worried about my personal security, no, it worried me there were so many people whose first taste of war was in this race to Baghdad. Yes, we journalists had taken a couple of casualties along the way but nothing like the coalition had planned, and now it was only a matter of time before civilian body bags started getting repatriated. It had to be; it was now a percentages game. With so many unqualified, inexperienced journalists on the ground, it's a fair bet you're going to lose more than a couple or three. Sky News really didn't get the job right either. Yes, they had a security man in JY; a top guy, ain't no one more qualified, but their budget only allowed for one security. Now isn't that crazy; naive management? Two security would have been OK, three would have just covered the job. You only know about strength in numbers when the shit hits the fan; up until then, it's just a game of numbers and financial constraints for shiny-arsed bean-counters to justify from the safety of their nine-till-five.

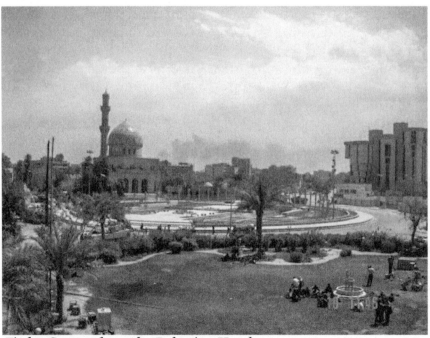

Firdos Square from the Palestine Hotel.

The odds of dying were going to be greatly shortened as more and more unprotected journalists piled into Iraq. They were shortened even before President George W. Bush announced that most ridiculous of statements, Mission accomplished. A war which appeared on the surface to have been won in less than a month, was really only in its infancy, let's face it, it was really only day one, week one. And in 2021 we are still there trying to sort out the disgraceful unimaginable mess the warmongers Blair and Bush created. It has been eighteen long, hard, bloody years, and still there is no Iraq exit strategy. Longer than World War I and World War II put together. Longer than the Vietnam War. Yes, the Brits and the Americans have formally retreated but we still have Special Forces troops on the ground on continuous rotation. Five thousand as of 2021 You didn't know that! We, our sons and daughters, grandsons and granddaughters, aunts, uncles and friends will still be fighting this unwinnable war twenty years from now. Blair's war more than Bush's because Blair lied.

I was standing alongside the journalists of the world and I knew their job had only just started. Arriving in Baghdad was the relatively easy bit! With that constant noise and the smell of war all over the place, I guess I expected more from the men and women of the world's press corps; more of an acknowledgement, more of an understanding of the severity of the situation they'd found themselves in. If they did have it, well, I didn't see it in their body language or conversation. And what about all the locals I could see cutting about the place? I knew it was their country, but nobody seemed to be challenging them as to why they were inside the Marine cordon. OK, some were fixers for the networks and some were there by appointment to sell their wares like Saddam cigarette lighters, phony cola and other stuff, but who'd vetted the other hundred or so Iraqis wandering around? Only fuck knew!

An Al-Rabie shower was something to behold. I stepped in fully clothed and did my laundry at the same time. The water was soft, but my soap contained a few bits of sand so acted like a cheap body scrub! I felt bloody marvellous. My face was tanned but my skin was really leathery and cracked, a bit like

my Saddam's arse. It was the first shower for three weeks and I really needed it. I wasn't sure about a bed and fresh sheets; far too much comfort in one day could be a false economy! I was tempted, but decided to stay operational and kip down in the Jeep. I wanted a bit of peace and quiet after all the festivities, I felt I needed some space. It was only during the nights one ever rest one's mind for a bit. As much as I tried to block it out, one thought kept reoccurring: everything seems to be too easy. The trip up seemed too easy. I expected to see much more of a fight from the Iraqis. No tyre punctures, which is almost unexplainable given the hard terrain, heat and driving conditions my Jeep had experienced. No dead, no team injuries. Entering Firdos Square and being gifted a piece of Saddam's arse seemed too bloody easy. I was very concerned at just how uncontrolled and unpredictable this place was getting.

From the relatively safety of the Jeep, I sprawled out in the back, pushing all my personal kit to one side, found a soft place to rest my head and started to plan my next move. The area around the Palestine and Firdos Square had grown in just a few hours from a secured, manageable environment to a sprawling metropolis of mayhem, so what could I achieve tomorrow? I could cut across to see Saddam's palace, go take in a museum, stuff like that. Why? Yes, why? What the fuck was I trying to do? No! Bollocks—I went back to my original thought and now I saw my new mission as being to, get the fuck out of here a-sap. I decided if I still felt the same in the morning, then I was defo out of here. I would make my move, solo, back to Kuwait, yes, on my own. I would drive all those hundreds of miles back on my lonesome. I figured if I stuck to the same route I came in on, then it would be fine. I would hook up with an American unit heading back south. Their supply lines would be well and truly established by now. Yes, I'd do a reverse piggyback of the route I came in on.

I had accomplished all I had set out to do, and more if I really thought about it. I had secured several great stories, had been the first un-embedded over the border and almost certainly the first into Baghdad. I had the privilege of riding into war with a great team from Sky News, headed up by a truly professional producer, Nick, a guy who I never once heard whinging about

this or that or indeed getting stressed out by the situation or the profanity of war. I was taken aback by the way all the team went about their business at every stage, even those who'd jacked back at Al-Nasiriyah. They had the courage of their convictions. A man's gotta know his limitations. I was reminded what Nick had said earlier about my Saddam's head encounter: 'If you'd bought it, it would've been a waste of your money because some officer or Kuwaiti would have confiscated it.'

I had to agree with him, but it didn't make me feel any better about the lost opportunity. OK, it wasn't something I could have easily hid away. It was a big, awkward piece and heavy too, a three-man lift and it might just have fitted into the back of the Jeep as it would have looked really stupid if it were strapped to the roof! Later on, Nick was proved 100% to be correct in his judgement.

I was up the following morning, bright and early. I felt so damn good. I felt ready to attack the day because during the night I heard my calling. All those indecisions of the night had passed and a pronouncement made. I would be sad to leave the team but I was done with Iraq for the time being. Go south young man.

I got out my old trusty Primus stove and made a nice cup of tea, threw some powdered egg in a frying pan, gave them a good scramble, added some Tabasco sauce from the smallest bottle in the world, courtesy of the United States MRE, then a young lad of about ten, an unofficially vetted street urchin, came by and sold me some fresh roti, well he said it was fresh. I only wanted one piece but he sold six pieces for a dollar plus a handful of my boiled sweets. His price was vastly inflated compared to Kuwait, where it was only 10 fils (20p), for six pieces and much more so than London or New York. I reckoned he'd found a UN local purchase price list as the UN tends to fuck up the local economy wherever they go, probably because it's not their money they're spending.

The occasional small arms fire was still being pumped out, more outgoing than incoming and not as much as yesterday. The crack and thumps were further away up to the north; seems like the Marines were doing a bit of FIBUA (Fighting in Built-up Areas). A shit job, house clearing, room clearing. Normally

the occupants would have left well before, but IEDs would be the big problem for some of those boys and girls. It's easy and quick to set up non-electrical IEDs; pressure plates, pressure release or tilt switches, trip wires, easy, kids' stuff. No electrics, no radio waves and no batteries to fail. I'm so glad I'm out of it now. Soldiering always favours the inexperienced young.

The smell of my breakfast drew JY out of his Hilux. He had a brew in one hand but didn't look too pleased.

'Well,' he said, 'we got our marching orders.'

'Where to, Tikrit?' I asked guessing his answer.

'Yeah.'

'Thought so. Saddam's home town! Screw that, you can count me out,' I replied innocently. 'I ain't on Sky's payroll!'

I was a free agent and my mission had been accomplished. JY knew that, and judging by his tone he was up for the trip, and fair play to that, only he's always been a tad Mr Grumpy in the mornings, whereas me, I get up sparrow's fart-ready to attack the day, whatever it decides to throw at me and I do it with a smile most times.

'There's a replacement Sky team coming in and they want me to stay on and head that one up. We got extra security this time.'

I nodded. 'Well, that's cool, mate. I replied.

I was just thinking, this party's done for me. I gave the eggs a stir and shook in more sauce.

'I'm gonna drive back tomorrow. When are you planning to leave for Tikrit?'

'The new teams expected to be here tomorrow, so possibly day after next. There's a media gang-fuck going on to find Saddam.'

'I don't doubt that,' I replied.

I spent the rest of the morning prepping the Jeep for the trip back and later that day I revisited the Saddam statue for the last time. JY came across too. Saddam was still in the prone position, now with only half arse up, in all his vulnerability. Things had quietened down a lot since yesterday, and there was air of calm about the square, then all of a sudden, a marine marched up holding a disc cutter, and with a couple of pulls on the start-cord, fired it up and broke the silence. The cutter died, he pulled it again and it burst into life, revved for a few seconds

and died again. He persisted. Two more pulls and it fired up, this time for good, spewing out a thick, two-stroke oil and petrol mixture smoke. A nostalgic smell which instantly took me back to my teenage years when I was one of the Yamaha FS1E moped boys riding all over South London thinking I was cool. The cutter was sporting a nine-inch diamond disc and he started to cut through the bronze. A mass of light-coloured sparks flew downwards and disappeared as they bounced off the marble tiles. Within seconds he had what he had come for. He was holding the hand of Saddam. You know the one, the hand which was cast in that, I love you all, but I can kill you at any time pose. Well, it was really part of his arm too, the bit from the elbow down. A nice clean cut. It would sit damn nice in the Marines Mess.

16. Break for the Border. Again!

The incoming team were going to be self-sufficient. They had a producer, correspondent, cameraman and security. So once the word got around I was heading back south, JT asked if he could come back with me. I said no problems. Then, because Nick was getting replaced, he wanted go back too. Then Andy the cameraman, and then Paul Thompson, the Royal Correspondent for The Sun newspaper, declared his interest in hitching a ride back.

'Mate, you should be back home hoity-toitying it around Buckingham Palace, not here with us, the great unwashed.'

He just laughed.

'Who'd you upset to get this assignment?'

'You wouldn't believe it if I told you,' he replied.

'Bad boy, that's what it sounds like.'

He kept quiet.

I first met Paul a few days earlier during a desert Q&A session before the final push on to Baghdad given by General Jim Mad Dog Mattis, the commander of our new host, the 1st Marine Division. The General was a soft-spoken man and Paul is a big bloke so the media had to jostle close enough to hear the General, and that's when our paths crossed. He tried to shoulder barge me out of the way, but I stood firm. Our English accents immediately made us allies in a pool of Yanks.

Paul was embedded in a Marine unit I had recently scrounged some oil from, but as he told me later, as his unit closed in on Baghdad, it got fractured in all the chaos, so he and another hack did a runner on their own and headed for the Palestine. He was solid in conversation and really didn't fit my perceived profile of a hack who could curry favours with royalty. Soldiers and Marines yes, but the Queen, ah, no!

There would now be five of us travelling back in two vehicles. My Jeep was to be the lead vehicle with Paul riding as my shotgun, then JT and Nick with Andy designated driver bringing up the rear. A two-vehicle convoy, nice and

controllable. I had a rough game plan in my head and I knew I could react to most situations as they presented themselves, but I'm used to working on my own, and thus I take all the decisions, and if there are any problems, I can deal with them or not as the case may be, and if I get them wrong, well, I've only got myself to blame. Having to take four other guys back with me presented problems. OK, the pros were obvious, strength in numbers and all that. The cons were, I was going to have to be the daddy; I was going to have to look after these guys. Could I do it? Was I responsible enough to do it? I wasn't really sure I was. I mean, I didn't plan to have company, I planned to drive alone, and looking back at it now, my feelings were a bit selfish. I came through a war with these guys, they had always held their own, and they were good blokes, so why was I worrying? Responsibility, I guess. The thought of being responsible if something nasty should happen. I mean, it was enough of a strain looking after myself, let alone these media types!

Over the next few hours, I scribbled down a set of orders for what I expected on the trip back, and what I expected from every one of them too. I made it quite plain, this was my operation and I was the boss.

'You listen-in to my brief good and proper and take it all on board,' I said. 'You have any issues or something you need to question, question it now, not halfway back to Kuwait! Any questions?'

They all shock their heads in silence. The funny thing was, they had no alternative. I had to sound formal, military-like, I had to get across the severity of all the actions-on, should they occur. Same old basic principle which may extend or save one's life. Action-on, a flat tyre. Who does what and when? Actions-on approaching a vehicle, front, flank or rear. Casualties! Where are the first aid kits located? And make sure all carried field dressings or anti- clot packs. Actions-on taking incoming. All sorts of eventualities to be covered, were, and, I made doubly sure all three vehicles were correctly prepped for the drive back.

'Oh, Andy, un-tape all ya lights, especially the rear. You're gonna need to see my reverse lights if we come in contact and

have to reverse because I won't be looking behind and won't be stopping,' I said without any more thought.

'What if the enemy see our brake lights?' he asked.

'Look, mate, there are far more good guys out there with guns than bad. I want the Yanks to see us coming and I don't want to give them any fucking surprises. They're gonna be as twitchy as hell at first light. He got the message.

If there's anything good to be said about journalists, they do have the ability to take in a vast amount of detail, and that's really what a set of orders is about, and some I know are like walking sponges. They learn fast, it's what they've been trained to do. The route back had to be ingrained in their memories. I made them carry certain survival stuff with them too. Some stuff they had to carry on their person at all times, the rest was to be in their grab bag kept really close to, not ten feet away but at a hand's reach so they could grab it and run, should the need be. I had to sort JT and Paul out a bag each. This was all new to them. I told them to fill it with kit like a compass, sweets, food stuff easy to carry, water bottle, a sharp knife, a piece of foil or a reflector and all stuff Girl Guides and Boy Scouts would know about. Silly little things may well save their life. The list was extensive but not endless. Nick and Andy were well drilled, but JT and Paul were not, so I took all four of them through it all again until I was sure they knew the score.

'Where the hell am I supposed to get a compass in Baghdad?' JT joked.

He did have a point though.

'Use a bit of ABI. Ask a marine,' I suggested.

'ABI?'

'Airborne initiative,' Nick replied smug and sarcastic like. He'd heard me and JY use it a lot over the past weeks.

I had no intentions of getting out of my vehicle unless death was right up close and the vehicle was disintegrating around me. I told the rest of them that too. I had to take all that stuff inside my head which had been accumulated over twenty-five years of working and fighting in hostile environments, spit out the less tasty bits and serve up a platter of easily digestible lifesaver titbits. Why? Because titbits were about as much as

anyone could understand and take in, given the self-imposed time frame I'd allotted for this road trip.

I know it sounds crazy, because it was crazy, the entire trip had been so fucking crazy, so far out there, paralleling the rest of my past close encounters in a foreign land, and it was just about to get crazier. I'm not known for being overemotional but when all things consider, the more it dawned on me, a break for the Kuwait border this early on in the war had the odds stacked up well against any of us reaching it intact; of that I was damn sure of.

It was forty minutes before first light. I was ready to go. I could see movement about JT's vehicle, which was a good sign, as I was feeling like shit and didn't fancy bollocking folk for being late on parade. My palate was dry and I had an ulcer coming, must have been that shitty bread from the street urchin. Fucking germed-up piece of roti! I took a swig of Listerine Original mouthwash—well, a fella's gotta have some pleasures in the field; gave the mouth a good fifteen-second gargle and spat it out. That would kill any germs breeding in my palate.

I'd gone through another one of those restless nights where I'd hardly slept a wink and had to fight off a whole load more demons; the ones which lurk in the depths of your mind, in those bad places. They were telling me it was payback and it was my time to die, but I wasn't having any of it. I ain't superstitious, never have been, that stuff doesn't work with me, maybe in my mind when I'm sleeping, but in real life? No!

We left heading south; we had no choice as tanks were blocking the north and it was the safest option. Intel said this was the safest route by far, less inhabited. The roads were deserted. No street lighting, no electricity and most things made of metal had been plundered. The skies were grey and a low cloud base told me it would be a few hours before the sun would pierce through. About a mile or so out I turned left on to a road which eventually merged on to the ring road which headed east, then would eventually turn south again. On both sides of the road was flat desert and sparse. Here the lamp posts hadn't been plundered but had been purposely pushed over, squashed flat by American tanks. Paul kept quiet. He was keeping an eye

out for any signs of trouble. We were entering a most critical stage. Baghdad was a shithole full of angry men, women and children with guns, some desperate for Western hospitality, some desperate for robbing, many determined on revenge and killing. We were in the heart of Saddam's Ba'ath Party's manor and it was no time for small talk.

The squashed street lights took on a strange but consistent pattern. For one hundred metres they would all be squashed over to the left, so you had to drive on the right, then the next one hundred metres they were squashed flat back over to the right. This went on for a few miles until we approached a bridge, a flyover, which dipped away down to the right and south. We were now entering a populated area built up with ramshackle one and two-storey flat-roofed houses off over to our right side. The street light pattern changed again. This time they were flattened on both sides of the road, leaving only a narrow middle strip to drive through.

'Bottleneck,' I said cautiously. 'Possible ambush!'

'No, look, it opens out again up there. Look,' Paul said pointing to the flyover.

Then all of a sudden, I heard a burst of AK-47 come from our right.

'Get down, get down. Ambush right,' I screamed.

'What you doin', what you doin'?' Paul pleaded.

Left hand on the steering wheel, I threw the big V8 into reverse and floored it for all it's worth. The front violently dipped while the auto box whining under the pressure of reverse-gearing. I only hoped Andy saw what I was up to and reacted the same way. This is precisely why I persisted with the actions-on brief. I was sure these blokes never thought they would find themselves in this situation, but this morning they did. Paul's head was still bobbing around like some ocean-going tadpole.

Again, 'Get down,' I yelled as I grabbed his helmeted head and forced it hard down. 'Stay fuckin' down.'

'OK, OK.'

Paul was flapping about like Ross did some weeks earlier, and the twat was pissing me off.

'What's happening, what the fuck!' Paul screamed.

I forced his helmet back down, this time with attitude, BANG as it smashed hard on the dash! Boy that must have hurt. He stayed down, and just as well, as I hadn't had time to think where Andy was. I hadn't smashed into him so he must have got the message. The firing stopped. It appeared we were out of killing zone. I saw Andy pull up about half a mile back and reversed up alongside, window down but no time for adebrief.

'Well done, Andy, mate. All OK?'.

It was the best I could manage without overstating the obvious. Andy nodded. For once they were all speechless. Then out of my peripheral vision, up in the distance I saw an object heading towards us. A tank, and the guys saw it too.

'American,' I said.

'Yes, it's just stopped in the middle of the flyover!' JT pointed out.

'What does it want?' asked Andy.

'Dunno,' I said. 'Maybe he's warning us about snipers. We can't stay still, come on, let's go and see him.'

'What! Go past that sniper again? You can fuck off!' Paul stated the obvious.

'The sniper won't show with that tank sniffing about,' I said reassuringly yet not believing a word I uttered, but what choices did we have? The tank came to a halt about a couple of miles away. Two civilian vehicles driving up to a lone Abrams at early doors in Baghdad is not without its complications for the two civilian drivers or the tank crew. I pitched my speed fast enough to make it hard for the sniper to draw a bead on us yet slow enough so the tank could make a sound tactical judgement and see we were not suicide bombers, and at the same time negotiate all the debris which lay as a trap to set the ambush, making my driving movements erratic and less worthy of a friendly advance on the tank. Our only hope was the tank had convinced the sniper to take cover and that by firing at us, he, the sniper, would only give his position away; AK-47s are renowned for their muzzle flash.

At about three hundred metres a marine appeared from behind the tank and waved me towards him. At one hundred metres I was on the forward slope of the flyover. He was still waving. As the flyover bent and dipped back down, it ran

straight and a whole a line of tanks came into view, spread out as far down the road as I could see. With both sets of arms stretched out through the windows adopting the now, well-rehearsed surrender pose, I approached with caution. I let the Jeep purr slowly and deliberately. I called out with my best British accent. The marine stayed silent. We were now level with him, and he just kept waving us through with a ten-metre stare, the same stare I saw those marines carried, back at the Diyala Bridge. I returned a friendly wave of recognition, but he was in no mood for high-fiving; no need for small talk. We were no threat, he could see that, his threat had just taken a pop at us.

We kept pushing on further south, mile after mile after mile of dusty road. Every half-hour we had to stop for my oil top-up. It was a Formula One pit stop. I would pick a place well away from any sign of human activity, culverts or suspect IEDs or ambush positions. I choose only flat, open spaces. My pit stops took less than ten seconds and if I had to add oil, forty-five. By 8am we made it on to the Mad Max stretch of desert. It wasn't as barren as when we had driven across it several days earlier. American military vehicles had cut a route through the desert floor and were speeding across; destination Baghdad. We would wave and they would wave back, only to get showered with a face full of dust. By noon we were back on the three-lane MRS on the deserted right-hand side and heading south; Godspeed.

On our left side heading north, the Americans had set up VCPs all along the route. We must have passed a hundred of them, all manned by three or four Humvees with two or three soldiers in each. These VCPs stretched all the way back to the Kuwait border.

In the past three weeks the Americans had built several massive logistic fuel storage camps. These camps were to service the fifty-truck convoys and their Humvee escorts who we passed heading north every half-hour! Yes, every half-hour I saw a fifty-truck convoy hauling pallets of bottled water, followed by fifty trucks of ammunition, then fifty trucks hauling portable site cabins, then fifty refrigerator trucks full of meat and frozen vegetables, then fifty fuel tankers would pass, then

fifty more of assorted spare parts, then more bottles of water, then heavy plant, bulldozers, diggers fork lifts and dumper trucks. The convoys were constant. Everything, every piece of kit needed to support the coalition forces was being transported in from Kuwait. I later heard, a year before, (through no Press reports) the Americans had bought up all the articulator trailers from all over the Gulf region, driven to Saudi Arabia then up through Kuwait. Thousands and thousands of them, all purchased or rented at a premium rate no doubt!

On the drive up I'd noticed these small lay-bys which we passed every ten miles or so. They were picnic areas from times passed with several Yogi Bear-style fixed-seat tables and a parasol for each, located on both sides of the MSR, but I never saw any locals or Americans using them. On the way back I pulled into one to do an oil top-up and a stretch of the legs. By mid-afternoon we had made such good time, amazingly, we now found ourselves only two hours from the Kuwait border. No time for reflection but I felt safer than I had for three weeks even though we didn't have an escort, but still, no excuse to drop one's guard. The Americans had secured the southern part of Iraq in double quick time; the road was taking a constant pounding from American trucks. I took a look around the picnic area. It was clean, I mean the desert around was free of any rubbish, not like the rest of Iraq. The facility looked as if it had never been used, really weird! But I knew the reason for that. I told the guys to keep to the hard standing and not to go wandering off.

'Why?' Paul said.

'Mines.'

'Fuck off! What makes you think that?' he asked.

'Instinct. And why twenty fuckin' questions all the time?'

Honestly, it was like riding with a five-year-old. 'Ever seen any civilians or military pull into these?' I asked.

'No,' Nick and JT replied.

Point made.

One last push to the border and one last tactical decision to make. How to make the exfil back into Kuwait? Safwan was the obvious route but now the military had established a crossing a few miles to the west, did we use that facility or take the easy

route back through Safwan? To be honest I'm not sure whose idea it was, I'm not sure I even discussed it, however I chose the much safer military crossing but for some reason we ended up getting funnelled towards Safwan.

We passed very few civilians on the way back, I would say twenty max, over those hundreds of miles, and not a single sole as we entered Safwan. Where were all the people? Where were all the stray dogs? It was like a ghost town, then all of a sudden, a riotous mob of screaming stick-wielding men came out of nowhere as if they had seen us coming and lain in ambush. They quickly surrounded the Jeep and started banging on the windows, rocking the Jeep back and fro and grabbing the door handles. It was frightening and it was going to turn nasty and some one's life would never be the same again I was sure of that. I could see they hadn't reached Andy yet. I hoped he'd the sense to stand-off a bit, observe and to recall what I'd taught him: keep doors locked and windows up and never get out of the vehicle!

We were now entering a life-or-death situation which demanded nothing less than decisive fearless action because these folks weren't here to thank us for their newfound liberation and freedom, I could guarantee that, and then, almost in an instant it started, one of them put the Jeep's rear windscreen through and tried to get in and make a grab for our gear. Next would be mine and Paul's windows, a pistol pulled, then we would either be dragged out, kicked, punched and looted, or more likely beaten to a pulp and our heads stuck on stakes as a warning to other invaders. But I wasn't having any of it. I pulled out my lock knife and made it ready, ready to stick and repel any boarder. I wasn't going to be intimidated by a bunch of slags, and I know from past experiences when a crowd smells blood you have two choices: fight or flight, retreat or attack. I attacked.

'Fuck it, hang on,' I screamed.

'What you doin', what ya doin'? You can't!' Paul pleaded.

Fuck me, not more pacification, Paul, please! I just didn't have time to question why he hadn't learnt his lesson during the sniper incident. I didn't have time to explain to Paul the micro-margins of war. I didn't have time to tell him our lives were in danger. I stamped hard down on the gas, and the Jeep violently

forced itself back on to the rear suspension then the weight instantly transferred forward as all four corners dug hard into the gravel and made traction. I drove straight into the killer crowd, bouncing four of them out of the way.

'What—look out!' screamed Paul. 'Holy crap, you've just run over them; you fucking ran them over stop, stop.'

Stop is not what you do. You keep on driving, crunching bones or not. You put your foot down and you drive like fuck, you don't look back, and you don't pass *Go* and do not collect 200. Don't worry, those scumbags got the message. See, that's the difference between folk like me and Paul. I'd rather be tried by twelve than carried by six. Andy saw my reactions and floored his Land Cruiser and followed suit, his path clear, bar some bloodied stragglers and mucus. Message received. Out!

Over the coming weeks, months and years, Safwan was avoided by all but a few who entered Iraq. It was put into isolation until Kuwait and Iraq reopened the civilian border crossing years later. I recalled what my dear Kuwaiti friend, Brigadier Abdul said of the inhabitants of Safwan: 'They are bastard people.'

17. Mission Accomplished

I raced through Safwan still fearing for my life and came out the other side leaving an angry cloud of dust swirling around the back of the Jeep's open tailgate. We passed the mortar-pit mosque and then into no man's land and across the DMZ and kept it floored back towards the safety of Kuwait. There were no military or civilians to be seen. I headed for the only familiar feature in view: the old customs building, then suddenly as out of nowhere a figure appeared from behind the building. It was wearing a uniform and carrying a rifle. It was a Kuwaiti policeman. Then another appeared from a police truck.

'Hell, they got this manned!' I said, 'I didn't expect this!'

They waved us down, rifles at the ready. I pulled up short. One waved me closer. I wound down my window.

'Ah, salaam alaikum.' I greeted the policeman. He had a head like a horse and I just knew this was going to be a difficult stop.

'Passport,' he demanded in English. All,' he ordered, and motioned to Andy's vehicle too. I handed him mine and Paul's passports and press IDs.

'British,' I said.

He ignored me and just gathered up all five passports without even opening one of them.

'Out,' he ordered. We all got out of the vehicles and stood hanging about while he and his mate had a quick chat. He then got on his radio.

'What's the problem, officer?' JT asked.

'Please wait,' the other policeman said in educated English.

Nick tried. 'We're Sky News.'

The policeman raised his right arm and curled his palm so the tips of all his fingers touched his thumb, a common Gulf gesture meaning wait. We waited, and waited. Twenty minutes passed then way off in the distance a dust cloud came racing towards us from the direction of Abdali petrol station. It was the big cheese, the Officer of the Watch. We were whisked

away in armed convoy towards Kuwait, not for our protection but to stop us from escaping.

We stopped outside a building with radio antennas and wires stretched out all over its roof. I stepped out of my Jeep, got down on my knees and kissed the ground, I can tell you, I was that pleased to have arrived back in Kuwait, and I have never been so keen to get back to a country which practices Sharia as I was that day. The policemen, I'm sure, saw my action as a sign of respect for his country.

We were led into the police station where we were interviewed at length.

'Yes, Captain. We have just driven back from Baghdad,' I spoke.

'Impossible.' He snorted. 'How could you?'

'Captain, we left Kuwait three weeks ago. Please let me make a call and explain.'

'No call,' the captain replied.

It was pointless trying to explain the last three weeks to him, and to be honest, I had trouble trying to work it out myself, but he was a pleasant enough man. He then ordered his men to give our vehicles the quick compulsory search.

'You have Kuwait plates?' the captain asked.

'Yes, sorry, we took them off to go into Iraq. Sorry,' I replied.

The last thing I wanted was to drive into Iraq with a Kuwaiti vehicle registration plates on. The Iraqi still didn't get on with the Kuwaiti so there was no point in antagonising an Iraqi civilian.

'Put them back on,' he ordered. 'You cannot drive in Kuwait without plates.'

From death and destruction and lawlessness to stable bureaucracy, yeah, I can handle that. He was all happy and smiling and ready to let us go until his men became really pissed off when they found several AK-47 magazines in Andy's vehicle, which were empty of any bullets, thanks be to God, but then they decided to give both vehicles a thorough going-over. They then confiscated JT's prized possession, the framed picture of Saddam he'd liberated from the Republican Guard barracks.

'You can't bloody well take that. It's mine,' JT pleaded.

The policeman raised his head slightly and made eye contact with JT. 'No, it is illegal for this bastard to be in Kuwait,' he stated.

Now, I'm sure there are similar words the officer could have used other than bastard, but when uttered by an English-speaking Arab, the pronunciation gives the word so much more meaning.

'I agree, officer,' I said, to the annoyance of JT.

I know how to pacify the Kuwaiti, and JT obviously didn't. Making any Arab cop lose face is not a good thing as you will always bring a whole pile of grief down on yourself. It's best to say nothing and let them do what they have to do. It was a pity though, because it was a quality framed oil painting. Then the other policeman spotted my arse.

'What is this?' he demanded.

'Oh, it's nothing, its bullet protector, officer. See, with the sandbags by my seat,' I explained.

He seemed disinterested but puzzled at the same time, so I advanced my reasoning.

'Have a look,' I said, and went to pull it out.

'No,' he ordered.

He accepted my excuse so the arse stayed behind the seat, and anyway, it was far too hot to be searching vehicles. For our minor indiscretions they keep us locked up for a few hours, well, no so much locked up but in a room with bowls of dates, plenty of fresh fruit and ice-cold drinks and TV. They interrogated us about Iraq with a thousand questions. 'What is it like? How do the Iraqi live? Do they drive donkey and cart like the news says?' 'Are the women still ugly?'

They eventually believed our story and should have let us go but held us just to alleviate their boredom, but we were keen to move on, so I asked the captain one more time if I could make a call.

'Why not?' he said, as if were the first time he had heard my request. He gestured to the landline on his desk. 'Press nine.'

I phoned my ace, Sheikh Homoud, and passed the receiver over to the captain, and after no-hard-feelings handshakes all around, he set us free. No face lost on either side.

And still the American trucks kept coming, still they trudged steadily north. The road back to Kuwait City was a mass of American heavy metal, fresh troops with much belief. I slowed down as we entered the checkpoint at Mutla Ridge. It was still unmanned, lazy bastards! As the sun set, we passed Jahra and I could just make out the mountain of scrap vehicles catching the very last of the fading light. Traffic was now heavy with civilian vehicles yet not one military in sight as they had all turned off on to the 6th Ring Road which orbited the city and ran back south towards Saudi Arabia.

By the time we pulled up to the Sheraton, night had set in. I dropped Paul and the lads off, and arranged to meet up the following morning. Nothing else needed to be said. We were all absolutely knackered from the long drive back and there was no doubting Lady Luck had been on our side all day. Just a few hours ago I had been in the hellhole of the world, and now, I was in paradise. I didn't have time to reflect; that would come later for sure, as I had to go get the rear windscreen fixed. The Sheikh's men could sort the oil leak, but I felt it only right for me to make the vehicle secure, so I headed off to a place called Canada Dry Street, and no, please don't ask, which is in the industrial area. This is the area where you can get almost anything made of metal, from hand-rolled pots and pans through to weapons and bulletproof vehicles, to garden gates and massive water tanks, and on Canada Dry Street I could also get my rear windscreen replaced.

It was another two days before I managed to get a flight out of Kuwait back to Heathrow. I got booked on the British Airways shuttle. It was a full flight because since I'd been upcountry, Saddam had lobbed a few Scud missiles into Kuwait, and that scared the bejesus out of the Kuwaiti, well it would any one of us, wouldn't it, so those who could, did a runner to their houses in Europe, mainly London, and some flew off to the US.

I normally travel light anywhere I go, I'm not a suitcase man and can't bear standing in queues, but this time I had to check two of them in: one for all my war clobber as I didn't see the point in leaving it all at my apartment if I had to go elsewhere in the world, even though the story was Iraq, and Blair hadn't

reopened the Afghan can of worms just yet, and one for the arse, which I just about managed to squeeze it into one of those massive heavy-duty plastic shell cases. I opted for a branded name and paid treble the souk price of a lesser quality one. I didn't want the arse popping out on the luggage carousel, now, did I!

I had my patter ready when I checked in.

'Did you pack your own bags, sir?' enquired British Airways.

'Yes, I did,' I replied subserviently as one does.

'Are you carrying anything on this list?'

I was shown a list of prohibited items and I couldn't see Saddam's arse on the list.

'No.'

'What's in the big suitcase?'

'Saddam's arse.'

'OK, you do understand there will be excess luggage charge on the arse. How would you like to pay?'

'American Express?'

'Thank you, sir, that will do nicely.'

PART TWO

18. War! I've Had Enough

For several years Saddam Hussein's arse sat in my garden shed, never seeing the light of day. It sat there harmlessly, quite inconspicuously between pots of paint and garden paraphernalia just gathering dust. I had quite simply forgotten about it.

While I was working over in Kuwait and Iraq my marriage was taking a bashing, and just like my first wife, the second one eventually ended it. I can't blame either of them for their decisions. Again, it was the years of dealing with other people's nonsense and not dealing with my loved ones had taken its toll. I carried on working in the sandpit, Iraq, as a PMC (Private Military Contractor/company). PMCs were unheard of in the British security scene before 2003. This is an American term now widely used across the security industry. We did use the term BG's (Bodyguards) or security/military advisors, but Iraq changed all that. Iraq was my bolthole and it was a way of forgetting all my responsibilities until I came to my senses, returned home and faced the consequences.

Historians call the area between the Tigris and Euphrates Rivers Mesopotamia, now modern-day Iraq, the Cradle of Civilisation, but now it's just a mess of tribal revenge and religious bigotry, and thanks to Blair and Bush the country is on fire with so much hatred. Much more than ever before.

The Kuwaiti may have a biased view of Iraq because they were invaded, butchered, raped and pillaged by them, and I would sit with many Kuwaiti for hours in their dewans (Arabic for meeting area or tent), talking about geopolitics, oil and of course Iraq, and to the man they said, 'If Blair and Bush do go into Iraq, they must beat the Iraqi with a stick, beat them for five years.'

'Why?' That's a bit harsh!' I asked.

'Because most Iraqi do not know what freedom is or how to deal with it. Many are uneducated and live in tribes.'

'You will see, my friend, you will see. You are strong in the West with technology, but your liberal minds make you weak and blind to their fiercely loyal and vicious tribal mentality.'

I heard this kind of talk so many times, and you know what? They were spot on. If Blair and Bush had come and spoken to any of my Kuwaiti mates and not just listened to their think tanks or policy advisors, the special interest groups or the so-called Middle Eastern experts on Iraq, who they wheeled out at every possible news briefing to give their expert point of view on Iraq while residing in US universities for the past twenty-five years, then it's quite feasible Iraq and the rest of the Middle East wouldn't be the dangerous unpredictable basket case it is today. Modern history is littered with failed examples of Western interventions by so called *experts* and thick politicians, especially in this region, and I really do think, we the people, give our political leaders far too much rope. I feel we all have been conned, especially post WW2 by ignorant self-serving governments and their experts. We are seeing it right now unfold before our very eyes with the Chinese Communist Party virus *experts*. This must surely change. It has to change and it has to change quick, before the likes of Blair and his self-proclaimed Globalist elites secure their internationalist New World Order—it's not a joke either. They would have us fighting in the Middle East forever if we let them get away with it. Why? Because they want war, they need war and confrontation, it is their way to get richer.

Back in the early days of Iraq just after June 2003, PMCs came in all sorts of guises and had all manner of ideas about how to travel around Iraq. They mainly took the hard, tactical approach, screaming about in big American gas-guzzling 4x4s, guns and chest webbing at the ready, bald heads sporting Oakley sunglasses, and pulling up at every road junction, spraying the locals with a sand gravel attitude. Now, I know why they adopted this tactic, it was a way to show strength in numbers, don't mess with us or we'll really fuck you up. And it worked most of the time and good luck to that, but since my contracts were of a more delicate nature, I used local taxis with vetted drivers, or old-looking 4x4s but with fully serviced engines and uprated running gear to cut about in. Other

security details thought I was mad, but in reality, they were the bigger and more obvious targets. I never got hit once.

On one job, an Iraqi-born doctor from a well-respected Sunni family flew in from Bern to Kuwait. He represented a Swiss group which was part-funding a large medical project in Baghdad and my business partner, the Sheikh, well, his group, was funding the other part. I had to drive this chap to Baghdad where his cousin lived, Abu Hassan, and then off to the Palestine, (yes, other than the Green Zone, the Palestine Hotel was still the preferred place in Baghdad to do business) for meetings, and then back to Kuwait. I had prepped a 1994 Mitsubishi Shogun long-wheelbase for the trip. It was an ideal vehicle, a 4x4 fully serviced, old-looking on the outside but uprated engine and well serviced, and had been upgraded and armoured to take low-velocity and secondary fragmentation attacks, it was the best available without distorting the shape of the vehicle and giving away its standard body profile. The glass was standard, which was a bit of a pisser, but on the inside, I covered it in a tinted anti-glare plastic film giving it a bit more strength and protection, so if the windows did blow-in it may just save an eye, and as I've mentioned previous, every little bit of protection counts.

I planned on a three-day trip max. I got the doc in through the military crossing up at Abdali avoiding Safwan and drove to a safe house just across the border to pick up a long my trusted folding stock Czech made AK-47 and ammunition from a secure facility run by a couple of ex-SAS guys. I was already carrying my short, a Glock 17 as one would be mad to enter Iraq without the correct hardware. Long and short are generic terms for any rifle or pistol. Obviously, a long, being a rifle. Terms I used way back in my NI days.

Pick-up complete, I headed up to Baghdad. It was a long, hard, dusty drive, only stopping to refuel from jerry cans, which I stored in the back. One stray bullet and we would have gone up in flames, but that was the risk we all took. I managed to bluff my way into one the US refuelling camps, which were guarded by the US Military but operated by US civilians who were on contract, and as long as you could get into these camps then you had free fuel. It wasn't the responsibility of the civilian contractors to ask questions about who was permitted fuel, as it

was taken as read anyone eligible to enter the camp was eligible for a full tank and a shower!

Coming off Tampa (the MSR) and making my way across the outskirts of Baghdad was always fraught with danger. Everyday hundreds upon hundreds of cars were pouring over the borders from Kuwait and Jordan. It was well known the sale of second-hand cars in Kuwait had doubled and was about to treble, such was the demand from the Iraqi with all their mysterious US dollar! So, as a consequence, generations of folk who had never driven a car let alone sat in one increased the RTA's (Road Traffic Accidents) rate times by a hundred. Also, illegal vehicle checkpoints (IVCP's) manned by Saddam supporters ready to pull you out and execute you in the street with no hesitation was something else you had to factor in. As a lone driver you had to be on the lookout all the time for IVCP's and of course potential RTAs, because these critters came at you from all angles, many times on the wrong side of the road, and being involved in an RTA in the middle of Baghdad as a Westerner, could well be game over. If you weren't well drilled in evasive driving techniques and the locals caught you, they'd lynch you for fun.

After hours of hard driving, a few scares and a wrong turn, I entered the street where the doc's cousin lived, and as soon the locals saw me, they scattered out of sight like they were avoiding an oncoming storm.

'Here, see the red gates,' the doctor said excitedly. 'Abu Hassan's.'

He was pointing to a set of large, sunburnt red oxide gates up on the right. We were in a leafy, wealthy suburb of high-walled and gated double-storey houses with their own armed security guards sitting lazily on rickety old chairs outside closed gates. Not a vehicle in sight. The street ran straight for half a mile and wasn't much wider than thirty feet. I made my approach, then all of a sudden, this massive explosion erupted somewhere off to my front and left. Now, that's not unusual in Baghdad but as soon as I pulled up outside his cousin's house, I watched up ahead as a US Army patrol in two Humvees came racing towards me, only to pull up sharp just short. Several soldiers dismounted and pursued on foot, smashing down the gates next

to Abu Hassan's, then another patrol tore through his cousin's, pushing the house security guards aside. I stayed in the vehicle as I couldn't see what was to be gained by getting out: never get out of the vehicle. The Americans were now doing a house-to-house search all along the street, back from where they came. I sat waiting, doors locked, engine ticking over, weapons at close hand, but out of view.

'I go,' the doc said.

'No problem. You're call.'

The doc wearily made his move.

'Don't be long Doc, I ain't hanging about here.'

The doc nodded.

On the surface it appeared a strange move to get out just as the Americans came-a-visiting, but what to do? We hadn't come all this way only to drive off because of the American Army. I didn't read anything into it other than to think back to Northern Ireland when the British Army regularly hot pursued a suspect through a housing estate; the local folk would just go about their normal daily business as if soldiers carrying loaded rifles running all about the place was the norm, and it was back in the day.

The doc had to wait a second while I manually unlocked the doors, the lock system had been broken some time ago; it was a security issue. He got out of the vehicle and hurriedly walked off. I immediately reset the locks. Then some kids appeared as if a storm had just passed and started to follow the Americans down the road as they area-searched through each gated property with the curious kids keeping their distance. I sat and watched these innocent kids play their game of chicken, when I caught movement and spotted a small kid moving up from the rear and coming alongside. He squashed his nose, then rolled his cheek against the side of my window. He looked about six or seven and his inquisitive smirk told me, he knew, I wasn't Iraqi. I quickly scanned his clothes and body language; no sign of a suicide vest or trigger, and his palms were clear. He was a clean kid. My natural reaction was to drive off, but I stayed put. 'Americana,' he whispered quietly through the glass, as if he said it any louder his mates might come over and not like what they saw, and why was he whispering to an American!

I smiled and shook my head. I lowered my window a couple of inches, he smiled back and then turned his focus over to the two Humvees moving slowly back down the road.

'No Americana, Ana Iraqi, habibi [I'm an Iraqi, my love],' I replied.

He shook his head knowing I was joking, and to keep him onside I pushed out a handful of boiled sweets. He laughed, a couple dropped to the floor so he bent down quickly, picked them up and then ran off shouting, after his friends. I was now compromised. I shifted into gear and pulled up outside Abu Hassan's gates. I could see the doc talking to a middle-aged Iraqi man who I assumed was his cousin, their arms waving in gestures of anger. Doc saw me, turned and motioned me to wait. I didn't feel safe, I didn't fancy waiting a minute longer what with the American Army swarming all over the neighbourhood, and this could tempt an insurgent come-on. (The coalition forces dropped the name fedayeen and now referred to any enemies of the state as insurgents, later Al Qaeda, but then dropped that when they found out Osama Bin Laden had no affiliation with Iraq, then they used a couple more names before going firm with the Arabic word Daesh, meaning a group of bigots who impose their own will on others: apparently a derogatory term which none of us simple folk understand and which doesn't resonate the true barbarity of this group, yet all the experts and officialdom uniformly refer to this new group as. It probably makes them feel closer to the subject matter knowing they can speak a little Arabic. The rest of us just use IS, Islamic State because that's what it is and what these radical Islamists are trying to establish, a caliphate, Arabic for an Islamic State).

I revved the truck, sending the doc a clear message to hurry up. He got the message and immediately came back. Good, Sheikh Homoud had briefed him well; *Do not mess Nigel about. Do as he says at all times, that way you will be safe, inshallah.*

The doc made it back to the vehicle.

'Let's go, no point in becoming a sitting duck,' I said grateful he hadn't pissed about too much.

The doc looked a bit flustered; he had spent most of his formative years in Iraq but this was only his second time back as an adult.

'Quite,' he obediently replied.

Slowly we moved off towards the Humvees. A soldier shouldered his rifle and drew a bead on me while another waved me towards their snap VCP. I could see he didn't want me to stop as he kept waving, so as I passed him, I put up a friendly wave and cruised on through.

'Back there, what was all that about?' I asked.

'My cousin was pleading to get him and his family out of Iraq. Bombs going off daily, Americans coming into our houses! It's not safe here now.'

'Safer than under Saddam?'

'No, unfortunately not, my friend. Not for the Sunni it isn't.'

An hour later, I was in my room in the Palestine. I spent two days in meetings, and the only time I ventured outside the hotel was to drive back to Kuwait. The doctor decided to stay at his cousin's and not come back with me, so offered me one of his trusted ministry men to drive me back to the border. The doc wanted my vehicle so we did the exchange and the following morning I was dressed up in my best Arab clobber and rode back with an Iraqi called Sami. Now Sami was a big fat chap with a Fu Manchu moustache times ten, and a haircut styled by Saddam Hussein's barber. He was indeed a complete caricature of what one might assume a Saddam Hussein bodyguard to be.

We rode south in his 1990's V8 Ford Bronco. He was really proud of his truck. He had decorated the dashboard by gluing a cheap-looking, garish, red brushed cotton material all over it, to which he'd stuck twenty-six of those annoying little troll-type creatures. Sami thought they were fantastic.

'You like my little friends, yes?' He said as he gave the biggest one a friendly pat on the head.

'Yeah, Sami, a very nice touch,' I said. What a load of bollocks I thought.

We took the more eastern route back towards a place called Al Kut, this was to avoid the masses of US checkpoints along Tampa and it was less conspicuous, less of a threat to folks like

us travelling in an old Bronco. We would fuel up at Al Kut then next stop Kuwait.

Al Kut was like any other town in southern Iraq, a smaller place than Al-Nasiriyah but in a similar state of dilapidation: a collection of buildings, some brick built but most mud huts, roofed with sheets of corrugated iron. It was run-down, dusty, dirty and had the same dangerous feel as Safwan. Sami knew his way around and as we approached the petrol station, I could see there was a large mass of noisy menfolk, no vehicles, just men dress in scruffy dishdashas holding empty two-litre plastic water bottles and empty fuel cans. A row of donkey-drawn carts took the place where one might have expected to see cars in a queue.

'I'm not keen on this, Sami. Is there another gas station?'

'No, this is the only one.'

'Let's pull off and come back when it's quiet.'

'Leave it to me.'

He hit the horn several times, then slowly the crowd reluctantly moved out of the way. The locals started shouting at us, annoyed we were jumping the queue, then one of them spotted I wasn't an Arab. This wasn't where I wanted to be. Sami unwound his window and ignoring all the protests, shouted something at an old man who seemed to be guarding one of the pumps. I didn't like this window-open business either. I double-checked the Bronco's locks on all doors, moved my AK safety to off and re-checked the position of the Glock; it felt comforting. I always travelled with weapons cocked and moved safety to off in desperate situations, no point carrying otherwise, because in this environment getting that safety catch off takes a split second and, in that time, it could cost you or your mates their lives. Contacts happen real quick, and the quicker you can react, the more chance you have of coming out alive.

'Sami, don't get out, fella.'

He nodded. I knew he wouldn't, but it doesn't hurt to confirm your words of command haven't been lost in translation. The old man came across, he looked gaunt and tired and it made me think what kind of a life this old man was living through. I didn't

feel sorry for him, just a bit inquisitive, that was all. The old man and Sami exchanged some quite angry words.

'Americana,' Sami turned to me.

'No, for fuck's sake, tell'em I'm Polish!' It had worked for me in Afghanistan!

They wouldn't have heard of Polish. British and Americans were not especially liked around these parts, that's partly because of 2003, partly 1991 and more to do with the British Army in this area in 1916 during the First World War, when we didn't treat the locals all that well and reneged on a lot of deals too. The Iraqis down here call the British, bonagee, sly like the fox, and to be honest, I couldn't blame them, because squeezed between the American and British idea of forced democracy, which they couldn't handle anyway and quite frankly didn't want, I'd be pissed off too.

'No, it is not you. He says the American Army are coming, heading this way and they're getting ready for them!' Sami then reached into his pocket and handed over a couple of dollars, and the old man started to fuel us up.

'What do ya mean, getting ready for them? I looked across at Sami. 'They gonna fight them?'

Sami shrugged his shoulders. 'Maybe.'

The crowd sensed the old man was almost done refuelling and if they were looking at doing something to us, they should do it now. They were really pissed off, but they didn't have a go immediately, they started to bully the old man again, the weakest and most exposed element for the protagonists to practise on, and I know from past experiences it would only take seconds until one idiot turned on us, and like a pack of wolves smelling blood, the rest would attack as if by natural instinct, and then people who would never do the unthinkable in normal everyday life, do the unthinkable. We were at that unthinkable stage. The old man screwed the filler cap back tight then slapped shut the Bronco's filler flap, then as we started to pull off, someone threw a stone which bounced off the side of the Bronco so Sami floored it tyres screeching, leaving a hail of airborne rocks falling short.

About three miles further south, the dusty track roseslightly up to a desert type hillock. Off to the right was a small flat-

roofed concrete-rendered shack and opposite side lay a small pile of rocks like a spot height marker. In the middle of the track looked to be a big fifty-gallon oil drum.

'Militia. A checkpoint,' Sami uttered.

'Problem?'

'Could be.'

'Always a fuckin' problem in this country. Look, Sami, don't stop, mate. Slow down, pretend you're gonna stop, then floor it.' I suggested with a hint of experience.

'Maybe they just want money?' he replied.

'Fuck'em, we ain't got no money!'

I was still wondering what lay in fate for the US Army heading south. At a hundred metres a man carrying an AK-47 came out from the shack. He heard us coming. I know this type of Iraqi very well, they're always sleeping, eating and generally slobbering about the place, they are lazy critters. It's the heat you see, and their mentality that makes them act this way, and they're always full of inshallah, which just exaggerates their excuse for idleness.

At fifty metres I could see this militia was a big cocky slag. I could tell that by the way he was holding his rifle. He had it shouldered with a long strap attached, much longer than the standard-issue AK-47 sling, which immediately told me he was double fucking lazy. Why? Because if you carry a rifle outside the armoury or the drill square it has to be part of you, it has to become an extension of your body and should always be at the ready. Where were his mates? These fuckers always had mates about. They hadn't appeared, so I guessed they were equally double lazy fuckers too, doing a bit of Egyptian PT no doubt. Sami slowed a little. At twenty metres the militia unslung his AK from his shoulder and let the longest rifle sling in the world, droop to the ground as he toyed with his rifle like some gangster punk keen to intimidate, and waited for our approach. This wasn't good. We weren't close enough for him see me that well, but I sensed he wasn't about to have a friendly chat either. He moved on to the track and forward of the oil drum, legs astride in defiance and blocking any attempt at a drive through. He was a tall, lanky critter, a bit like Plug out of the Beano comic and just as pig ugly. Sami slowed down and the big V8 auto-box

jerked down a couple of gears. I sensed the gearbox oil was thin, as thin as water, and I was betting it hadn't been changed recently as the juddering of the gears was a sure indication it hadn't. I only hoped the oil would have enough viscosity left to drive us out at full torque.

'We have to stop.'

'No way, just drive through this fucker,' I ordered.

It was too late; Plug wasn't going to budge off the track. Sami pulled right up close to him, the Bronco's bumper almost touching his knees sending him a subtle message. He and Sami were eyeball to eyeball. Arabs don't like this eyeball style, it's that loss of face thing again; all that macho stuff—first one to blink's a sissy bollocks, a bit like petulant kids. Brits don't give a toss about that stuff, that's why we make the best soldiers, it's our mentality, our temperament. I looked around to see where his mates were. I couldn't see any, I couldn't see any vehicles either, but he wouldn't be on his own, I was certain of that. He then gave me the ten-metre stare and started to move around to my window instead of Sami's. He was shouting something but it's very hard to make out if these people are angry or not. Arabic can come across as an aggressive-sounding language but you can usually gauge an Arab, (and I apologise to all my Arab friends if I appear to generalise, because I am) not by their pontifications, but by their mannerisms, although you have to have spent some time around Arabs to understand their manner, but I knew Plug was really pissed off about something. 'What's he saying?' I asked, and then Plug pointed his AK directly at me.

'He's ordering us to get out.'

'Fuck no,' I shouted.

Plug now had the business end of his AK up alongside my window. I gave him the eyeball. He then started to tap the muzzles flash idler hard against it; *crack, crack, crack* as he prodded the glass, I thought the window would shatter. He was a crazy Plug. His eyed told me so. My right hand felt for the Glock as I cautiously half lowered my window to get a better feel of the situation; talk to Plug mano a mano but unfortunately, at the same time he made a grab for my yashmak and in doing so his rifle fell away to his side. I fended him off with a push from my

left hand but he wasn't having any of it, he was not backing down. His breath smelt, it was rank, my right hand firmly gripped the Glock. He tried to open my door. The door was locked. He made another violent grab for the yashmak, and as he did the banana shaped magazine on his AK, again smashed hard down on the door skin. My choices were limited. Plug was becoming more erratic, screaming, and in this lawless land with no witnesses I could either do as he wanted, get out the vehicle never get out of the vehicle, go all compliant only to take a bullet in the back of the head, or deal with the threat the way I have been trained. I didn't have to think, I was in auto-mode and I wasn't going to be submissive. I had a life I wanted to keep. I still had ambitions and goals to achieve and one of them was to live to a ripe old age. He took a step back raised his rifle and pulled back on the cocking handle. I heard the round snap into the chamber, this is it, he was going to kill me, no question. How long did I have left to live? I could shoot through the door skin with the Glock, that would be OK, but I didn't because as he fumbled with his safety catch, I calmly raised the Glock and double-tapped the largest mass to my front It was a familiar instinctive movement. I assumed I'd killed him, but unless I treble-tapped him, I couldn't be sure. I didn't actually see Plug fall like; targets fall when hit, as the situation happen that fast, all I did was shoot and scoot using the old SAS adage. I find no triumph in killing. It is literally, them or me!

At the same time I fired, Sami again floored the big old Bronco, swerving around the fifty-gallon oil drum and disappeared over the brow of the hill. Life-changing decisions can take seconds to unfold. This one, I ended in two, and it needed no more intellectual considerations of the situation. My life was in danger. It was clear Plug was intent on causing me and Sami harm, it's the way of the animal. Life is cheap in Iraq, but my life and Sami's were precious. I didn't look back, only a couple of glances into my side mirror told me there was no immediate follow-up. We were on our own for the timebeing.

No need for small talk, and I couldn't hear anyway because my ears were still ringing from the two shots. Later, Sami and I kept the conversation down to the bare minimum. I was expecting a chase so Sami concentrated on putting maximum

distance between us and them. Driving at speed in the desert can take it out of the driver as well as the vehicle. Avoiding punctures and overheated engines is as much a skill as avoiding the enemy. A few hours later we arrived at the border military crossing point and I immediately reported my fears about Al-Kut to the Americans and was told the battle had already started. I then made Sami conversant with US protocol and introduced him to a friendly American who would get him fed, watered and refuelled. I asked Sami if he wanted to come into Kuwait, I could make it happen, but he politely declined. Maybe he had some history with Kuwait!

After giving him my AK I never saw Sami again, because as I crossed back into Kuwait, I made a command decision. I felt I had played with my life just one too many times. Enough was enough, and just like back in 2003, I dropped down to my knees and kissed the State of Kuwait for a second time. I was finished with war.

19. The Arse Revisited

It's not often one can break away from the pressures of 21st century living; not many people want to, most people like the consumption-driven world, but my body and brain were telling me they needed some long-term rest and recuperation after a rather unpleasant and costly divorce. A good way to do this would be to take it easy for a bit, take a sabbatical on modern life and get back to a less complicated existence. I would try living off-grid in the deepest English countryside, grow my vegetables, harvest rainwater and write up my experiences. Sounds idyllic I know, but I had to try it as my mind was awash with desert dust and the emotions of war.

Eventually the matrimonial house sold, which released a bit of cash, so I had to move out all my worldly goods. They filled half a dozen cardboard boxes only, quite sad really! Is this what life boils down to! I now had fewer cardboard boxes than after I came out of my first divorce. Most blokes are of a similar mindset, we don't haggle over the washing machine or sofa or beds, we like to get out as quick as possible, all that stuff, well, it's just stuff which can be replaced. Sure, you need the white goods and a chair to sit on but it's still only stuff. My boxes held clothes and personal belongings, and I've found that as one gets older one's personal stuff seems to decrease in varying amounts too. Perhaps we just get more selective about which parts of our lives we want to recall. Photos, an old childhood toy or your kids', Mum and Dad's wedding rings, it's personal stuff which make you feel good and warm inside at whatever time of life you're at. Nostalgia is nice.

One day as I was raking over my newly turned vegetable patch, I got a call from a production company, ZigZag Productions, they were London based and wanted to do an hour documentary on me hosted by a fella called Danny Dyer. I had no idea why they wanted me, and I'd no idea who Danny Dyer was, so I Googled him and up came this cheeky chappie cockney actor. ZigZag were doing a six-part series on hard men, so I

asked them what their perception of a hard man is and they came back with the usual stereotypical doormen, gangster characters. I know a few doormen and women and they are damn hard folk, but I didn't want to be associated with any gangster types or drug dealers or slags, so I said thanks but no thanks. I knew I wouldn't have any editorial control and they could quite easily make me out to be a complete tosser as I had no idea what their angle was going to be!

About a week later I got a call from one of their assistants, a nice-sounding chap called David, asking if he could come to Hereford and just talk about the project over a lunch.

'Why not, if you're paying.'

It was a Thursday. Dave arrived from the capital by train. It's a three-hour ride from London Paddington and you can either get a straight-though, which stops at all stations west where it alights at Hereford, or get the Great Western Paddington to Swansea, change at Newport and pick up the Manchester train, which goes via Hereford. An early lunch and Dave could be back in the great metropolis by early evening.

Dave turned up and explained I would be the ideal character to break up the stereotype of hard men. He was a great persuader, but the title given to the project, Britain's Hardest Men, made me feel very uncomfortable.

'You gotta be kidding me. If I don't do it, I'm not sure you'll get any of my mates to do it either, not with that title.'

'It's only a working title. It will change, they always do,' Dave replied, 'and the producer wants you, not any other ex-SAS. He wants you. He's read up on you and we all think you're the right man.'

Flattery is a weakness of us all.

Lunch lasted two hours and was sober. We spoke about my life and how he saw the documentary, and what angle ZigZag was aiming at.

'It's going to be a straight documentary, and anything you can bring which will make the viewer understand your skill set and your industry, we can make that work. I'm sure of that,' Dave replied.

I let him know I wasn't being awkward but I had to think about it a bit more.

'You'd better not make me out to be twat, and I'll need more money to convince me,' I said.

Dave nodded, he understood. 'Money's not my department but I'll ask the boss. I'll get the boss to call you,' he paused. 'Can I say to him you'll do it if the money's right?' Dave hesitated.

I knew he had to take something positive back to his boss.

'Get him to call me,' I replied.

We shook hands. I didn't expect to hear from him again, but the following week, Friday around four in the afternoon, I received a call from a chap called Lars who said he was the executive producer for the series. I stated I would do it for an increased fee. He came back with a figure which was just taking the piss, so I told him to have a think about it.

'Get back to me next week,' I said.

I wasn't playing hardball, but I knew my worth and he knew my worth too, because he came back with, 'I have to have a decision today.'

'Can't you make it Monday?'

'No. We're having a meeting today, now, to finalise the budget, so may I call you before seven?'

'Please do,' I said, puzzled as to why Friday was so crucial to their preproduction.

Ah! Life is truly a game. Lars called me back just before seven and offered up a figure which I agreed on.

The series was called Danny Dyer's Deadliest Men. The title still didn't sit right with me but it was compromise. When it came out the reviews were a lot better than I had anticipated, and my episode was completely different from the other five gangster-filled-cum-violence-overload episodes. Although I had no control over the editing, I had persistently expressed my wish they create an image of controlled aggression and skill, and I achieved this by asking an old ex-para friend of mine, Eran Bauer, who lived in a big pile over on the east coast, if we could use his magnificent country estate which dates back to the Norman Conquest to shoot the majority of my episode. It worked. Eran was a fully licenced supplier to the MOD and other friendly countries of specialist kit, and had a vast array of weapons, black kit and counter-terrorist equipment the film

crew could use. Eran and I had done business in the past, selling stuff into the Middle East, and he trusted me, and me him.

The opening scene was shot at the front of his estate. I had never met Danny before so I suggested an opening scene where he would be driven up Eran's long winding drive to the big house, where I would be there to meet him, and then we would move over to a weapon and equipment display and show him the tools of my trade. He didn't know what to expect. That was part of the programme's MO.

'Let's ambush him first thing as he gets out of the car?' I suggested. Sue the director was all up for this but she was concerned about the health and safety aspect, so I put her mind at rest and confirmed we would only be using blank ammunition ha-ha, but live smoke grenades and flash bangs. Did she really think I would use live rounds!

On the morning of Danny's arrival, I carried out a quick walk-through-talk-through of the ambush drill. Eran's staff were all ex-military, so after a quick rehearsal they all knew exactly what I wanted to achieve, so we went for a dry run at full pace. Danny's car would pull up. I would walk over to greet him. Danny's car would drive off, then shots would be fired from a van which would be parked off to a flank, and then it would drive up where terrorists/hitmen would open up on Danny and me with machine guns. I would grab Danny, throw him to the ground in an effort to protect him, then, a big BMW would screech up alongside, blocking the van and I would bundle him into the back of it and speed off. Result, Danny's life saved.

It took me less than twenty minutes to figure out the complete scenario and after a two-minute dry rehearsal, we were ready. Sue had a difficult time as she had two cameras to site and apparently it takes an age for the camera team to agree on what camera should go where, but Sue didn't have the luxury of time, she had to make her decisions on the hoof, and off we went. When the call of *Action* came, it happened fast and furious and very noisy. It was all over in seven seconds from the first shot being fired, and, it confused the bollocks out of Danny. So professionally executed thanks to Eran and his staff. Danny was really impressed and so was Sue.

'That scene would have taken a film crew all day to set up, quite possibly two. Sue said after ''

And that set the standard for the rest of the filming. The episode was very well received and is still being shown on TV today.

Some months later, I had to pop across to see Eran about a problem with one of our ongoing Kuwaiti contracts, and when the meeting finished, he asked if I could help him shift some antiques.

'I have some objets d'art I need to sell,' he said.

'Objets d'art,' I muttered. 'Nice.'

Eran has an impressive antique collection, mainly military but some Queen Anne and Georgian furniture too, and he knew I've always had a keen interest in antiques and thought it would be a change from the norm. I was rather more interested in seeing his collection than in the offer of paid work. I agreed to help out.

Eran shared the manor house with his wife Linda. It has an east wing and a west wing. He put me up in the west wing, which was decorated to a five-star standard. An anteroom led you to a lounge, then through into a beautifully spacious bedroom with a kitchen and an en-suite. The view from the lounge looked out over the courtyard where I set up the Danny Dyer ambush and over a stunning four-acre lake full of carp and pike. It was quintessentially English. He was a lucky guy.

The antiques were secured in one of his warehouses. They were taking up a lot of space which he needed back for some other project, so the antiques had to go. When I pulled open the warehouse doors, I was amazed, I could see many wooden crates of different shapes and sizes all stacked up on top of one another. I counted about fifty but I could see many more tucked away down the back. They contained stone sculptures, wooden carvings and bronze castings from all over Thailand, and it was probably the largest collection of its kind in the country at the time. Someone already had a go at opening a few of the easier crates to get at, as a massive Buddha carved out of a soft stone, looked like sandstone, was sitting cross-legged and peaceful at

the collections entrance; it must have weighed half a ton at least!

'Hardly objet d'art, this one,' I said, pointing to Mr Buddha.

'No, I guess not but there are some smalls in and amongst this lot, or so I've been led to believe.'

'Where did you get them from?'

'They came into the country twenty years ago. I've had them stored in here for years,' he replied.

The previous owner owed Eran money for seven years of storage, but as he hadn't paid, Eran went to Court and obtained the legal right to sell the pieces. Even I could see the seated Buddha wasn't particularly old, not antique, by that I mean it had no visible patina, no signs of use and no obvious exposure to the elements. I suspected this was a modern consignment and not five hundred or a thousand years old, as the story had been told to Eran, but Eran knew that anyway.

The task of sorting out would take weeks so Eran's business partner, an ex-Royal Engineer and jovial Mancunian by the name of Jim Thorpe said he would lend a hand. The deal struck was this; Jim and I would do all the heavy lifting and get the objets d'art sold and Eran would finance what was needed to get the job done; we'd then split the profits three ways. Of course, there was a hook, there always is. No one works for free.

'Why should anyone go to such great lengths and expense to ship all these stone statues from the other side of the world? Where's the money in it?' I asked.

'Somewhere within these crates there's meant to be one or two pieces which are potentially worth millions.' Eran replied.

'How do you know?'

'Maybe, the previous owner was trying to conceal a real statue or two and hid them in this big consignment. Customs aren't going to check every single one of them now, are they?'

'Understood,' I said.

The plot thickened!

'I wouldn't have let them stay here rent-free for so long if I didn't believe there was a grain of truth in that, now, would I?'

'So, one box is going to make us all rich? Ah!' I replied.

And that was the hook. I wanted to trust Eran's judgement; after all he was a shrewd businessman, he'd built up a

multimillion-pound company through years of high risk and hard graft, and anyone outside the self-proclaimed political elite Establishment who can make even a crust from just one MOD contract deserves real respect. So, Jim and I went all-in and this time next year we'd all be millionaires!

For three days Jim and I fought the warehouse dust kicked up by the big diesel-fuelled forklift we used to shift crate after crate, while piles and piles of shredded Thai newspaper packaging, which had been stuffed into the crates so tight it last saw the light of day several years before the War on Terror, was strewn all across the warehouse floor, creating a chaos of confetti.

Every single one of these statues was indeed a work of art by itself, incredibly detailed and I could see their great appeal as garden features, or even in the case of the smaller ones as indoor ornaments, but they all looked very clean and new, 1990s new, new old stock, as they say in the trade. There were, however, a couple of old-looking statues carved from a different stone, still sandstone-like but with more of a yellow tinge, which Jim and I both agreed needed someone more qualified than just two old soldiers to offer up an opinion. We put them to one side. Several days later and for a hefty day rate, Jim arranged for an expert in Asian art to view part of our collection, so I loaded up twenty pieces and drove them across to one of Jim's warehouse in Derby because we really didn't know what we had, and if they turned out to be a dodgy consignment, we certainly didn't want to expose the whereabouts of the rest. Well, this chap turned up and was quite astounded to see just how many pieces we had, all neatly laid out in three straight lines as long as the warehouse. We had opened fifty crates at the last count and these twenty were what we deemed to be the best of them. He introduced himself as Hans from Holland, he was a late sixties tweed jacket chap, rather rotund with an unkempt, wispy mop of grey hair sporting a pair of thick-lensed spectacles which hung on a soiled leather strap from around his neck.

He started to march down the first line stopping at each statue, raising his milk bottle lenses into place only for a brief moment like an officer inspecting the troops. Jim and I had

spent all morning brushing off dust and shreds of newspaper ready to get them on parade.

'No,' he muttered to himself as he passed each one in turn.

Jim and I thought it best not to interject and ask, 'Why, no?' He reached the end of the first line, had a casual glance to see if he had missed anything, grunted, then shuffled across to the second line.

'No, he kept saying. Moving further along. 'No, no, no.'

There was an electric kettle perched on top of one of the crates so I filled it up with bottled water and flicked it on. 'Brew, anyone?'

Hans popped his head up and said cheerily, 'Oh, yes please. Coffee, black, three sugars,'

Nothing wrong with his hearing then!

'Tea, NATO standard,' Jim said.

When he had almost reached the end of the second line Hans started to hum softly to himself. He was stood by one of the yellow-tinged statues I had deliberately brought along, which was lying down on its back. It measured about two-foot long and half a foot in diameter. It was clearly a giant, bent penis.

'Uhmmm.' Again, he hummed.

'It's like a penis but bigger,' Jim shouted out. 'Is it real?'

'Yes. Early to mid-17th century.' Hans deliberated as he stroked the object. He continued, 'Nice texture, a nice piece.'

I could have been forgiven, but was old Hans getting sexually aroused!

'What's it worth?' enquired Jim.

I like Jim, there's no airs or graces about him, straight to the point, after all, it's all about the money. It has to be. We can all play the royal game of biggin' it up with all the pleasantries, but it always comes down to money.

'I wouldn't like to say.'

'Aren't we paying you to tell us?' I said, turning to Jim and looking for confirmation.

'Not strictly true,' Hans paused, 'I'm here to tell you if your statues are of any value,' he said in a non-stuffy tone. Jim and I closed in, and all three of us stood around looking down at the phallic stone.

'My dear friends,' he continued, 'I can tell you what is old and what is recently carved, what has value and what has not. There are many differences of opinion about what a statue is worth, but generally the older the statue, the more it is worth.'

'That makes sense,' Jim agreed.

'Well, I say that, but that's not quite true. Any statue has a worth, and you can generally tell the sculptor or the era when it was carved by the sculpture marks and tools used. It's easy to tell a stone carving from twenty years ago from one carved a thousand years ago.'

The kettle clicked off, so I went back and made the brews.

'Identifiers. Like fingerprints,' I said.

'Not as defined as fingerprints, more like footprints I would say, so we have to use someone like myself to give an educated judgement on a piece,' he replied, still looking down at the giant penis.

'An expert, like you?' Jim pushed it.

'Quite.' Hans replied.

'And there's a cost, no doubt?' I invited the obvious reply.

'Look upon it as clarification for a potential client. There are fifteen maybe twenty people in the entire world whose opinions are valid on pieces like these, and any one of their judgements can make the difference between a thousand dollars and ten million. It's that simple.'

Was he was sending Jim and me a message?

'So, if we have a piece you or your buddies could feel comfortable about putting your name to, then your percentage is?' I enquired.

He didn't rise to the bait. He continued, 'There is something called UNESCO. Have you heard of UNESCO?' He paused, waiting for a reply. Nothing. He continued. 'One does not come by such a collection without!'

Jim and I stood by like a couple of gullible tourists listening to the spiel of an old tour guide who knew all the strings of greed and emotion to pull to get that big tip.

'Yes, of course we have,' Jim replied.

Hans wasn't convinced.

'UNESCO is the United Nations Education, Scientific and Cultural Organisation. They are what their title says, and they

have a Red List of all looted antiques especially from all the world heritage sites, such as Thailand, which is where all the pieces I've seen come from, and if there are any in among this collection...' He paused and looked across at Jim. 'I take it you have more?

Jim nodded.

'Then, Gentlemen, I'm afraid I cannot be part of it.' Hans conceded.

It was clear Hans knew of the old smuggler's consignment trick too: ship a hundred well-nailed-up crates of modern but presentable statues to hide one or two very valuable ones in amongst them. Had we been sussed, and were the police about to come crashing through the door?

Jim sounded him out. 'Just say we had a stone statue which you say is worth a couple of million, but...' Jim paused, and looked across at me. 'But not on the UNESCO Red List. Would you know of a potential buyer?'

'I could place you with a potential client but it's about the provenance of said piece too,' Hans said guardedly.

Jim looked bemused.

'Proof of life,' I said.

'Proof of what temple it came out of, or who dug it up and when. Proof of ownership, proof of purchase, proof of customs and shipping documentation.'

'Oh,' Jim replied. 'That sounds all a bit complicated!'

Hans looked at Jim while cleaning some warehouse dust off his thick lenses with a silk handkerchief and continued his lesson, 'Well, before a client's going to part with two million dollars for a piece of rock, they will want to see documented evidence of what they are buying, correct? You may think it rather odd to pay two million dollars for a rock but the buyer needs to see the proof that it is a special rock. These collectors are not stupid!'

Hans paused for effect then continued, 'For example, and let us take a more recent example, if you had the head of Saddam Hussein, you know, from that statue the Americans pulled down in Baghdad.'

'You're saying if someone wanted to buy it, well, that head ain't going to come with a receipt, now, is it?' replied Jim.

'Precisely my point. Now, if you would please let me finish. If it were to ever come up for sale, at least you would know it is from that actual statue because there are hundreds of photographs of it. There is your proof and your provenance. Ownership debatable, but its very uniqueness makes it extremely desirable and in turn extremely valuable.'

'What's that gotta be worth then, Hans?' Jim said.

I walked across and handed Jim and Hans their brews.

'Thank you, Nigel.' He turned back to face Jim. 'What! Saddam's head?'

'Yeah,' said Jim.

Hans pondered for a bit, 'Fifty million US. Yes, I'm sure there is someone out there willing to pay that for it.'

Jim took a swig of tea. 'Fucking madness. Fifty million dollars for that. Fuck off!'

'Hans,' I said, 'if you're saying the head is worth fifty million, then what's the arse worth then? I mean, if the head's worth fifty million, the arse has to be worth something, right?'

With that Jim spewed out a mouthful of tea all over the giant penis.

'What! Whaddya mean, the arse?' Jim choked.

Hans looked just utterly perplexed.

'I've got his arse; I said, 'I've got the arse of Saddam. So, what's so funny?' I replied.

20. The Arse Auction

Jim and I spent several months shifting five or six statues at a time to one auction sale and then more to another. We had 133 to de-crate, catalogue and re-crate, then shift off to sale. We didn't want to flood the market so it took time, energy and money, all three of which were in short supply. I was disappointed we came across no million-dollar pieces, but I knew in my heart the previous owner surely would have got shot of them as soon as they arrived in the country. I was more disappointed for Eran.

Visiting all the auction houses got me thinking about the arse; in fact, the arse was never far from my thoughts. I've been in and around auctions most of my adult life. I enjoy the crack. Antique auctions, car auctions, heavy plant auctions, livestock auctions, I've been to them all and I know the games that can be played across these marketplaces. I can sense when an auctioneer is taking a bid off the wall, the highlyillegal practice of running a particular lot's value up past its reserve to an invisible bidder, and I can spot a ring taking place too. This is where a group of dealers get together and divvy up the lots they want even before the lots have come up. If one guy wants a particular lot then the others all agree not to bid on it, well, only up to the prior agreed figure, which would have been worked out in the ring. If he or she gets the lot at a cheap price, below the ring price, then after the sale and away from the auction, the buyer will split the cash difference with the ring. Now, that could be a couple of quid or much more, so the dealer who has the biggest buying power, the deepest pockets of cash, could arrive at an auction and take money off the ring and go home with a couple of hundred pounds basically for just turning up, especially if he or she didn't want to buy any stock that sale. It's a funny old game!

Other peculiar things happen at sales too. One time I was at a local farm auction of about eight hundred lots, which wereall laid out in a big field in several long, straight lines, items like

old ploughs, boxes of nuts and bolts, lawnmowers and rusty old bits from a bygone age. The auctioneer started off at Lot 1, not as obvious as you may think because I've seen auctioneers start a lot further up the line and then return to Lot 1. Why? Couldn't tell ya, but just a pointer for the future if you ever find yourself at an auction and an early lot takes your fancy. Anyway, this auctioneer did it correct and started at Lot 1 then moved off down the line. On average, auctioneers will get through between sixty and one hundred lots an hour, and with eight hundred lots to sell there were two auctioneers on, and the second auctioneer at this particular sale, started an hour after the first one.

Auctions generally finish on the high-value lots such as period pieces of furniture but this for auction it was vintage tractors. Anyway, there was this sad old-looking little Fergy Grey tractor. Now, the only way I can best describe a Ferguson Grey is to say it's the tractor equivalent of the Mini or the VW Beetle or the Model T Ford and it came in one colour only, grey. It was built at the end of the Second World War and production carried on for over ten years, during which time it sold in its hundreds of thousands all over the world. It was a great tractor and still is, I had one until I moved it on for a handsome profit, and for the collector who has limited space it is the ideal piece. It's so easy to maintain, that's why they can command such high prices for what is really a basic piece of mid-20th century engineering.

There just happened to be three at this sale and all three were side by side, the first two were in very good off farm condition and as the auctioneer made his way slowly down the lots, so the crowd built up around the first Fergy in the belief one of the punters was going to get a bargain—not! Bargains rarely happen at farm sales because local farmers like to outbid their neighbours in a show of wealth and bravado; an auctioneer's dream. The first Fergy sold for £1,000, the second made more and the hammer fell at £1,250. Nothing unusual about those prices, so as the crowd shuffled to surround the third and final Fergy, the auctioneer opened the bidding at a cheeky £1,000. No takers, obviously! He dropped to £800, no takers, he dropped it down again this time to £500 and silence, then a

punter standing right beside the auctioneer threw in an offer of £100. There was a grunt or two of derision, probably from the owner hiding among the crowd, and then the bidding picked up and gradually rose in £20 increments. Still, at only £400 the auctioneer was struggling to get any more interest. After all, £400 maximum was all it was worth as the engine had probably seized up from sitting outside for decades, its front tyres were deflated and rotten and the rears were just as bad, albeit the nearside one still held air, so it sat at a thirty-degree lean to the left, its bonnet askew, and at some time in the past it had been robbed of its starter motor, dynamo and steering wheel. It was a very sad-looking Fergy.

The auctioneer was going to sell it. Yes, it was going to be sold for £400; he tried his best shot at humour to encourage the crowd.

'Come on now, £400 for this little Fergy? It's a bargain, surely it must make more!'

The auctioneer's tongue-in-cheek line prompted a lone, desperate voice from the back to shout, 'Twenty.'

Then the under-bidder went to forty, thinking that would knock out the voice at the back. But no.

'Five hundred,' the voice at the back shouted.

The crowd gasped. What kind of a fool is this?

And that killed the bidding. A jump of £60 plus a five per cent commission plus VAT, took out anyone else thinking of having a punt.

'That's more like it.' The auctioneer applauded, and without hesitation he slapped his gavel-cum-walking stick on the side of the Fergy's bonnet, making a single solid, metallic clunk. 'Sold.'

The auctioneer strained to look across the crowd in the direction of the bidder.

'Thank you, madam. Number, please?'

The new owner held up her bidding number and the auctioneer's assistant made a note, so with all the excitement over, the crowd followed the auctioneer like sheep on to the next lot.

As the auctioneer made his way slowly down the line of lots, I spotted the new owner of the Fergy; a smartly-dressed, middle-aged lady in tweed inspecting her latest acquisition,

then overheard a gruff old farmer say, 'There's no such thing as a cheap lot if you haven't viewed it, my dear.'

'Oh, I know,' replied the smartly-dressed, middle-aged lady in tweed.

'Far too much money, you paid. Far too much.' Said the gruff old farmer shaking his head and self-satisfied in his misguided belief that all things only have a financial value.

'My grandfather taught me to drive on this very same tractor when I was young. This little Fergy is priceless to me,' then the lady walked off towards the porta cabin to pay, followed by, and I'm guessing here, her daughter, two granddaughters and a sprightly Jack Russell.

The saying, there's no such thing as a cheap lot at an auction if you haven't viewed it, is generally about right, and when they say, there's no cheap tractor lot if all the tyres are shot, well, that's also true because a full set of even the cheapest tyres for a Fergy will set you back several hundred pounds. But, there's also a lesson to be learnt here, it's not only the condition provenance and uniqueness which give a thing its perceived value; there's also an unquantifiable but very powerful bidders emotion too called nostalgia, which will always push the price up past the market's worth.

I had got to know Jim really well over the past months so I suggested I'd like to try and sell the arse to raise money for military charities. He thought it was a noble idea and said he would help in any way he could, so I called up an old friend of mine, Barry McKay, ex-Scots Guards, ex-policeman, who I knew was involved in raising money for the RCDM (Royal Centre for Defence Medicine) up at Birmingham. A tall, gracious man with a great sense of humour and a splendid after-dinner speaking too, and, like me and Jim, he comes with an inbuilt honesty and a sense of honour and duty.

Barry was more than happy to help me in my quest and offered to arrange a visit to the RCDM to get a feel what his charity was all about, and to meet with the major in charge of the wounded soldiers' welfare unit. Now, I defy any ex-serviceman, or woman or indeed anyone, to visit a similar ward in whatever country and not want to help. You could virtually

feel the dedication of the staff and the desire of everyone involved to do their bit to aid the wounded soldiers. It's so true, the phrase, they gave their lives today for our tomorrows, and I know there are still an enormous amount of people who understand this, but my concern as we move forward is the respect for our freedom and what it has cost, will be diluted and this should never be allowed to happen—sorry, I digress.

The hospital housed the best medical team in Europe and every wounded soldier was afforded the very best care possible, however, astonishingly, at the time there was no budget to help immediate families to stay in Birmingham while their son, daughter, brother, sister, mother, father, wife, husband or whoever was on the critical list, and there were many such patients, indeed, far more than I was aware of and from what the media put out!

The charity Barry sponsored was operated by the British Army and not a single penny went on salaries or staff expenses, and this alone was the most salient point as far as I was concerned. Like Jim, I was brought up on a council estate, Jim in Manchester and me in South London, and I appreciated that when I was in the army, if I'd been injured and shifted to the other side of the country my parents would have found it very difficult to find the visiting cash for travelling, to pay for hotels and to take on the nose, loss of earnings too.

And here's a crazy thing, Barry outlined to me and Jim if a soldier gets injured and his or her injuries are so bad, they have to get flown back to Birmingham (that decision, of course, is made almost immediately on the ground), they will get airlifted out, for example, from their FOB (Forward Operating Base) and flown home, and as in the case of Afghanistan, possibly via Camp Bastion first. And because of operational reasons, none of their personal kit could travel with them. It's all left in the FOB for their mates to look after.

When the injured soldier arrived at Birmingham there was no easy system available to purchase small items for them, like a book or guitar or a mobile. Sure, there was an army system but it was too stuffed with form-filling, too bureaucratic, so Barry's charity came up with a solution to charge up a Visa card with his donation money and sign it over to the duty officers,

who would then be in a position to make those immediatelocal purchases for the soldier. All purchases would be itemised as, in standing with Army Queen's Regulations. This was the very cause I could empathise with, cutting through reams of red tape and delivering soldiers' requests within hours, not days. What a great cause to donate some of the arse money to.

As Jim put it: 'In order to understand the overall strategy that Nigel proposed, it is necessary to appreciate some other aspects that relate to injured soldiers. In the first instance, the word 'injury' should be accepted to mean both physical and psychological injuries. Nigel was in 2 Para during the Falklands War and had kept up to date with some of the statistics relating to the ex-vets who had been involved in that conflict. These stats make very bad reading, as the incidence of suicide is many times higher in this category than in any other known category; in fact, it is alarming. Nigel recognised that immediate help was available for injured soldiers, but long-term help for those suffering from what was glibly known as 'combat stress' was negligible. Nor was there (at this time) any adequate long-term help for servicemen who were permanently incapacitated.

As was explained to me by the major in charge of the medical team at the RSDM, 'As an example, imagine a very fit young man leading an active life who is seriously injured and loses the use of his legs. It would mean a complete and irrevocable change in his lifestyle. His natural courage would carry him forward for a time but eventually, his restricted environment would start to encroach on his mental state and in many cases, this could lead to alcoholism or even suicide. Once such a person is discharged from the forces, there is very little support he can draw on.

Things have improved tenfold with the many military charities now dedicated to specific areas of injury like combat stress, but it is still too early to see how all the good these charities have done and will do in the future will work out for the long-term injured. As stated, Nigel recognised this and wanted to help remedy what he believed was a partially solvable problem.

Nigel is a fanatical patriot. If you were to cut his head off, I have no doubt you would see 'UNITED KINGDOM' scrolled

around on the inside of his neck in the same way as a stick of rock carries the 'Blackpool' banner. I suppose you have to be either ultra-patriotic or insane to spend the best years of your life in the Paras and SAS, and Nigel is anything but insane. This patriotism is the fuel that drives him forward and motivated him to risk his life for his country. It is the same fervour that made him want to help ex-vets who are suffering as a result of putting their country first.

It should also be noted that before Nigel does anything of significance, he analyses it inside and out and always looks at the long-term consequences and how it may impact on other aspects of the scenario. He decided that in this case, there was a requirement for a long-term commitment. As he once explained to me, 'As long as body bags are being shipped back from Afghanistan or Iraq and the media is picking up on the story, help will be available. However, once the casualty rate decreases to an extent where it is no longer newsworthy, or once we are no longer involved in active combat, these people may well be completely forgotten. If I could go some way towards helping this situation, then I had to.'

Would the arse have appeal? The only way to find out wouldbe to test the market. The arse now lay in my new shed still resting up amongst the pots and tins of paint, but this time I'd put it in one of those extra-large, ridiculously strong black Cordura bags which the SAS use to stuff all their body armour and heavy equipment in. I decided to have a real good look at the arse.On pulling it out, it still hadn't lost any of its sharpness or attitude. Several times it got snagged on the bag's inner protective layer before it finally released its grip and I managed to pull it out and view it, in all its glory. From an artistic perspective, the inner surface looked just as good as the outer. It had a really crude, deformed inner skin, grey in colour with a hint ofeffervescence about it, which only added to its artistic appeal.

To sell a piece like this, one had to find a suitable auction house. It's not as simple as just putting it in the weekly local general sale, it had to go in decent sale, one that commands attention and has a history of selling objets d'art along the same lines as the arse. Jim knew one of the BBC's antique specialists,

who by coincidence had an auction house in the Derby area. It was Charles Hanson, who is a star on such programmes as the BBC's Bargain Hunt and Antiques Road Trip. Charles is a jovial and likable chap and when I asked him if he had a track record in selling unusual items, he said yes because of his TV fame, 'Folk do come to him with all sorts of oddments,'

One of the oddest items to land in his lap recently was a pair of Queen Victoria's underpants.

'They had a forty-five-inch waist and made several thousand pounds' Charles slightly boasted.

He said the sale attracted several telephone bidders from across the world, including America and Australia. Although his wasn't one of the bigger auction houses, I felt we should at least give Charles a try-out. I did put in a call to all four of the big London auction houses, and one of them was very helpful but needed more information, and they work on a three to six-month catalogue but I felt I needed to get the arse to market as soon as possible.

A date for the sale was set and Charles suggested we put an inviting, come-and-buy-me £25,000 reserve on it. Jim was happy but I wanted a second opinion, so after a few calls, my friend Duncan Raban, called his friend, a dealer over in Dubai, suggested £25K was far too low and if he had the pleasure of selling the arse, he would start off at £40K minimum, and that it should fly to at least £250K. With this in mind, and using the old SAS demolitions formula of P for plenty, not G for greedy I readjusted the reserve to £250K and I don't think I was being greedy at that. Charles didn't seem to mind, and that worried me slightly; after all, wasn't he the expert! But I guessed he and his auction house was getting the publicity even if the arse sold or not.

Weeks before the auction I did several TV and radio interviews. It seemed the arse was attracting worldwide appeal. I was getting calls from across the planet. I spoke to media as far off as Australia, Russia, Spain, Germany and America. They all wanted a piece of the arse! And I realised the more publicity that came, the greater the potential of the arse making the six-figure estimate. It was an exciting time knowing the bronze had attracted so much worldwide attention, and I was grateful for

that, and all the networks wished me good luck with the sale. One media organisation urged the arse to hit one million pounds.

The day of the auction arrived. There was no internet set up but six lines had been booked by telephone bidders and when the bronze arse came up there was total silence. Charles, like all good auctioneers, gave those few extra seconds break between the last lot and a big lot coming up. The tension mounted. There were people hanging outside in the hallway and the saleroom was full to bursting with no standing room left.

'Lot 233,' Charles announced.

The crowd went silent.

'The left buttock of Saddam Hussein. In bronze, from that most famous of all statues. You know all about it, you've seen and read about it in all the newspapers,' Charles gave a pause before he threw to the floor a starting price. 'What shall we say, £50,000?'

Only silence; not a mumble.

'Come on now, you've all had a chance to view it.'

Laughter, followed again by Charles.

'Fifty thousand pounds. Who'll open at fifty thousand pounds?'

Silence. It appeared more folk had come here to view the bronze than to bid on it, and that was OK, it's quite normal. Bidders on big-end, rare items are cautious, especially if they are dealers and they know of other dealers in the room who trade in similar genres; they don't want to give away their hand too early, so looking disinterested and trying to keep a low profile would be their MO. I've seen it many times before. It's a game, and many dealers know just how much another has to spend; they know the budgets their competitors operate within. Sometimes a big dealer cannot or doesn't want to attend but will bid anonymously, so they put in a sleeper to bid on their behalf who the auctioneer won't know. Other dealers may make an unholy alliance with a competitor just to throw off the auctioneer, after all, a lot of auctioneers are estate agents and can be sly buggers too, if you know what I mean. Like I say, it's a game.

The familiar auction house silence was broken by a man standing at the back.

'Ten,' he shouted out.

'Thank you, sir, ten thousand pounds, do I hear eleven?' Charles had started the game off. A £10,000 opening bid was really great. No! It was a fantastic opening bid.

One of Charles' staff, who was holding a mobile, raised her hand.

'Eleven thousand, thank you, madam.'

Then the under-bidder came back. Twelve, thirteen, fourteen, the bidding was frantic and Charles was having no trouble meeting £1,000 increments, but it started to slow down at £19,000, which I took to mean that dealer tactics were now coming into play on the part of those who were really interested, but it only went up a further couple of thousand pounds, stopping at £23,500.

'No, sorry, can't sell it for that,' and, that was last thing I heard Charles say before he quickly moved on to the next lot.

All those weeks of build-up, all that excitement and all over in a few minutes. Was it an anti-climax? No, I felt quite the opposite.

Jim chose not to come into the saleroom as he was too apprehensive and preferred to stay outside, waiting for the result puffing away on cigarettes. I spotted him over in the car park and couldn't tell whether he had heard the result or not; if he had, his face wasn't showing any signs of anguish or disappointment. Either way, I assumed Jim would be disappointed, but he wasn't. Jim saw the positive side of it all, he's like me, his glass is always half full, never half empty. I wasn't disappointed either, in fact, I was relieved it didn't sell because I now knew it was worth much, much more.

The auction house started to empty. The arse was the main lot and since all the fun was over it was time for the punters and onlookers to go home. The BBC wanted an interview so I held it in the car park, and when that finished this Asian gentleman came towards me. He knew who I was because he was heading straight for me with purpose, in a kind of aggressive way I didn't care for much. I took a deep breath and tensed up. As all news networks do when they've finished with you, got whatthey

want, they disappear rapidly, on to find their next victim, and if you're lucky you may get a shake of the hand and a thank-you, but don't bank on it, so I was pleased to see the BBC were out of earshot by the time this chap made it to me.

'Mr Niggle?' the Asian chap called out as he approached. His rather clipped English told me he was from out of the country. Not British-born.

'Yes, that is me,' I replied in a monosyllabic tone. I sensed no offer of a handshake was forthcoming, so I didn't make the first move; my hands stayed down.

'I give £25,000,' he said.

I shifted a little. I knew what he meant, so I wasn't going to be rude and ask what for. I looked around for Jim, but he had been ambushed by the BBC.

'Yes, that was you reserve. I know, I ask auction.'

'That was the auction house reserve,' I confirmed, 'but I'm looking for £250,000.'

'I am from China. Wait.'

The mention of £250,000 didn't seem to faze him at all. Maybe he misheard me, no, I doubt it, these Chinese are smart cookies. The Chinaman hit the redial on his mobile. He spoke for less than ten seconds and hung up.

'Ninety thousand pounds.'

I wasn't sure exactly how much he was offering. I couldn't quite understand what he had just said. I was sure he was acting as an agent and had called his client, who was possibly in China, but who knows? I looked to see if Jim had finished, he hadn't, it would have been nice to have his opinion, so I made a command decision. I took a deep breath, 'That's a very generous offer, sir, but it has to be a quarter.'

The Chinese fella shook his head. 'No,' he replied.

I offered my hand and he took it then off he went. Now, I was thinking that offer was OK; it gave me more information on how the market was reacting to the arse. I'm not a greedy man but I knew this bronze was utterly unique, and if rich Russians and Chinese were paying absolute millions for what most normal-thinking folk see as crap-art because some art snob somewhere said it deserved to command such a value, then something as tangible and as aggressive and as powerful a piece as the arse

unquestionably is... well, it surely had to be up there with the crap-art too.

Two interesting quotes I like: The 20th century sculptor Constantin Brâncuși once wrote, 'Simplicity is not an object in art but one achieves simplicity despite one's self by entering into the sense of things.'

Yeah, me too, ha-ha! But I think Andy Warhol summed it up a bit better for me when he said, 'Don't think about making art, just get it done. Let everyone else decide if it's good or bad, whether they love it or hate it. While they are deciding, make even more art.'

After the sale I decided not to take the arse back with me to Herefordshire but to leave it in one of Jim's secure warehouses up in Derby until we planned our next step. Jim tucked it away in a safe place, locked it up, and left it all on its lonesome.

21. One of Our Arse's are Missing

Sometimes there is just no reason why things happen as they do. No logical explanation. Perhaps a butterfly's wing flapping across the other side of the world prompted Brigadier Abdul to call me up and tell me the arse was being talked about on Kuwait's equivalent of Good Morning Britain or Fox & Friends America, and the networks were holding up a page of the Kuwait Times showing a picture of me and the arse. He said most of the Arabic newspapers across the Gulf region carried the story, and asked if the figure of £250K was true.

'Yes, it is, why?' I joked.

'Good, so what's my cut, my friend?' he replied.

To understand his question, again, one has to understand the Arab. Most I know live for a commission, even if they are only involved on the periphery of a deal. They expect. They ask with hand held out. They aren't embarrassed in doing so either.

'Nothing, why?'

'Well, I can help you.'

'What can you do?'

'I have a contact in Jordan and he knows Saddam's eldest daughter, Raghad.'

'What!' I exclaimed.

'You must understand the culture, it's her father's butt and she would buy it out of respect.'

'Like the sandal thing,' I said.

'Throwing your sandal is an insult. No, she will buy it to STOP her father being insulted. Before someone throws a sandal at it.'

I laughed, yet the brigadier was serious.

'Look, thanks for the Kuwait Times info but let's see how things pan out over here first, but test your contact in Jordan anyway.'

I hadn't got my breath back from the auction and people were holding their hands out, but if the brigadier could get a price from Raghad, then I wasn't going to rule anything out. And then

the situation changed almost as soon as the news of the arse hit the Gulf dailies. I got a call from a number withheld. Boring.

'Hello, is that Nigel Ely?'

'Yes,' I said. I just couldn't be bothered asking who it was as I very rarely pick up on numbers withheld and haven't had my voice mail activated for years now, as I believe if a caller has something important, they will text or email, if not, it's going to be tele sales, so I added, 'Send', which is army radio procedure when one's not interested in who's calling.

'This is Sergeant Sergeant from Derby police station at St Mary's Wharf.' [Police HQ for the entire county of Derbyshire]. The voice continued, 'Would you be able to attend an informal meeting with myself regarding the Saddam bronze buttock at Derby police station at St Mary's Wharf?'

The voice spoke in a continuous blurb.

'Hold it, slow down Sergeant Sergeant?'

'Yes,' Sergeant Sergeant replied, as if ignoring me and not wanting to expand the irony.

'Why Sergeant?' I paused. 'Sergeant.'

'Because we have received an enquiry about the bronze piece of Saddam and I'm the sergeant assigned to the case.'

'Case, enquiry! Is this some kind of joke? You're not serious, Sergeant, are you? Sergeant!'

'I'm very serious.'

He finished by saying all would be explained when Jim and I presented ourselves to him. I found use of his word presented, very odd indeed. I didn't know one could present oneself to a police station. It all sounded rather gentlemanly and oh so British. I called Big Barry McKay and asked him what I should do. He said if it's only an informal meeting then Jim and I should attend so as not to antagonise, and it would show willing and not guilt.

'Guilt of what?'

'Go find out, it can't be anything serious,' he replied.

I trusted Barry's judgement and he was right, I had nothing to hide and was guilty of nothing, so a few days later I hauled myself back up to Derby.

Jim and I walked side by side up the steps to the doors of Derbyshire Police HQ, St Mary's Wharf, Derby. What intrigued

me more than anything else was why we had been invited to attend an informal meeting. As you can imagine, I've been around a bit and I've spent a lot time in and out of police stations, but on the right side of the law, and, I will add, Jim and I are of a generation past who believed in the police, who have full respect for the police. Yes, I know, it sounds a bit fingers down the throat, but this is what we believed in, it's the way both Jim and I had been brought up, to respect law and order, and I have several friends who are cops, so I had nothing to hide and nothing to prove. I went in as law- abiding member of the public—innocent until proven guilty.

'You know they can hear everything you say as soon as you enter!' Jim nonchalantly remarked.

'Yep,' I replied.

'They have directional mics.'

'Yep.'

'You recording this interview?'

Without turning to Jim, I replied, 'Yep, and please don't waffle on, will ya, mate?'

Jim's a salesman and a very good one, and I know he has a tendency to sweet-talk and sweet-talking wasn't what was required at this early stage of the proceedings. The object of our attendance today was to gain information, not give it.

'OK, and I promise I won't keep saying Sergeant Sergeant,' he laughed, then we entered.

Sergeant Sergeant was a short, dumpy fella, much shorter and dumpier than I had imagined a member of Her Majesty's Police should be allowed to be; only on the grounds of a health and safety and fitness aspect, you understand, but then again, I'd better watch myself for fear of getting arrested under a sizeist, fattist charge. He was young-looking, too young for a sergeant. Is that ageist? I apologise if it is. I tried very hard not to let my first impression cloud the reason why he was grateful we were both attending his interview.

'We have received information about the bronze buttock of Saddam Hussein which you tried to sell at Charles Hanson's auction house is stolen, and you should surrender it to me whereupon it will be returned to its rightful owner.'

'And who do you consider is the rightful owner?' I enquired.

'The complaint has come via the Iraqi Embassy in London.'

Jim interjected. 'Do you have a name, an individual, Sergeant? Or are you saying the Iraqi government in its entirety has made the request?'

Sergeant Sergeant looked stumped. He appeared not to have a clue where the complaint had originated from, that was obvious because his face flushed an irksome red. Sergeant Sergeant was probably just following orders to supply the arse. In that brief interview my belief in the police system took a battering. I know it sounds naïve, but was I hearing it right; no proof, no evidence, and he wanted me to hand over the bronze, shake hands and walk away?

He threw in a desperate plea. 'Bring me the arse of Saddam.' Was he fucking crazy?

'You are aware I'm trying to sell it to raise money to help our wounded servicemen and women? You do know that, right?'

He stayed quiet. I then made it very clear I didn't trust the police and I wasn't going to bend to political pressure. Jim interrupted, which was just as well as I was getting agitated, and asked if, hypothetically, if we did surrender the arse, what redress would we have in getting it back from the police if this claim had no foundation, but all the sergeant could muster was, we could take out a civil action. Really! Take out a civil action against who? And with no arse, as for sure, the arse would have been stashed in a diplomatic bag and whipped out of the country on the first available RAF C17 Globemaster heading east or on Iraqi Airways. Possession being nine tenths of the law, right!

I finished off with, 'What a load of shite.'

Forty minutes later, Jim and I walked out of St Mary's Wharf police station.

'I thought you said you wouldn't say anything,' Jim said.

'Well, he was taking the piss and I was trying to get him to give me a name but he didn't, which makes me think they're jumping to the tune of some higher authority. Something ain't right here Jim.'

As soon as we were out of the earshot of Plod, Jim immediately put in a call to his close friend Chris, a local solicitor, and took counsel.

As the saga progressed, Sergeant Sergeant wrote to our solicitor denying he had ever made the statement about civil action and said he may have mentioned something along the lines if we had freely surrendered the arse to him without any encumbrance, he would have returned it to the Iraqis. Luckily, I have taped evidence to the contrary and this becomes extremely significant and would form part of our defence if the arse ever resulted in a Court appearance. I returned to Hereford so angry, so defiant, because of an absurd accusation made by a nameless Iraqi (allegedly).

I do like the world of Facebook and Twitter because you can fart on Facebook in Derby and it can be instantly smelt in Baghdad, and I just had this feeling on the long trek home my bronze arse wasn't going to go quietly, that I was sure about! Later, Jim called me asking if I could I get back up to Derby because the BBC and Russian TV wanted to interview me about the arse.

'Why did they call you?' I asked, surprised. I would have liked to have vetted these interested parties before agreeing to any interviews as I didn't want Plod turning up masquerading as Russians!

They didn't call me, they called my office,' Jim replied.

Charles Hanson was still receiving calls from the media chasing up on the arse story, but since he was finished with the arse, he told them to contact Jim's office, which made perfect sense.

The following morning, I got up early and drove to Derby. Jim had arranged two interviews, one at ten in the morning with the BBC, and a four o'clock slot for Russian TV. Jim said they both wanted to do a what next for the arse piece-to-camera. It would be great publicity to keep the arse out there in the media. Any publicity was good publicity, right!

I had just entered the outskirts of Derby and wasn't more than a mile from the office when Jim called up in a bit of panic.

'Where are you?' he said anxiously.

'About a mile out, why?'

Jim's wife had just called him saying Sergeant Sergeant from St Mary's Wharf had just pitched up at his house and asked of his whereabouts, so she told them he was at the office, 'Where else would he be?' she replied. His missus had grassed Jim up to Plod and they were now on their way to his office, which was where the warehouses were and where the arse was resting up.

She laughingly asked, 'Have I grassed you up to the fuzz, darling, and shall I bake you a cake with a file in it? They were ever so polite and you'll sort it out, won't you, love?' She replied.

Jim explained where she should stick her cake and asked why she hadn't called him immediately after their visit, as he needed some time to rearrange the BBC interview because if he was going to be arrested, he wanted it filmed.

My concern was the security of the arse and not Jim's possible arrest.

Jim continued, 'Stop worrying. They won't find the arse and you have to hold off until it's safe, no point in both of us getting lifted.'

I agreed and went to find a Greasy Joe's.

Unfortunately, the BBC crew got stuck in traffic on the A52 and were running late, but in the meantime, waiting for the arrival of Plod, Jim asked Nicola, his daughter who also worked in the office, to let the BBC know Plod were en-route to the office, and if they wanted an exclusive then they had better come quick. Jim was planning to keep the police entertained for as long as possible and to record the forthcoming event. He would put the telephone in the main office on speaker so Nicola would be able to keep tabs on the situation, and in the event the BBC people were near enough, she could let Jim know so that, if necessary, he could think of a way to stall a little longer.

A police car screeched into the rear car park of Jim's office and warehouse complex, and two coppers got out.

'Eyup, it's the police,' a police constable announced rather loudly to whoever, as he ran towards the main warehouse door as its roller shutters were quickly closing. Sergeant Sergeant made a more graceful entrance. Jim appeared from a side door just as the shutters clunked tightly shut. Things might have gone differently if Jim had returned the sergeant's Masonic handshake but he was too busy trying to think of stalling tactics.

All the same, he invited them to hold court inside the warehouse rather than discuss whatever business the police wanted to discuss out in public.

The two coppers were, Sergeant Sergeant and a police constable, and no Black Maria parked up around the corner ready to deploy ten heavies. The sergeant immediately eyed the warehouse, taking in the mass of racking filled with boxes but totally unaware that anything you say may be taken down and used in evidence against you was being broadcast upstairs in the main office. Jim sensed their inquisitiveness.

'You have a warrant?'

'No. Not at the moment. I'm just chasing up some enquiries,' Sergeant Sergeant replied.

I've said this before, and both Jim and I have a great deal of time for the police but sometimes they really do lack imagination, and I think Jim best describes the sergeant's demeanour by quoting a bit of Shakespeare:

But man, proud man,
Dress'd in a little brief authority,
Most ignorant of what he's most assur'd—
His glassy essence – like an angry ape
Plays such fantastic tricks with high heaven
As makes the angels weep...

... and the sergeant didn't disappoint, so with stomach held in and at full stretch, which was about five-foot bugger all and referred to by his own men and women as the dwarf from the wharf', quoted from an old episode of The Sweeney: 'We can do this the easy way or the hard way.'

Now this may sound intimidating if you consider Jim is an old-age pensioner, but in reality, Jim was OK with it; however, it would have been very menacing to most.

The constable, on the other hand, seemed a really nice chap and looked embarrassed about the entire affair, and quite frankly, Jim said he was more than confident he could have tied one hand behind his back and laid Sergeant Sergeant out in a second with his other. But the end result was, it was done the hard way, and Sergeant Sergeant made the arrest on Jim,

quoting a charge of, withholding stolen property with regards to an alleged stolen piece of bronze in the shape of an arse from a far-off land.

Whilst Jim was being read his rights, Nicola was covertly trying to get his attention via the pre-rehearsed arm-waves and nods of the head to indicate the BBC were still some way off. Jim saw his daughter making the wild and crazy movements and thought if the sergeant saw this, then she too would be led away by but folks in white coats. Jim stalled for more time; he needed the BBC crew rolling their camera right now.

'Sergeant, may I have a request?'

'No, you may not,' replied Sergeant Sergeant, eager to haul this slag off to the nick.

'Please, Sergeant,' Jim pleaded. 'Just one last request. May I have a cigarette?'

Sergeant Sergeant looked Jim square in the eyes. 'You're not gonna piss me about now, are ya? Constable, grab his arm and let's go.'

The request for a last cigarette ate up a couple more vital seconds but time was not on Jim's side and he was led quietly away under escort into the back of the police car. No pomp and circumstance and the BBC with breaking news, no, just Nicola asking the sergeant if they would handcuff her dad so she could Facebook a photograph to all her friends, which he duly obliged. An arrest strictly by the book!

At the police station Jim was told they were applying for a search warrant on his home, and was then subjected to a humiliating search. He had all his personal belongings taken off him, phone, wallet, keys and laces, and then went for a spot of fingerprinting and DNA swabbing before being shuffled along a corridor and locked in a cell.

He was left in the cell for a couple of hours before being escorted to an interview room after a meeting with a solicitor whom Chris had recommended. The interview was a waste of time because Jim couldn't tell them anything they didn't already know. Then Sergeant Sergeant popped his head into the cell jangling Jim's keys and said, because he was applying for a search warrant to search his house, could Jim please identify

the relevant keys? For normal law-abiding citizens, can you imagine just how helpless Jim felt?

I'll keep on saying it again and again: we have to protect our freedoms in our great country and remember the State can lift any one of us and bang us up for thirty days without trial. Tony Blair and many MPs went about foaming at the mouth because they failed, and quite rightly in my opinion, to pass a law under the guise of counter-terrorism to bang us citizens, us little people, us normal people up for ninety days—yes, the warmonger, war criminal Blair wanted a ninety-day detention without any prima facie, but thank God many more MPs cut Blair off at the knees. It really bears no thinking about as it makes me shudder, and it should all you too, because this legislation may have been drafted for suspected terrorists but who can trust any government? Remember when half the Councils in the UK used the existing counterterrorist laws to spy on their own constituents for suspect wheelie bin crimes, for Heaven's sake! Yep, that's a fact, so why wouldn't the law use a similar MO, to bang up me and Jim, or indeed you, your wife, your son or daughter, your mother or father on any spurious charge, just because they can? Governments crave power, they extort our money through tax which gives them power over us, and don't they just love power. Why? Because we are easier to control when suppress, when slaving away to an early grave so they and their siblings can gorge to a ripe old age off the Trappings of State. Governments love confrontation too, that's why they love war. War makes them rich and also keeps the masses down. Nepotism, cronyism—way to go you Plebs.

Now, Jim's a dog owner, he loves dogs and suggested the police might like to take Nicola along with them because there was a great possibility his dog might decide to defend the property. Jim's dog, Kobe, is a Japanese Akita, weighs in at about 110 pounds, has inch-long incisors and his jaw pressure is about two thousand pounds per square inch. Akitas don't bark or even look aggressive, they just look like a big old nice bundle of fluffiness with sad eyes. Oh, you little doggy doggy, come here to Daddy and let me stroke you, you sad-looking big old ball of fluff! I'm sure Kobe would have allowed them to enter. Hello, doggy, my, my, you're a tame, nice doggy. Good

doggy, then ripped them to shreds! (Sadly, during the writing of this book Kobi passed away).

Jim had no problem with the police searching his home and would gladly have agreed to take them there free of charge, after all he was innocent, and what harm could it have done? However, the illustrious sergeant really did like to do things the hard way and he spent more taxpayer's money and police time in getting a search warrant. I asked Jim if the police ever mentioned what they were specifically looking for the arse.

'No, never mentioned it once,' he said. But it was obvious they were, and in hindsight Jim wished he'd never suggested Nicola going with them.

Sergeant Sergeant didn't find anything at Jim's house, so to justify the time, effort and cost of his operation so far, he wasn't quite finished; the day was still young, he had another search warrant in his back pocket. It makes one wonder why so much effort was being pumped into the pursuit of the arse. At this stage I assumed they were looking for the arse, unless Jim was operating some international underground ring which he hadn't told me about. But in defence of the police, Nicola did say she was encouraged by just how thoughtfully the search team carried out their duties, and how they behaved quite decently and didn't cause any mess, for which Jim's wife was most grateful, but that's not the point, is it? It's the intrusion of those size twelves cutting all about your castle on an arse mission, that's the point.

With nothing to show for their labours, they raced around to Jim's business premises, where the sergeant went on full attack against the contents of Jim's filing cabinets, while other members of his search team went looking around the main warehouse. They looked in about forty or fifty packages in the racking, then just left. Next door was another large warehouse, which was fully endorsed with Jim's livery and company logo, but they didn't even bother to search it. If they had, they would have found it contained fifty or so semi-precious antique statues from Thailand; many of them still in crates which provided the absolute ideal place to hide a bronze arse. The search team in the office were acting just as unprofessionally, and under the ever-observant sergeant, searched Jim's office in a fashion

more suited to children looking for the biscuit jar when Mummy and Daddy were out of the room.

They took away a lot of irrelevant documents including a picture Jim had downloaded from the internet months previous regarding a German who had imported the leg from the Saddam Firdos Square statue. Jim had shown it to me and I told him it wasn't from our statue. One only had to look at the leg to see it wasn't a match for the Firdos Square statue, but Jim kept it as a reminder that Saddam statue items were being sold legally and with no threat of the full weight of the law coming down on the seller.

Given all the effort and cost it takes to get a search warrant, I assumed these police officers and indeed the sergeant had passed the relevant search courses, because I've passed a couple in my time and was surprised when Jim told me Sergeant Sergeant Sherlock Holmes didn't even bother to look at the following crucial and educational papers, which would have provided potential evidence for whatever criminal case the police thought they were compiling. All of this would have been relevant, as I will now describe.

First, Sergeant Sergeant totally ignored a file clearly marked Proof of Authenticity for Saddam's Statue. Included in this file were the names of the various well-known correspondents who had hitched a lift back to Kuwait with me when I brought the arse out. It also included a lab report on a small piece of the arse Jim had paid to get scientifically tested to determine the molecular structure of the cast, so it could be used to verify or negate any further claim of pieces being presented. There was also the official receipt for the excess baggage I paid to British Airways when I brought the arse back to the UK.

Second, on Jim's computer there were several files headed Artefacts from Iraq. What you have to understand about Jim is this: he's very through, so of course he looks for similar genres and information pertaining to items similar to the arse. Some of these files referred to several items which had been shown to Jim by Jordanian business contacts who had asked Jim to act as their broker and completely separate from the arse project. They included pictures of a 2,400-year-old book and a bird made of solid gold encrusted with diamonds. The

accompanying correspondence included Jim's open request for the provenance and details of ownership. The correspondence confirmed the provenance could not be supplied, but the owners were powerful politicians in Iraq, so there would be no comeback if Jim could find buyers. Jim declined getting involved after making it clear the goods in question were obviously looted and it was illegal to sell them.

Of course, Jim and I aren't a couple of dull chaps, we knew this kind of trade goes on and we knew the very good reason why the UNESCO Red List existed, but the obvious ownership of the arse in question explains why it is not on the list.

Third, there were two files headed Saddam: Legal Status. They contained the correspondence from various barristers and legal experts we had accumulated since Jim and I took the arse out on its first venture. They included an exceptional article written by a prominent American attorney explaining why our case would not stand should it ever go to trial. One article referred to the fact both the British and US governments were refusing to return some thirty thousand official papers and files they had seized from Baghdad—an excellent precedent. Further, it explained how the statue belonged to the Ba'ath Separatist Party and not the State, and how this party was now classed as illegal by Allied Command, and who had deliberately instructed the troops to deride and condemn this party wherever possible. In other words, the arse belonged to a now illegal organisation when it was freely given to me by the USMC. As the USA and the UK were then recognised as joint occupiers of Iraq under the Security Council Resolution 1483 from May 2003, neither the CPS (Crown Prosecution Service) or the United States, treated statues of Saddam Hussein as cultural property, and if they had been cultural property, US involvement in the episode at Firdos Square and many others like it might have constituted violations of international humanitarian law. Why weren't the statues treated as cultural property? One argument is because they were powerful ideological symbols of the Ba'ath regime, different rules applied. Coalition Provisional Authority Order Number 1, De-Ba'athification of Iraqi Society, for example, expressly prohibited Displays in government buildings or public spaces of

the images or likeness of Saddam Hussein on the basis it was grave threat to Iraqi society, so another argument to plead our case is that even if the arse was cultural property, which I vehemently disagree with, removing symbols of Saddam Hussein was justified by military necessity in order to prevent any Ba'ath Party resurgence. This was done by British officials when they ruled Basrah. They publicly stated they allowed looting of the Ba'ath Party buildings, which housed important archives.

Also, whether Ba'ath Party documents should have been considered cultural property during the 2003 invasion could depend on a number of factors including whether Iraq was treating them as such; compare, for example, Ba'ath archives within the Iraqi National Archives with those in recently active government offices. Regardless of what the answer to that question was in 2003, however, if the UK government is now taking the position that statues of Saddam have ripened into cultural property, it raises similar questions for various collections of captured Iraqi documents. Have the forty-eight thousand boxes of documents seized by US forces in Iraq, for example, become, with the passage of time, archives constituting cultural property while sitting in a military warehouse somewhere in Qatar? And if so, have they now returned these forty-eight thousand boxes to Baghdad? This would be at least a part precedent.

Another article also confirmed the artist and former paratrooper Mark 'Jacko' Jackson, son of the famous British general who just happened to be my first officer commanding in 2 Para, General Mike Jackson, and, incidentally jailed me for twenty-eight days when I was a young paratrooper, and quite rightly so, had been commissioned by the Irish Guards to sculpt a large generic statue of an Irish Guardsman out of several bronze Saddam statues brought back by the troops from Iraq. The commission was completed and is on official display in Windsor High Street, within eyeshot of, Her Majesty Queen Elizabeth II's Winsor Castle, and, there are a dozen other reasons why I would end up keeping the piece of bronze arse.

While the police were doing a search-and-destroy mission on Jim's business life, I moved from the Greasy Joe's and ventured into the city centre where I pitched up at a great little boozer which serves a lovely pint of Burtons local beer, one of Derbyshire's finest ales, beautiful stuff, pure nectar, one might say. I'm a pub man and Derby city still has a few traditional ones as I discovered in the Silk Mill and Cider House. I was tempted by a pint of Burton's but stuck with orange juice as I knew it was going to be a long old day and if I was to meet the Russians, then I needed the vitamin C boost and to be on my best behaviour.

I called up Nicola, who said the police had left for the second time that day and asked if I was still on for the Russians. I said yes, then enquired about her father. She sounded quite matter-of-fact about the entire affair.

'It's quite fun seeing Dad led away,' she said cheekily.

In the meantime, Jim was getting the right hump and I was so glad to know our taxes were being spent on useless search warrants and poor old Jim's incarceration. He was locked in a cell twiddling his thumbs. He asked if there was anything to read and was given a choice from about thirty books, every single one written in either Polish, Hungarian or Romanian. Jim was a smoker without cigarettes, and had not eaten at all day. At some stage in the early afternoon, he was offered some food by an embarrassed officer.

'All the police were great, with the exception of the dwarf,' Jim said later.

The food was a choice of curry and rice or mashed potatoes and sludge. He opted for the curry but after one mouthful, left it. The food in question still had the price stamped on the pack as £1; he reckoned they were robbed and began theorising about this so-called food. He summed it up: 'For £1.50 you can get a tasty steak and kidney pie made from horse as per all those well documented news stories, but what can you get for £1?' He knew Derbyshire Police Force had recently dispensed with some of their police dogs and this could be one answer, but it's worth considering an alternative. There were plenty of books written in Eastern European languages, but no Eastern Europeans in the cells. They were obviously coming in but then disappearing. Where to? In the interest of cost efficiency, could

Eastern European migrants go missing without questions being asked, and be used to help feed the rest of the prison population? This may sound outlandish to anyone who has not had the pleasure of dealing with Derbyshire's finest criminal mind, but who knows!

I think Jim was theorising far too much because after hours of boredom and three interrogations, during which he was advised by his solicitor not to say anything (which was avirtual impossibility for a Mancunian like Jim who tells it like it is, and who, on this occasion, didn't hold back and told the police exactly what he thought of them). He was then interrogated one last time and again advised by his solicitor, but this time, if he had to say something, not to say too much, but Jim wasn't finished by a long way and kept on browbeating Sergeant Sergeant with sarcasm. So, Jim was eventually released after nine hours by a contorted-looking sergeant whose parting comment was, as if in a fit of desperation, 'Just give us any old piece of metal.'

'You really are as thick as the arse if you think that would resolve this problem,' Jim voiced back as he stepped out into freedom.

22. Resistance to an Arse Interrogation

I arrived at Jim's office in time to receive RT, Russian Television and led them to the boardroom. They were a friendly bunch Russians and were really quite excited to get straight on with the arse story. They saw this as an exclusive and were well chuffed the BBC hadn't beaten them to it. The boardroom was on the second floor, which overlooked the main street.

'You boys bring any KGB with you?' I asked to the Russians, peeking through the venetians.

'Sorry?' the Russian director said, a bit startled to hear the letters 'KGB'.

'KGB. Do they follow you guys around when filming in the UK?' I was joking with them, but then realised, Russians don't do irony.

'No, of course not.'

'Well, they must be our Plod.'

'What is Plod?'

'Police. Look for yourself,' I pushed the blinds to one side and deliberately rustled them so Plod could see we could see. 'Looks like you and me are both under surveillance,' I laughed.

'No, cannot be, let me look.'

I pointed to a silver car with two heavies in it. They were pretending to look away when they saw me, really quite amateurish, which upset me a tad because I wanted to believe our police were good at this stuff, no, not good, bloody fantastically invisible, but they weren't.

'Quick, get the camera over here,' said the Russian laughing, as he took shots of Plod.

A dozen questions, a quick piece to camera, the interview was all over and RT left with an exclusive.

I was still at the office when Jim returned from his period of incarceration. I knew Jim wanted a drink, he needed a drink and so did I, so he cracked open a bottle of whisky, poured two nips and took me through his nine-hour tale, and in between

triads of expletives, I briefed him on how the Russian interview went.

'I had to play it coy,' I said. 'The Russians were just setting up in the boardroom when I saw this vehicle turn off and drive into the office car park, do a U-turn, drive back out and park up on the opposite side of the main road facing your office. It was two-up with a couple of shifty-looking characters.'

I started to relay the story to Jim in a hope it would cheer him up, but he still persisted with a bulldog chewing a wasp grimace. Jim did try to cheer up but I knew it would take more than a bunch of Russians shooting footage of a Derbyshire Police surveillance team, even though the Russian scoop for TV would lead with the arse getting full exposure to compensate his nine hours loss of life.

Apart from being taken out for questioning, Jim had spent far too long in a police cell without adequate food or cigarettes and for no obvious reason. In the first instance, he had not broken any law other than to refuse to surrender something which should never have been asked for in the first place, and the most galling aspect of it all was, the smiling face on the man who deemed it necessary to arrange his incarceration. Did the sergeant think it was a game in which he was the star player? In reality, he was a bully who faced two choices: one, to stand up to the Iraqis and tell them they should take their own civil action if they wanted to pursue ownership, or two, to pick on a pensioner whom he thought he could browbeat into advancing his career. Jim wasn't a happy bear.

'What did you tell them? Why did they keep you locked up for so long?' I trying to calm him down.

'I told'em nothing, and that sergeant's a right fuckin' twat.'

'Well, you must have pissed him off about something. Nine hours, mate, ain't no joke.'

I've never forgotten my SAS resistance to interrogation training, an experience like that becomes ingrained in one's memory, and the first thing you get taught, is not to piss off your interrogators.

Jim continued, 'I worked the shit off him and told him he was a fat fucking twat and should be out dealing with all the scum and not beating up on some poor old pensioner.'

'That's it then, you played the pensioner card!'

As if on cue, my mobile rang showing unknown number.

'Send.'

'This is Sergeant Sergeant at St Mary's Wharf,' the voice said.

'OK,' I replied.

I frantically waved across at Jim, who was still chuntering to anyone who would listen. I needed him to be quiet.

'What time tomorrow? OK, got it,' I closed the phone. 'Your mate wants to arrest me by appointment, noon tomorrow,' I said.

'Arrest by appointment, has the world gone fucking mad?' Jim sighed as he held his head in his hands.

'A nice cup of tea, Dad?' Nicola suggested.

I interjected, 'Something to do with cost-cutting, the sergeant said. Pity, I would've loved to have been taken down and led away in cuffs.'

Jim was still cradling his head. 'Arrest by appointment, Jesus fuckin' Christ.'

The following morning at five to noon I met with my solicitor outside St Mary's Wharf police station. He was the same chap who represented Jim. I told him I was going to say nothing in the interview and he agreed it would be best for me, as yesterday's nine-hour epic attending to Jim had left him with a backlog of other casework.

'Let's see if we can get in and out of here in an hour,' he said hopefully.

'Sure,' I replied, knowing that would be pushing it.

'They won't keep you in after four anyway.'

'Why.'

Well, it's Friday, they'll need the cells. Drunks start filling them up then you see,' he winked.

I've already mentioned I've done a stretch in jail. I'm not mentioning this to show you I'm the man, the big daddyo, quite the contrary; I'm letting you know I'm a reformed character, and I suppose I get embarrassed about it, and I'm letting you know just how much I love my freedom, so I wasn't going to stay locked up for a minute longer than necessary.

I was serving in 2 Para when the Battalion was sent on a two-year posting to Northern Ireland at the height of what is called The Troubles. My company, B Company, was on a one-month guard duty in the relatively safe area of Ballykinler well overon the east coast, and apart from securing the Battalion Lines by making sure those who entered and exited the camp had the correct passes, and running the camp's jail, the Company's other duty was to supply from the lower ranks, such as myself (the privates or Toms as we were called in the Paras back then, or Joes in today's vocab, Joe Crow), waiters, skivvies and bottle-washers to the Officers and Sergeants messes, should either of them have an official function or an excuse for a piss-up.

Well, on my watch, both the officers and sergeants did have a piss-up; it was joint piss-up and was held in the Officers Mess. So along with four of my mates, I was detailed as a bottle-washer for the duration, as my sergeant deemed me not suitable to serve the ladies and gentlemen. He preferred to keep the riff-raff out in the back away from all the festivities, but unfortunately not away from the half-drunk glasses of wine, beer and whisky, constantly being whisked back into the kitchen on trays by more suited, more respectful B Company Toms for disposal down the sink. Hard, fit young men in a war zone sniffing free alcohol, well, much of it didn't make it down the sink, it was far too much of a temptation for me and my mate and we got absolutely hammered then went on a drunken rampage.

Being a member of the Parachute Regiment, the punishment was of course unambiguous, brutal and swift. I got twenty-eight days in the para nick. The CO, the Commanding Officer was actually being very lenient as he could quite easily have sent me for Court Martial then to Collie, the Military Corrective Training Centre (MCTC) at Colchester. And, if I have learned anything in my life, it is that twenty-eight days in para nick taught me I never, ever want to go back to jail ever, ever, ever again. It wasn't the constant early morning beastings across the assault course, or the constant polishing of my own personal Wombat shell, a three-foot-high brass shell casing which I had to take everywhere with me including the toilet, the scoff house and across the assault course, no, it was being locked up; the sheer

boredom and waste of life. That's what did it for me, and I vowed never to waste my life ever again.

So, when I entered St Mary's Wharf, I was on my best behaviour. I was asked to confirm my name and had a charge read out to me.

'You are charged under the United Nations Sanctions, Iraqi Cultural Property Order 2003, stealing or knowingly taking Iraqi cultural property. Do you understand the charge?' said the custody sergeant.

After the 'anything you say will be taken down' bit, I held steadfast. My body language didn't give anything away, yet inside I was seething at the ludicrous charge. I sensed the custody sergeant was a bit embarrassed too as he read out the charge in front of Sergeant Sergeant, who was positively beaming with pride. The entire process was demeaning, well, it's supposed to be, but more so for me because I was innocent. I was then asked to take off my belt and shoes then to hand over my wallet, mobile and any other personal items. I watched them getting sealed up in a plastic bag. I was then led away to the fingerprint room whereupon a burly uniformed lass sneered as she rolled my fingers in ink and stuck a stick into my mouth. I suspected she had already found me guilty as her sneering was constant throughout the process. I was then led away to a cell. My solicitor was shown to the guests' room and waited patiently for the games to begin.

I must have been in the same cell as Jim because all the books were for the Eastern European guest. I didn't have long to wait before I was led out followed by my solicitor into a tiny room. There was a small wooden rectangular table, which filled up one fifth of the room, and four chairs, two either side of the table, which took up another two fifths with barely enough room to stretch one's legs. On the table, pushed up against the wall, was a recoding machine of sorts. Present and seated next to each other were Sergeant Sergeant in plain clothes and one other, an older-looking fella, also in plain clothes. They reminded me of the twins, Tweedledum and Tweedledee.

My solicitor prompted me to sit. We sat down together as if we were a coordinated tag team. Under my watchful eye, Sergeant Sergeant proceeded to unwrap two cassette tapes from

their crisp clear polythene and snap them shut in the recorder. I didn't know they still used cassette tapes; guess they are a lot harder to interfere with than digital.

If you have never had the pleasure of being interviewed by the police, well, don't fret, you haven't missed anything, it's exactly the same as you have seen in any modern-day crime drama a hundred times before with the good cop, bad cop scenario. And, oh why do they persist with this staid combination? Well, because it works as an interview technique, and because they are not allowed to call them interrogations, but they are interrogations, they wanted my arse, excuse the pun, they wanted me to spill the beans, they wanted me to grass up Jim, and they have quotas to reach; you do know that, right? And you're just a facilitator to help reach their quota. But what about procedure and due process of law I hear you ask? Well, that went out with Dixon of Dock Green, my dears, as we are now served by a police service not a police force, yes, a service wherein, we, the public, are termed clients or customers, and whose sole job is to rack up as many fines on the hard-working, easy-to-find taxpaying folk as possible. Is fighting real crime, like cleaning the streets of druggies, scammers, muggers, scumbags, blaggers bent bankers, bent politicians and all those Big Tec cyber slags still a police priority? I'm not sure, as a, 'If it ain't nuffin' to do with community policing and quotas, I ain't interested Guv' attitude appears to be the preferred operating choice of today's police service. Anyway, that's how I feel about our police now. It's wrong of course, as common sense tells me, all coppers aren't bastards, but what to do!

You know how interrogators start off: the lead interrogator, which in my case was Sergeant Sergeant, reads out the standard legal statement, verbatim, 'For the record, in the room we have blah, blah, blah', and then he'd introduced his oppo, and in my case everything was played by the book, but I can't remember his oppo's name, but I shall just refer to him as, Harry Snapper Organs from Q Division!

But just before we start, I'd like to give a few pointers, a few interrogation tips should you ever happen to find yourself in a similar position. OK, if you decide your MO is to stay completely still and completely silent in utter defiance of the situation you

have found yourself in, then stay completely still and completely silent, but I wouldn't recommend this old school method if you're caught behind enemy lines, you'll probably get a bullet in the back of the head after they have some fun, and back in a nice warm interview room it takes far too much mental and physical effort to keep up with the play dumb routine and you'll concentrate too much on standing your ground and then you'll slip up. If you decide to take this stance, and like I said I don't recommend it, you're not being clever, defiant or hard, because I guarantee, you WILL fail. Your interrogator will know this technique, it's the first one in their book of, clients interrogation stances, and they will keep you at it for hours, and once again, you WILL fail, please believe me, and don't be surprised if folk in white coats come and take you away for a few hours respite or longer; Section you, even. If you do decide to go hard, then don't rub your nose or scratch your bum or do anything, as that will be interpreted as a sign you are agitated. Even a blink can be read as an indication your defences are breaking down, so you have been warned.

However, personally, I would recommend using the slow movement technique to alleviate any unnecessary discomfort arising from sitting down for long periods as this will not draw any unnecessary expectations on the part of your interrogators. Rub your hands, scratch your nose or bum, but do it in a controlled way even if your nose doesn't need scratching. Raise your butt off the seat slightly, get some air around it, but keep your movements slow and demeanour constant.

Be polite: 'I can't answer that question, sir.'

If you just happen to or prefer to start off by replying, 'No', keep on saying no. Don't deviate by saying, 'No, you fuckin' tosser' or, 'Fuck off, you knob', or, 'Suck on this you cunt,' as this will bring so much joy to your interrogators and they will adjust their interrogation techniques according to their advantage.

You should also make pleasant eye contact, then pick a point over your interrogators shoulders and focus on it. Don't be a twat and give them the ten-metre stare, don't act aggressive, no snorting of derision, no supercilious grinning at a probing question, act subservient and always remember this Latin

phrase: Illegitimi non carborundum translated: Don't let the bastards grin you down.

Let the game commence.

Sergeant Sergeant: 'Is your name Nigel Ely?'

Me: 'I can't answer that question, sir.'

I looked across at Sergeant Sergeant with my poker face, not aggressively, not frowning, just plain old poker-faced and studied his face and body language. He was sweating as he sat on the edge of his chair, eager like, holding the hand of God and ready for the kill.

Sergeant Sergeant: 'Are you not Nigel Ely? You have signed this form stating you are. So, I'll ask the question again. Are you Nigel Ely?'

Sergeant Sergeant was holding up the piece of paper I had signed when I attended my first voluntary interview, the one Big Barry McKay said I should attend. It detailed who I am and why I'd volunteered to attend that particular meeting.

Me: 'I can't answer that question, sir.'

Sergeant Sergeant: 'And please, you don't have to call me sir, call me Sergeant, OK?' 'I can't answer that question, sir.'

'Do you know why you're here?'

'I can't answer that question, sir.'

'I shall jog your memory. You have been arrested under the United Nations Sanctions, Iraqi Cultural Property Order 2003: the alleged theft of the bronze buttock of Saddam Hussein from the statue in Firdos Square, Baghdad on the 9th of April 2003. Do you understand?'

Did he really say buttock? Again, it reminded me of the Tom Hank's film Forrest Gump! Ah, that word 'theft', now we know. Now I get the picture.

'I can't answer that question, sir.'

'It carries a seven to ten-year jail sentence. Would you like to go to jail for seven to ten years?' Of

course, I wouldn't, you idiot!

'I can't answer that question, sir.'

'Your business partner, Mr Jim Thorpe, says you have the buttock. Do you have the buttock?

Wow, he's started early with the 'Jim's a grass' routine. Naive interview techniques. And there he goes again. Concentrate. I

had to keep a straight face as I kept thinking about the Tom Hanks 'buttocks' thing. Please don't say the word 'buttocks' again, I'll burst into fits of laughter. No, come on, Nigel, pull yourself together man. Act professional, don't give the enemy anything.

'I can't answer that question, sir.'

'Jim, Mr Thorpe says you and he are selling the buttock to raise money for military charities, which I think is a very noble cause. Do you think it's a very noble cause?

'I can't answer that question, sir.'

Sergeant Sergeant now dropped his head down to read the next question from a large notebook he held close. I could see his list of questions. Obviously, his brain could only remember three off the top of his head, so I lowered my gaze slightly, and like a schoolboy cheating in an exam trying to read a fellow pupil's paper, I could just make out his list, but in a complete reverse of what I thought his reaction would be, he pushed his notebook towards me, just enough to show me his list was a long list, and this interrogation was going to be long one.

Thank you, Sergeant, for letting me see your notes, but fill your boots fella, I'm in no rush, I've got all day and then some.

'Look, I know you can do seven years standing on your head, after all you've been in the Paras and the SAS and you're a real hero to all of us and to the country, but we don't want it to come to that now, do we, so why don't you just hand over the bronze? Not to me, but to the Property Sergeant, where you can book it in and get a receipt for it and it will be safe.'

My brief sat very quietly, only rustling his briefing notes in response to the sergeant's rather audacious mention of the word safe and a Police Property Sergeant in the same sentence. Sergeant Sergeant carried on. 'I can assure you of that, and if there's a dispute about ownership, I'm sure it can all be worked out. So, will you hand over the bronze buttock?'

Oh, I'm a hero now, am I? Let's get one thing straight here, Sergeant: all the soldiers I know hate – yes, hate – being called a hero, it's probably the most embarrassing term you can use to describe someone from my background. If you must refer to us as something, use vets, veterans or even victims, but not heroes.

'I can't answer that question, sir.'

The interrogation went on for another fifteen minutes, and after a slightly awkward and unprofessional moment when my brief accidentally cut one, passed wind, a mild squeaky effort at that, Harry Snapper Organs took this as his cue to jump in.

'Look, Spud, I served as well, I was in the Royal Engineers and I know how you guys are taught and I respect that, but this is a very serious charge.'

OK, well done, chap, you've done your research and know my nickname, Spud, but don't you think it's a bit informal and very unprofessional to be calling me that? And what's with this 'you guys' bit? What are you trying to insinuate? Are you suggesting you did SAS selection and failed yet you still understand 'the guys', the SAS, or are you inferring we are all buddies, all us ex-servicemen and women, and you can empathise with my cause, but...!

This bloke's a complete knob too!

'Why would you screw up your good name with a custodial sentence? Because the longer this goes on, seven years minimum is what the judge will hand down. Have a long, hard, serious think about it, will you please?'

Ah, he's found me guilty even before going to trial. Another tactic to start me singing.

'I can't answer that question, sir.'

There was a long period of silent intimidation of about fifteen seconds.

'Nigel, the interview has now ended,' Sergeant Sergeant said.

'I can't answer that question, sir.'

He then reached over, switched off the recorder, popped out the two tapes and proceeded to break the lugs off to guarantee they couldn't be recorded over, then struggled to write something on both as I knew he was pissed off. His interrogation had failed. He finally finished whatever he had written and shakily snapped them back in their original cases and sealed them up. He showed them to me in the presence of my brief.

'OK. Happy?' Sergeant Sergeant asked.

I wasn't aware of the procedure, so how could I be happy.

My brief stepped in and indicated to the sergeant everything was above board. He turned to me and said, 'Nigel, it's OK now,

the interview is over, you're free to speak and nothing can be used in evidence.'

Oh, really!

'I can't answer that question, sir.'

23. A Security Service Tip-Off

I live in a quaint, picturesque English cottage a mile down an isolated dirt track in rural Herefordshire. To get to my cottage one has to drive very steadily or you'll bounce all over the place and do yourself an injury. It's an unmade road, riddled with ruts and when it rains these ruts fill deep with water and change the fertile Herefordshire soil into an oozy, thick terracotta clay which turns big, chunky all-terrain tyres into slicks. A tall hedge running either side can make the track in winter seem like a small tributary feeding into the River Wye. I was on my way back from the Derby interrogation when the mobile rang. Iwas fortunate the track was frozen over and Bubba, my old Toyota Hilux pickup, was making easy work of crunching through inch-thick slabs of ice.

'Is that Spud?' an unfamiliar male voice asked using my nick name.

I gave it a couple of seconds. 'Who's calling?' Replying with a question. I don't have much time for cold callers. I know they have a job to do but there isn't much I want these days, perhaps World peace maybe.

The voice came back with another question. 'Are you Nigel, the man with the arse? This is a friend.'

Oh well! It's been a bit of a long old journey with the arse so far and now every man and his dog wants a piece of it. Could it be a potential buyer!

The voice continued, 'This is a friend and this call is not taking place.'

Here we go, not that old chestnut!

'This is a friend,' again the voice declared.

Wow, some line, and did he actually say, 'This call is not taking place'? Yes, he did!

'Yes, mate, it is. What can I do for you?' I asked, resisting the urge to tell him to piss off. 'What's up?'

'You have the bronze arse with you?

He didn't give me time to answer.

'Well, the police want it and they're coming for it.'

'What! What do mean, coming for it? How do you know? When?'

I had to think fast. The caller now warranted some respect, and if he was speaking the truth, and there was no reason why he shouldn't be, unless the guy was a bit of a nutter and just wanted some attention.

'It's no duff,' the voice replied.

'No duff' is really NODUF; an old military communications term. If you say something is NODUF that means it's for real, it's not a joke. So, the guy on the phone using this particular term, told me he was possibly ex-military or more probably a friend in the know in one of the many government security services. Either way I read the situation to be NODUF. I had no choice but to take his call seriously.

'OK. How long do I have?'

'What's today?' The voice asked.

'Friday,' I replied.

'Friday uhmmm,' the voice mused. 'Shall we say Monday then.'

I closed the phone and turned my attention back to steering Bubba. Hell! What are the police up to now? First the raid on Jim's house and business premises, and now my place. Initially, the police thought the arse was still local to Derby, and even with my limited knowledge of how the judiciary works I knew judges don't just hand out search warrants for any notion the police may come up with, I'm assuming a judge will have to look at the evidence intelligently and make a judgement. But what would be the evidence to make a judgement? Would it be a call from some faceless government minister's lackey up in London; part of the old boy's network, part of the Establishment, a creature from the swamp? And why would a judge sign multiple search warrant's? Was Mr or Mrs or indeed Miss Big (at the time of writing there are apparently now, 72 new pronouns I could have used but I'd rather like to keep the narrative flowing if you don't mind) using their influence to try and give Jim and me a damn good kicking, metaphorically speaking! Why? For the sake of Saddam's arse! Why was this saga turning into

something quite pathetic, and a scandalous waste of taxpayers' money? Yes, I felt it was getting all rather pathetic.

I did have the arse with me, it was in the back of Bubba riding shotgun since leaving Derby. The police knew my truck, they had already done a number on Jim's property and interrogated both of us, so why didn't they think to stop and search old Bubba? The evidence was not stacking up. Why eat into the Derbyshire Police budget and go to all the expense of search warrants, interrogations and surveillance and not effect a stop-and-search on an old red Hilux pickup heading south?

Derby is not a large place, one could cover all four points of the road system; north, south, east, west quite easily, and the M1 cuts right past the east side! There was something not quite right. I racked my brain as to why Sergeant Sergeant was operating the way he was, as the image I had up until now of him and his team was pure Keystone Cops! For those of you who have never heard of the Keystone Cops just Google them, you'll then get the picture. It's a silent film series made in black and white in the early 1900s about a patrol of incompetent American cops. Why else would one of Derbyshire Police's finest be acting in this sort of manner? Was it a simple case of utter incompetence? Couldn't be! Surely not!

I stuck Bubba in reverse, made a quick turn and drove off. I'm not a manyana man, if I think something needs to be done, I generally get it done sooner rather than let chance take its course. My first wife was a manyana woman and it used to drive me crazy. I don't trust the State either. I'm not saying I didn't believe the voice at the end of the phone but things change, circumstances make that change. In the army there's a saying: On the wagon, off the wagon. It's nothing to do with stopping drinking alcohol, no, it's to do with being fucked about. For example, an NCO or officer will say, 'Come on, lads, get on the wagon,' so, all excitedly, you climb on the truck to take you home. You sit there patiently for five minutes, then are told to get off; change of plan. This could happen two or three times in the space of an hour. On the wagon, off the wagon—you get what I mean!

I quickly headed to a friend's farm, thinking Plod were on their way right now and not Monday; things change. My friend, a cantankerous old farmer (is there any other kind!) named Andrew was the owner of Letton Court, a beautiful 18th century country estate, but not so old, as it was completely rebuilt in 1921 after a fire burnt it to the ground. It is set in over twelve hundred acres of prime Herefordshire land with mini Capability Brown-style hedges and gardens and a paddock which ran all the way down to an oxbow in the river. What's an oxbow? Well, it's quite a rare feature in a river, an angler's dream; it's where a slow-moving part of a river cuts back on itself forming a U-shaped loop, which then creates a lake in between the looped river. It gets its name because it resembles the bow pin of an oxbow, a wooden frame which goes across an ox or bullock's neck.

I knew the ideal spot to bury the arse. I pulled into a 120-acre field of grass, just adjacent to Andrew's big house and under cover from view, got out and put the front hubs into four-wheel drive. The field was cigar-shaped and ran right along the northern bank of the River Wye, but didn't flood because the land sat thirty or so feet higher than the river, and in the field were three large oak trees, probably three hundred years old, spaced out in an equilateral triangle shape. Oaks are very slow-growing so it's fairly difficult to properly date them without measuring their trunks, but as a general rule fourteen inchesin diameter equals a hundred years of growth, so a four and a half-foot diameter trunk will be about four hundred years old, and that's amazing as it would have been a baby in the reign of Queen Elizabeth I. These three weren't that wide; they were saplings during George III's reign and the Battle of Waterloo. Amazing tree, the oak.

I drove around the headland, pulled up and I decided to pace the distance between the two furthest oaks. The ground was just beginning to thaw and it didn't cut up as badly it might have, so I walked over to the nearest oak, bagged arse in one hand and an old army collapsible trenching tool in the other, which I always carry in the back of Bubba; for the use of! I then took a direct bearing from the furthest oak and marched on. At 150 paces I reached the trunk. The idea was to pick the midway

point between these two oaks, but 150 paces was far too many to gauge an accurate spot. I turned towards the third oak, and that distance looked a lot shorter so I paced that out; seventy-eight. Good. I walked back, following my footsteps, and stopped counting at thirty-nine. I looked around at all three oaks. This was the ideal spot, so with no one about, I started to dig. Once through the frozen turf the going became easy. I went through a foot of topsoil and then into the subsoil; subsoil is the hard-packed earth which has been compacted by a thousand years of working the land, first by human feet, then cattle or horse hoofs and now seven-ton tractors hauling sixteen-ton trailers full of spuds. I continued to dig down to three feet, well past the depth of any plough, dropped the arse in the hole, filled it back in and marched back to the first oak just to double-check my pace count. Thirty-nine steps. Spooky!

It's said, in the world of espionage, the old methods are the safest. In a world of global tracking and GPS you can be pinpointed down to the nearest inch, where government computers can read and learn about all your intimacies and political persuasions, where eyes in the sky can read your vehicle number plate from way up in the heavens and where tiny drones the size of a penny can sit in your bedroom and send back video of all your idiosyncrasies in real time, well, isn't that just dandy ah! One can now understand why the security services and their enemies are moving back to dead letter boxes and X-marks-the-spot methods of operation. Me, I've never stopped using them.

Unless someone saw me digging, the arse was safe. I knew where it was and even if I didn't come back to recover it for a hundred years, I could still find it; the oaks weren't going anywhere. If I got taken out or met with an accident then maybe some metal detectorist would stumble upon it in years to come and make a fortune, or might even get jumped on by Plod, ha-ha.

I didn't want to involve Jim any more than he was, so I told him I wasn't going to tell him the whereabouts of the arse so if the police asked, he could quite honestly say he didn't know. However, I had to tell someone, someone who Jim did not know. I told Old Joe about the thirty-nine steps. Old Joe's a

gnarly old woodsman, about as gnarly as those three oaks and with hands like well-worked granite. Old Joe's been working the land all of his seventy-six years, and he's, well sorry, but I have to write this in the vernacular; a short, stocky, bald as a coot, but fit as a butcher's dog and as hard-as-nails sort of chap. Old Joe keeps telling me he isn't hard but his father was. He says his father was the hardest man he ever knew because as a young lad, Old Joe was given the honour, above his elder brother Tom, of picking almost microscopic splinters of shrapnel out of his father's head courtesy of a German shell, which landed near him during the Battle of the Somme in late October 1916. Old Joe said, 'Dad's left arm was fucked, but you know what? He never once complained, did Dad.'

My Uncle Bert was a hard man too. He was in the water three times during the Second World War. The first time, as a young submariner, he got torpedoed whilst his submarine was on the surface; the second time on board a Royal Navy ship and the third, torpedoed again while on the North Atlantic convoys whilst serving in the Merchant Navy as a seaman. Just think about that for a moment, will you? Three times abandoning ship and Uncle Bert wasn't the exception. It wasn't common but it happened more than one might have thought back then. Now that's hard, real hard; I'm not sure we know the meaning of hard nowadays, do we? We think we do but in all honesty we don't, well, not compared to those who fought in those two world wars, because we now use words such as devastated to describe our feelings about losing a football match. 'Oh, I'm so devastated we lost today.' No, mate, you're not devastated, you might be pissed off but you ain't devastated. I'll let you be devastated if you've lost a loved one or a leg or two in Afghanistan. You can be devastated then, OK snowflake!

Old Joe was happy about the X-marks-the-spot arrangements and the potential legal fall-out that might come his way. He was full of it, 'I won't tell'em nuffin' lad, they can piss off, and anyway, I'm an old-age pensioner, they wouldn't dare.'

'That's right, Joe, they wouldn't dare have a pop at you because you're an old-age pensioner,' I said, not having the

heart to tell him about Jim and his most recent run-in with Derbyshire's finest.

24. The Ten Million-Dollar Arse

Monday. When it rains in South Wales it really rains, and it had been raining all weekend up in them thar Welsh hills, so much so a torrent of water had flowed off the Brecon Beacons at a rapid rate of knots, and as it gathered more pace through Hay-on-Wye it hit the lower reaches of the River Wye like a super-tanker on full steam ahead, sending a wave of ice-cold floodwater down the track towards my cottage, filling in all the dips and ruts and turning the track into a small tributary.

All morning I waited in anticipation for Plod to turn up, only to be let down by a no-show, so rather waste a day I went outside and tinkered with my old Fordson Major tractor, circa 1958. The rain had stopped by now and the sun was just starting to push through when something disturbed a pheasant a couple of hundred metres up the track. Noise can be tricky to pinpoint as it can travel quite a distance depending on which way the wind's blowing even if your ears are tuned-in, but this noise was close. Movement is more direct, more obvious, you see the direction it's coming from. Someone on foot; not an animal, not a deer. No, it was Man. Pheasants aren't spooked by deer or any other creature in the woods, only Man scares pheasants or perhaps a very hungry fox.

I waited to confirm the noise as the pheasant fluttered again. Pheasants are big old lazy birds so if they can walk or run rather than fly that's what they'll do every time. It was definitely Man, only one man, perhaps a hiker, but whoever it was, they were sure on a mission; only a fool would venture down the track today. I moved back into my cottage and watched through the pantry window. I was only half shocked when I saw Sergeant Sergeant in plain clothes struggling across the muddy puddles, through my gate and up towards the cottage. He was making his way to the front door but then checked himself and decided to walk around the cottage towards the rear door which faces south over the garden, probably wanting to have a nosy whilst trying to act a bit cute in the process. Why not just use the front

door like everyone else? Bubba was parked outside, so the chances of me being in were pretty big.

I moved out from the pantry through the kitchen into the lounge and waited. As he passed the lounge I rapped on the window, just to let him know the cottage was occupied. He was startled, then there was long pause before he moved further around and knocked on the door; I guess he thought I'd open it automatically but I didn't. He knocked again, and again, this time with a bit more agitation. I almost expected him to pull out a megaphone from under his coat and call out, 'This is the Police. You are surrounded. Come out with your hands up. Come out, I know you're in there.'

I could sense his tension; I could smell it through the door. I let one more second pass, then opened the door. He was dressed in a green Barbour-style jacket and wearing a pair of very new-looking Wellington boots. No hat though. Although the sun was shining it was still cold out, and forty per cent of one's body heat is lost through the head. Sergeant Sergeant, do cover that bonce of yours or risk getting a head cold!

Now, I'm not one for confrontation but I know how to deal with it should it raise its ugly head. Far too often in my life, my kindness has been taken for weakness and it's always a difficult balance to manage, but over the years I've learnt to manage it just fine, as I'm really not a bad judge of character. For example, I used to allow folk who really didn't know me from Adam, but were, say, a friend of a friend to have a laugh with me, you know, down the pub maybe, and they'd make a slightly sarcastic remark to make them feel loved and I'd just nod and laugh it off, but the thing is, I wouldn't take the mick out of anyone for no reason, especially if I didn't know them, as some folk unfortunately take it upon themselves to do. Anyway, the next time we'd meet, and there's always a next time, they'd try it again and I'd let it go again, but not these days, I'll pull them up on it every time even though it may cause a scene, and now I don't tolerate sarcastic remarks from no stranger any more, and when I verbally defend myself it invariably ends up in tears and the perpetrator is so shocked.

I saw Sergeant Sergeant as being antagonistic; he should have used the front door.

'What d' you want?' I said firmly as I opened the door.

'Can I come in?'

'No.'

'I have a search warrant.'

'Show me.'

'It's in the car,' he said as he shuffled about in his Wellingtons as if his socks had twisted up inside and around his ankles, as cheap wellies tend to do for you after a long walk. 'It's in the car and the car's stuck up the track.'

'How far up?'

'About half a mile.'

'Well, you'd best double away and go get it then,' I said, as I closed the door.

I watched him shuffle back up the track and thirty minutes later he returned this time with two heavies in tow who were also in plain clothes. The two other officers showed me their IDs and the sergeant handed me a copy of the search warrant. I took my time and studied it.

'It's, all in order,' Sergeant Sergeant offered up. 'I'm sure it is, Sergeant, I'm sure it is,' I replied.

The warrant appeared ok, so I let them in. To be fair, they were fine, they even took their boots off when I asked them to as they went about their business upstairs. I unlocked my desk and said they were welcome to look at anything. I had nothing to hide, nothing what so ever, not even my guns, and Sergeant Sergeant was shocked when I did tell him I had guns on the property; I assumed he had done all the background checks on me first, especially for firearms, but by the look on his face he hadn't. Please tell me that's unprofessional! I unlocked the gun cabinet, checked and made safe the guns in front of all three by showing the chambers were empty, just in case they got a bit panicky. Some people do when they see those two little words, SAS and guns together. I get panicky when I see the words police and guns together! They spent about an hour upstairs, rummaging around my smalls, and decided to take away the following items: Loose papers in folder marked Iraq and Kuwait. Newspaper clippings about the arse. All my press cards, UK, Iraq, Kuwait, an out-of-date passport and my Iraqi

diary made an inventory of everything they took and got the sergeant to sign for it, as indeed I signed his inventory. I was really concerned about the diary; if that went missing, I would have to sue the police, but I was told it would be well looked after and returned to me.

'When? I enquired politely.

'After the trial or when all avenues of the enquiry have been exhausted,' Sergeant Sergeant assured me.

They spent thirty minutes outside looking through my workshop and generally sniffing about. The two heavies were more interested in talking to me about war stories and Danny Dyer. I was on my guard all the time as it's a well-known technique to get you to spill the beans; say something that could incriminate yourself and then, 'You're nicked, me old matey,' and at no stage did any one of them ask me if I had the arse, and if not, did I know where it was. Why? As I've said they were very well behaved at all times but never out of search mode. They were cutting about the place like terriers sniffing out rabbits. They had a warrant, so clearly someone upstairs was taking the arse issue very seriously, but why didn't they ask the obvious question? Were they so taken aback by the beauty and splendour of the Herefordshire countryside or concerned about the condition of their car, or had they quite simply forgot!

I heard nothing from the intrepid trio for two weeks, then I got a letter requesting me to, once again attend a meeting at St Mary's Wharf, where I was to be interviewed yet again under caution. The same old questions and the same old 'I cannot answer that question, sir,' then they bailed me and allowed me to carry on with my business, but I had to let the sergeant know, if at any stage, I was planning to leave the country. I have never been bailed before in my life so it was a completely new experience. Surely this entire charade would be over in a month or two and the faceless bureaucrats and innocuous bean-counters upstairs would look at the evidence and the ever-increasing cost and come to their senses, but then my bail was extended for another month and being left in limbo made my family and my business suffer even more. This was the unforeseen consequence of the arse saga because some

unknown, foreigner somewhere had ordered the British police to a DEFCON state of alertness. It made me angry, it made me dig in and I wanted answers from the State.

All Jim and I had ever wanted to do was raise a bit of money for the wounded. Jim had spent a lot of his own money in promoting the arse and getting the concept of War Relic Art out there, and his staff had put in their time too, especially Jane, Jim's PA, all unpaid by the way, in assisting where and when they could. After all, anyone who's registered as self-employed knows how much unpaid work has to be done in order to promote one's business. I didn't seek fortune or fame and nor did Jim, the deal was quite simple; channel any proceeds from the sale of the arse through Barry's route and I was to be the silent donor. I was not to make a penny out of the arse and like I stated earlier, this was my way of giving something back to those less fortunate, but now it was costing me my good name and loss of business.

So, we then formed the company Trebletap (an old SAS/SF shooting saying) to promote War Relic Art and I'd designed a range of bespoke T-shirts based on my military-themed quotes and images, which had never been seen before which were really well received and ready to go. The initial production and design costs were met solely by Jim, and he was in to Trebletap for a hefty investment of tens of thousands of pounds so we needed this arse thing sorted with the police.

Shortly into my second bail month I had to go to Kuwait on a business trip so I called up St Mary's Wharf to let Inspector Sergeant know I was off to the Gulf and if he wanted to stop me, he'd find me boarding the 2200 hours BA non-stop shuttle to Kuwait out of Heathrow on Sunday, and to bring backup because I wouldn't be coming quietly. Inspector Sergeant said it would be probably be OK but I had to tell his sergeant when I arrived back. What! Inspector I hear you scream, yep, and I was shocked too, the dwarf from the wharf had now been promoted to inspector. I was in no doubt his promotion was directly due to his exceptional and diligent work in making such great strides into solving the all-important, and definitely, in the public's interest Bring me the arse of Saddam case. Stuff like this you just couldn't make up.

Kuwait is a mystical far-off land in a searing hot climate; probably the hottest country in the world. Culturally it's a million miles away from Herefordshire. In Herefordshire we drink flagons of cider made from the millions of locally grown apples. In contrast, Kuwait is a dry country under Sharia, so there is strictly no alcohol. Our police do not carry guns, in Kuwait the police carry guns. The Herefordshire borders are steeped in a warring past with its neighbour Wales, while Kuwait still has a warring presence with its neighbour Iraq.

Iraq is a mess; it's much, much more of a mess after a reckless, dangerous Tony Blair took us into this illegal and unjust war on the strength of a fabricated, sexed up Weapons of Mass Destruction dossier. A complete lie.

I have seen first-hand, from day one of the invasion, just what a can of worms Blair, his 2003 Front Bench, his spin doctor Campbell and Powell, Blair's chief permanent bureaucrat had opened up. It's just quite disgusting. The International Criminal Court in the Hague lets our warmongering leaders get away with war crimes and crimes against humanity, yet the UN and the Globalist Establishment including Blair, the gall of the man, are still foaming at the mouth using all their influence to get President Assad of Syria hauled up before the Hague. So why not Blair! Assad is protecting his Sovereign State. Blair invaded one.

You can look at the political motives all you want and try to make them fit whatever reasoning, but there is one thing you can't spin, and that's how badly equipped the British Armywas when Blair sent them off to war. Just on this charge alone ALL of his Ministers must be held to account in a Court of Law, a British Court of Law.

When Blair gathered all his generals around the table in COBRA (Cabinet Office Briefing Room Alpha) for his many war planning meetings, didn't he or any general think about our troop's safety? Didn't Blair or any on the generals say, 'Do we have enough armoured vehicles to carry out boys and girls into battle? I mean, Blair just loves to mention the Good Friday Agreement at every opportunity, so didn't he say, 'OKgenerals, we have just finished a war with the IRA, who's main weapon

used against us was the IED, so what's the risk of the Iraqi using IED's against our troops?' Such an obvious question to ask. Now, I would say the threat of IED attacks on our troops was the biggest threat; not air attacks as Iraq had no airworthy aircraft to speak of, a decimated coast guard Navy, and most soldiers knew the Iraqi Army wouldn't stand either, because history has shown that. And, I've never attended the Royal Military Academy of Sandhurst, the place where all our generals are made and train for this type of warfare. So why weren't us, the people, ever privy to the COBRA transcripts so we could check up on this bastard Blair to see if he did ask this question, and who answered it? I find the whole episode of sending our soldiers into Iraq without the proper kit utterly incredulous. It is beyond treason.

I watched in complete disbelief as the British Army took to hiring soft-skin 4x4s from Hertz and Avis rent-a-cars in Kuwait City to run the daily gauntlet across the most dangerous fifty-mile stretch of no-man's land on the planet, up into APC (Airport Camp), now Basrah International Airport, where the British HQ was garrisoned. The British Army were being shuttled into war in eighteen-seater Toyota coaches and Nissan Pajeros. And then, the area of Southern Iraq was deemed so dangerous, the British Army cut their daily runs, down to weekly runs, and even then, Blair couldn't be bothered, or the political will was still not there, or just not give a toss, to provide our soldiers with at the very least bulletproof vehicles like most PMC's drove around in. It still saddens me today that 37 of the brave 179 British soldiers who lost their lives fighting in Iraq, lost them whilst travelling around in soft-skinned vehicles, and tens of thousands scarred for life, many with body parts blown off all because of Blair just couldn't be bothered to protect our troops with the correct vehicles and equipment. Please, just pause for one minute and try to picture an image of your most treasured possession, your son or daughter, speeding across the most hostile war environment in the world, in full combat gear, less body armour with their SA80 rifle poking out through a side window of a Mitsubishi micro-bus, then tell me Blair shouldn't be put on trial.

I like Kuwait and Kuwait likes the UK. My Kuwaiti friends refer to the UK as the Mother Country, and they all love Winston Churchill, London, Scotland, Wales and, surprisingly Brighton. This time my business kept me in Kuwait only, and thank God I didn't have to venture back into Iraq. I'd lost far too many of my friends who'd been working as PMC's on the rebuilding, or as the Americans called it, the Reconstruction Programme of Iraq. What an appalling waste of life and trillions of dollars. We and America could have re built both our countries failing infrastructure for less.

My business this time was of a less aggressive nature; muscle cars. My Sheikh friend had a long list of engine and transmission parts he wanted me to source in Europe and elsewhere. It was good business as I would buy them from salvage companies in the UK and have them shipped out through me. If the Sheikh tried to order them over the internet or phone, then first there was that language and interpretation barrier, and then the hundred per cent price hike as the seller finds out the parts are to be shipped to the oil-rich State of Kuwait.

During my stay the Sheikh told me about an Islamic art exhibition was showing in Kuwait City and since I was now into art, he suggested we should both attend. I liked the idea since there's not a lot to do in Kuwait when the sun goes down. No pubs, no clubs, just a café racer lifestyle where young and old mingle to drink coffee or fruit juice while people-watching from five-star complexes. Really very boring if you're a Westerner who likes the nightlife. For me, I always see my time in Kuwait as a period of abstinence, reflection and detox. I can understand why their religion is so entrenched within their society because the sun is so powerful and you just can't do much outside during the day, yet when it sets that's when the business starts. Imagine a time before running water and air conditioning, when there wasn't anything else to do apart from sleep, forage for food and water; survive and worship a God; the great creator of a powerful force like the sun. But I have another take on that, maybe religion was invented by the rich to stop poor people killing them.

Canapés and cola were offered. This was a modern Islamic art exhibition where bold yellow, orange and green colours were the fashion. None of it took my fancy but the news networks from around the Gulf region were all there in force interviewing exhibitors, artists and VIPs. Over the years all the Gulf States I've visited like all this pomp and circumstance; I call it a garish trashiness, but I guess it works for the Arabs. The freebies get handed out during these events probably never get taken out of the plastic bags they are received in. Pen sets in cheap cases covered in brushed velvet, glass mouldings of the Kuwait Towers, quality printed glossy magazines full of pictures; next year's car boot clag! Anyway, I was trying to get my head around an abstract scene of a camel in the desert, but I just couldn't see the art in it. It looked like a ten-year-old had painted it. Sure, it was better than I could paint, but still, I'm not a painter. The Sheikh found a microphone to talk into and was giving an interview to the media, so I found myself standing next to the only other Westerner, a man wearing a suit. He was a short, white American, clean-cut with black hair in his thirties.

'I'm a dealer from New York,' he said.

'I'm with the Sheikh,' I replied, pointing him out over by a camera crew, trying to give my presence more meaning than I had intended and wondering why a man from New York should have the accent of a Texan.

'Is he buying?'

'Probably, he likes supporting the arts,' I said politely, not knowing if the Sheikh liked art or not. 'And you?'

'I'm here supporting too,' he replied.

He went on to tell me he buys for America clients and Texas was a big market for him, but not necessarily for Islamic art. He was over in the region visiting. Folk like to use the word region when they want to sound a bit important. The region can mean any of the Gulf area: Oman, Bahrain, Qatar the UAE (United Arab Emirates) such as Dubai or Abu Dhabi, or indeed, now Iraq, since everyone at the time wanted to give the impression, they had experienced Iraq, and you were somehow of a lesser mortal if you hadn't. My guess, he was coming out of Dubai as his hands were far too soft, and not Iraq as his choice of phrase implied.

'You heard of that bronze Saddam's arse?' I prompted. Not sure why I said it, but I just came out with it.

'Yes, of course, it was all over the States. Some Special Forces Brit, wasn't it?'

'Yes, that was me.'

'Hell, really?'

He shook my hand and looked impressed, so I asked him the obvious question.

'What do you think it's worth?'

'Oh...' The New York dealer from Texas paused. 'Easy that, say, seven to ten million.'

It was as if he had already priced the arse up when he first heard about it.

'Dollars?' I said, almost choking on my kofta. 'How, why?' I was truly shocked. He offered up the story of the Mona Lisa as his example to explain his pricing.

'The Mona Lisa wasn't really known outside the art world until 1911 when it was stolen from the Louvre, only then did it become famous and people flocked to look and stare at the blank space it once occupied,' he said, enjoying the moment.

I was enjoying it too—seven to ten million US dollars.

'This painting, no one can tell for certain who painted it. Some say Leonardo da Vinci, others not, but because it was stolen it's now become the most famous painting in the world,' he paused. 'And the most expensive.'

'How much?'

'Ah, it will never come on to the market, yet it's by far the most valuable painting in the world. Last estimate, seven hundred million dollars US.'

'Really!' I gulped.

'Probably a billion if it ever came on to the market, which it won't, and it's not even a good painting. If you saw it at a yard sale, I doubt you'd pay ten bucks for it.'

He had a point. I didn't think the Mona Lisa was that good a painting either. It commanded no attention other than it was once stolen. But did the arse commanded attention because of the monster it represented? I was convinced it did, because one bad word about Saddam meant certain death, and you only have to look back to see how the Shia of southern Iraq or the

Kurds in north were treated by him, I mean, certainly from what I saw first-hand in the south, the people had nothing in their lives and nothing to look forward to, I've seen better African villages where people know they have nothing and will never have anything in this world apart from the instinct to survive, so I can appreciate and understand the significance of the bronze arse more than that of the Mona Lisa, regardless of what one may think it's worth or not. But anyway, what do I know about art apart from what Andy Warhol said and what appeals to my eye.

He continued, 'It's the perception, you see, and of course what someone wants to pay for it. There are hundreds of copies of the Mona Lisa, some rather excellent copies, but only one Saddam's arse,' he paused. I looked across at the Sheikh; it looked like he was almost done with the interview.

'You have provenance?' He eagerly enquired

'Yes,' I said firmly.

25. Arse on the Run

I returned to England with a renewed vigour and keen to let Jim know of the latest arse estimate, but while I'd been away Jim had been re-bailed and was now being pursued like a common criminal. He had been instructed to attend another interview where he was asked a load more bone questions again.

'In the notes we took from your office there is a copy letter to your solicitor advising him you would give him the statue's provenance. Did you give him this?' Inspector Sergeant enquired.

Jim explained he had intended to but never got round to it. He assumed the inspector would ask for this proof, but he did not. This was another stroke of luck or just pure incompetence on the part of Inspector Sergeant and his fellow interrogator. Again, Jim had no intention of giving the police more information than they were asking for. However, once again he told them he didn't trust them one bit and said straight to Inspector Sergeant's face, 'I find your whole line ofquestioning very unprofessional like', and for some strange reason Jim tempted them with a bit of appeasement and said, he'd agree to surrender the arse to the Court if he knew where the arse was, which of course he didn't. Maybe he wanted to show some goodwill, after all, he was under the cosh as he was right on Plod's doorstep, easy to pick up, and a soft target to beat up on being an OAP, but the inspector said that surrendering the arse to the Court would not be possible, it must be surrendered to the Police. Later, Jim and I found his answer very odd but accepted it. Anyway, it didn't matter as I wasn't about to surrender the arse to anyone. Equally, Jim wasn't at all fazed when I told him about the American's valuation. Jim's been in sales all his life and knows the power of exclusivity. Art, old, modern or abstract, has always been seen as an investment, a bit like gold and silver, but with art one can at least appreciate it, or try to, and we both knew we should keep the arse's new valuation under wraps until we could get Plod off our backs,

otherwise, whoever it was ordering about the British Police and the British justice system, would be chomping at the bit to whatever Government Minister when they got wind of the seven-to-ten price tag.

Over the following months the police bailed Jim and me seven times. The first couple of bail hearings I had to report to St Mary's Wharf, which was such a bind for me, having to drop work and travel all the way up to Derby just for the police to tell me they were still continuing with their enquires. I always took these opportunities to have an overnighter and discuss tactics with Jim. We would plot our next moves over a pint of Burton's, but we felt we were heading for a stalemate as the police started to prolong the issue, and the foreign political impudence from whoever had made the arse complaint had gone, had tailed off, or so we were led to believe. But, unbeknown to us, behind the scenes, the police were actively pursuing this case as hard as they could, and the CPS, whose job it was to take the police's evidence and make a case stick, was just as aggressive in their attack on the arse, yet all this was kept oh, so secret from Jim and myself until I received another rather odd phone call, this time from someone at the CPS end.

'We [the CPS] do not have a specialist on UN law so are spending a lot of money out of our budget reading up,' the voice paused, 'it's an utter waste of our resources and could never end in a prosecution. This is a civil matter, not criminal. You'd do well to look up the Iraqi Ambassador in London,' the caller then hung up.

Well, if you believed in that call, then we had another friend on the inside! But I was going to play careful with this new, possible piece of disinformation? No, of course I wasn't!Attack is always the best form of defence, so Jim and I went on the attack. We were going to force the hand of the State to put up or shut up. I called the Iraqi Embassy in London, told them who I was and asked to speak to the First Secretary, one always asks for the First Secretary to get to the Ambassador, but it seemed the First Secretary had run away as he wasn't available to talk to me. So, after several more attempts, I decided to change tack, and as was my right as a British citizen, try the Parliamentary

chain-of-command route. I managed to secure a meeting with my local MP, a Tory, not that that should make any difference, as an MP's job is to represent ALL their constituents, but as soon as I mentioned the Arse, he couldn't wait to walk me out of his office. I knew it was a long shot because MPs feel more comfortable cutting ribbons and obfuscating than looking into a waste of taxpayers' money, anyway, that's how I saw it. Ah, useless, cowardly Establishment swamp creatures.

Jim wrote to the heads of the Derbyshire Police Command. The process of writing is a fast one but receiving replies back from the police is incredibly slow; it was slow for a purpose because they, the CPS, and whoever the hell else was pulling the strings wanted to beat me and Jim down with their bureaucratic truncheons, they wanted us to lose heart, they wanted us to hand over the arse to them and subject it to the Police Property Act and a Court of Law and for us to say, 'It's a fair cop, Guv.'

Look! I don't mind a Court of Law to determine true ownership, but if they thought were going to hand it over to the duty Lost Property Sergeant, they were deluded. We may be old soldiers but we ain't that thick, we're made of sterner stuff. We are patriots. I know that may come across as a bit naff in these days of political correctness, wokeness and concerted efforts from some political quarters, such as the Globalists to paint this country's patriots as raving nationalists, but Jim and I are from a breed who look after our own and don't pander to some State-driven ideology of appeasement to a bunch of unelected foreign Internationalists, and certainly not without due process of Law. I would quite happily surrender the arse to the Court and I know the process of law in this country, any case, has to be heard in a Magistrates Court first off, and here, the arse, in spirit, Jim and I would be in and out of the dock very quick because a case of such importance would only pass through a Magistrates Court as a point of procedure. It would have to go to Crown Court, and if it went to Crown Court then the person or persons, and all those State apparatchiks, British and Iraqi, who were crying out, making the claim, it's my arse, it's my arse, would have to attend Court; Jim and I would make them. Then, the Bring Me the Arse of Saddam merchants would have their cover blown, and be exposed to public outrage and ridicule.

Also, if the attention the arse got at the auction was an indication of just how newsworthy it was, can you imagine how much more interest there would be if the arse ended up in the Crown Court of England and Wales? Can you imagine all the jokes which would come out about the Derbyshire Police and the CPS for their alleged complete mishandling of all who persecuted the arse? And the cost, yes, the cost, would just increase beyond all proportions!

I wrote to Derbyshire Police with a Freedom of Information Request for the cost of the arse case so far, and guess what? They refused to release any figures; they just nonchalantly refused my request.

So, as usual when David fights Goliath, the run-around was just beginning. Attack, attack, attack. I had a friend who had been working in the legal industry for over thirty years, and once I'd briefed him on all the police and CPS hanky-panky, he gave me a very conservative figure for the arse case's cost to the taxpayer of £93,000 so far, even before it had seen the inside of a courtroom. My legal fees were being paid by the taxpayer via Legal Aid, as per my right.

I've fought all my adult life, whether as a soldier for Queen and country, as a military advisor or PMC or as a photojournalist and author, writer for people's freedoms, and have always been right up there on the front line of that fight, and you know what? Sometimes, it's not always about what's legal or illegal, it's about what's right and what's wrong, and if you know something's not right you must forget the law and follow your heart. I was trying to help others while others were helping themselves, perhaps, for their own financial gain or warster. It was all so British Establishment, Trappings ofState, snouts in the trough stuff, and I wasn't going to be pushed around. I believe in our Legal Aid system, it's the last bastion available for the hard-up, less wealthy working or retired man or woman, disabled or unemployed, to try to extract truth and expose any wrongdoing, and I also believed my lawyer was one of the good guys, he was on our side; the side of right.

I know all about fifth columnists and spies in the camp and small-town nepotism, and poor solicitors wanting, waiting to climb that ladder into the judges' chambers, whilst not wanting

to rock the boat of local politics. I heard it first-hand from my own solicitor. Years ago, in Hereford, I was gazumped on a house purchase (a scandalous practice where by owners, mainly driven by unscrupulous estate agents, scare the buyer into upping an agreed price on a house purchase, pretending someone else has come in with a better offer; illegal in Scotland, where a handshake stills means something), and I wanted to go round and tell the estate agent just what I thought of them. These critters had driven my wife to tears while I was away in London on a tense counter-terrorist op (is there any other?) and I wanted to return their words. My solicitor was dead against me going around to the estate agents.

'Nigel,' she said, and I can still hear her words today, as crisp as when she told them all those years ago, 'do not upset the equilibrium of Hereford.'

And that's when it all clicked; as a young SAS trooper I realised we weren't all in it together, and some were in it for themselves. The Hereford Mafia, I heard it called once; the gracious and the blessed making it all good for the Plebs. Yeah, give me a break.

I was up against the Establishment; a system I regarded, well, up until now, as fair and just (and I'm the wrong side of 50 so how fucking naive is that). I have been a working guy all my life. I've never had anything handed to me, no silver spoon, no nothing. I've had to fight and graft for everything, and I'm not talking about material stuff either, and I learned from everything I've gained, and everything I've lost. I left my secondary modern school not knowing how many exams I passed. I really didn't like school and just wanted to get out into the big world and taste it, not read about it from behind a desk. I might have ended up in jail if I hadn't joined the army, I was pretty sure on that. The army gave me direction, a sense of pride. I saw and learned the meaning of honour, courage and duty on the battlefields of Northern Ireland, the Falklands, and took what I'd learnt into other wars such as Mozambique, Afghanistan and Iraq.

I needed to understand why the State wanted to prosecute me so badly. I started to read up on the law and educated myself on the procedures, while Jim devoured the entire United

Nations Cultural Property manual, to such an extent he is probably now the country's leading authority on the subject. I say this because I was told by another insider, yes, we have our insiders, State-paid supporters inside the wire, feeding us snippets, and one told me there was no so-called expert in the entire country who the CPS could reasonably put on the stand to defend the United Nations Sanctions, Iraqi Cultural Property Order 2003, so the CPS were forced to find a volunteer, a retiree, and put them on a mega hourly rate by any working man or woman's standard to figure it all out. Let's say a junior legal working for the government rate of £100 plus per hour working with the CPS, sitting at home and reading up, shovelling pieces of paper and sending through anything he or she deemed relevant to the case of the alleged stolen arse. Once again, nice State work if you can get it.

Set against that, Jim was so well-read, he would, if the arse ever made it into Court, certainly upset the equilibrium. He would destroy any prosecution to do with the United Nations Sanctions, Iraqi Cultural Property Order 2003 and if the CPS knew that, perhaps they'd find a way to subpoena him with a big note to treat him as a hostile witness or even try to turn him; every man has their price! But then again, it's not always about the money.

Jim's weapon was time; he had time on his hands. His company ran itself and to be honest, Nicola said to me, 'Please keep Dad away, we're OK running it. Can you keep him occupied?'

'Sure,' I said.

I cajoled Jim into a bit of further education and he did fantastically well. He found many discrepancies and flaws in the police and CPS case; it wouldn't even pass muster with a day one, week one law student.

The United Nations Sanctions, Iraqi Cultural Property Order 2003 article in question has never been invoked previously—ever! I was the first person in the whole wide world to be charged with it, and yes, I really do wear it as a badge of honour. And, historically, similar claims have always been classified as civil matters, that's to say, two people have a disagreement about who owns what, it's not a criminal matter, it's a civilone,

and why should the taxpayer be burdened with the expense of a trial? But the head-down-arse-up policy of the police and the CPS just kept pushing on, further and further into the pot of our tax paid money—scandalous really.

Jim said there was also the question of identification. 'It's ludicrous, they [the police] don't even know what the arse looks like. OK, they've seen it in your photos but they don't know for definite. Do they? And what about the complainant? Does he or she even know what it looks like? And, could they test it scientifically? Against what? Another piece of the bronze? No, of course not, because how would we know if it's from the same statue?'

'Could be from the head, if it still exists,' I said.

I was right; the only other piece the CPS could test the arse against was the hand I saw a marine cut off, and that would be acceptable as it could easily be identified through photographs. But would the CPS budget stretch to that expense? And who would conduct and oversee the test? It would have to be a neutral entity, and would they ever get permission? I doubt the USMC would give permission. Why would they stop money being raised for military charities and fight for the right of some Iraqi apparatchik to fill his or her pockets? And, there was the issue of the demand for the arse's return. It was only made after I created that demand and classified the arse in my own art genre, and of course, when I attached a six-figure sum to it. Hell knows what will happen when they hear about the millions it could now be worth. Stand by! And there were still so many inconsistencies, real schoolboy errors. The CPS' claims were embarrassing as I was always led to believe when the CPS is deciding whether to prosecute or not, they should look at the evidence. They actually use two criteria to work on. For example, their first criterion, in their own words: Is there enough evidence against the defendants? And, if that evidence is to be used in Court, is it reliable and credible?

The CPS must at least be satisfied there is enough evidence to provide a realistic prospect of conviction against me and Jim. Well, they have failed on that one, so let's try their next criterion: Is it in the public interest for the CPS to bring the case to Court? Now, the key word here is public and not the CPS'

interests! Again, in the CPS' own words, a prosecution will usually take place unless the prosecutor is sure the public interest factors tending against prosecution outweigh those tending in favour. Where is the public's interest in racking up tens of thousands of taxpayers' money for a complaint madeby a faceless, nameless and I'm assuming foreign national?Where is it? There isn't any, there is no advantage to the public in pursuing a conviction against me or Jim, and it's not evenlegal because no official request or demand for the arse's return has ever been made to me, the rightful owner of the artwork. Equally, I made the arse what it is, it is my creation and it would be physically impossible to separate some of the object from my artwork, and any attempt to do so would probably cause irreversible and expensive damage to my artwork, the arse! And, I completed my artwork before anyone, anywhere claimed the arse was subject to any United Nations SanctionsOrder.

The end of Police Phase 1 of the arse case was thought to have been timed to perfection by Inspector Sergeant. He waited until my solicitor was on holiday (after being given the dates by my solicitor, only out or pure courtesy) then issued a PressRelease advising there was no proof the arse had, in fact, been taken from the original statue and therefore they were dropping the charges. Jim and I were notified in writing the following day and assumed Inspector Sergeant regarded this as a piece of clever manipulation!

Police Press Release Statement

Two men arrested on suspicion of breaching Section 8 of the Iraqi Sanctions Order 2003 have been released without charge.

The pair, aged 67 and 52, were arrested in January following claims the 52-year-old had illegally imported a piece of a statue of Saddam Hussein. The statue was toppled in Firdos Square, Baghdad, in March 2003 and it was alleged the piece had been put up for auction in Derby but not sold.

Under the order, anyone possessing Iraqi cultural property must give it to the police.

The Iraqi Government made a complaint via the Iraqi Embassy and Derbyshire Constabulary launched an investigation.

A spokeswoman for the force said: 'Despite a thorough investigation, the piece alleged to be from the statue has not been recovered and we found evidence to cast doubt on the authenticity of its origin.

'As a result, the men have been released from bail and the Iraqi Embassy has been informed of this outcome.

'It is disappointing a large amount of police time and resource has been required to investigate the claim this item was genuine. If any new evidence comes to light, or if the item is traced and is shown to be genuine, further police action will be taken.'

The paragraph I found particularly funny was this one: Despite a thorough investigation [oh, really!] the piece alleged to be from the statue has not been recovered and we found evidence to cast doubt on the authenticity of its origin.

The fact of the matter is, they didn't find any evidence to suggest it wasn't the real arse, they were just covering their own arse and making Jim and me out to be liars, a comment which I found very unprofessional, and I was quite appalled at how low the police could stoop in order to justify their position; a typical arse covering excuse.

It was becoming clear a very influential Iraqi was pursuing the arse, and later I heard a story about a legal representative from the Iraqi Embassy in London had marched into Scotland Yard, the Met's (Metropolitan Police) HQ, citing UN Iraqi Cultural Property 2003 article and demanding the return of Saddam's arse from the Firdos Square statue, and probably fully aware most of it had been hacked to pieces by the locals and the bulk of it had been hauled out of Iraq into Jordan and melted down for scrap.

The Met was obviously concerned about all the bad publicity which would come from such an arse issue, so how could they palm it off? By luck and good fortune, they managed to come up

with a valid reason. You see, as no alleged arse offence had taken place in the Met's jurisdiction, they quite skillfully passed it on to the Derbyshire Police because the original attempted sale, the auction, had taken place in up in Derby. But what should have happened is, someone in the Met, should have grown a pair and told the Iraqi representative to sling his hook as they had better things to do, and if they were so keen on getting it back, they should take civil action. I have known many specialist operators in the Met, and I can tell you they are very hard-working dedicated professionals who have stopped numerous terrorist attacks in the UK and really did have better things to spend their time on; a friend, a serving member of the Met, told me they were really lucky to dump what was potentially a rather nasty political case on to the Derbyshire Constabulary and were very happy to do so.

I smelt a rat, an Establishment rat, and these apparatchiks are the worst. We all know there are two laws; one for the Establishment and one for honest, decent folk from all other ranks of society, and when the Establishment gets a sniff of big money, those in positions of influence and power start to snort, and when you challenge this snorting grimacing Establishment, they will go after you. (One need look no further than Brexit to understand what lengths the Establishment would go to get their own way. The then Prime Minister Cameron threatened the people of the United Kingdom with a 'World War III...' if we voted to leave the European Union. Really! Utterly disgusting. Similarly, if that wasn't enough of a threat, the then Chancellor of the Exchequer, Gideon Osbourne, (yes, I know he changed his name to George to sound more like one of the boys and not some privileged Tory swamp critter) followed up with, the markets would collapse and every family in the UK would have to pay £4300 more per year. And equally false and disgusting remark, so I had to flush out the rat. I decided to take the arse on an outing around the greatest city in the world, London, to see who would come out of the woodwork, who dare raise their head and demand, 'Bring me the arse of Saddam.'

My good friend Duncan Raban helped me and organised the tour of London. He's a way-out-there professional photographer of some note, and certainly worth a Google. He

would document the tour. I was first introduced to Duncan when he shared a flat with my brother way back in the early '80s. Very recently back from the Falklands War, I'd been out on the beer with my brother and so had crashed out on the floor of his apartment he shared with Duncan, but unbeknown to Duncan, he didn't know about my sleep-over, came in during the early hours and saw me crashed out he gave me hefty kick.

'Who the fuck are you?' he demanded.

Without warning I jumped up and put him in a Vulcan death grip until I realised where I was. My flashbacks and post-traumatic stress disorder are still as common now as they were back then.

I recovered the arse from the thirty-nine steps and drove to London, sparrow's fart on a Saturday morning and RVed with Duncan in the West End. Duncan planned an entire photo shoot of famous London landmarks. Duncan snapped the arse in front of a London bus. I have to say the bus driver was extremely tolerant about his forced stop. I wasn't sure if he knew what the large piece of bronze was but he accepted he wasn't going anywhere fast. Then, while Duncan was busy taking pictures we were joined by several passing tourists, all armed with cameras and who started to snap away in unison, grateful for the chance of capturing something different to add to their portfolio of London landmarks. By now the bus driver was starting to get irritated so I calmed him down, and to my surprise he recognised the bronze arse so we were OK for a few more seconds, and by the time we moved off a large crowd had gathered and all cheered and wished us and the arse the best of luck. We then moved on to outside St Paul's Cathedral where we drew an even bigger crowd, and then off to the British Museum and actually managed to sneak it pass the security and it into the Norman Foster Room 4, the great Egyptian exhibition, where the arse stood proudly alongside a giant pharaoh, before being escorted off the premises by friendly but ever so mortified security staff.

We then jumped into a black cab and headed off to Buckingham Palace, Big Ben and the Houses of Parliament, then across to the Imperial War Museum and then finished up

at Damien Hirst's Golden Skulls exhibition. This was going to be a bit tricky as walking into any place with a big heavy-looking bag over one's shoulder would surely raise an eyebrow or two. It would require a combination of my SAS skills and Duncan's sleight-of-hand talents. A quick brief and a short eyes-on told

The Arse with its disciples outside St Paul's Cathedral.

us there was only one staff on duty at the front desk and the place was empty of customers. The gallery was fairly narrow, say fifteen feet wide by twenty feet long, with a small 'L' shape off to the right at the back. I walked in first, and as planned, I walked up to the young male behind the counter and immediately engaged him in conversation about buying a golden skull and talking about how great and inspirational Damien's art was so this got him thinking about his commission and he completely forgot about Duncan who'd come in a several seconds after me. We were in and out within three minutes, and to be honest, we could have robbed the place blind. Art worth tens of thousands was there for the taking that day. I couldn't make out any cameras but if there were our entrance would make great viewing. But we are not dishonest fellows, and Duncan managed to get some brilliant photos, which he

published in an attempt to bait the Iraqi out into the open; but to no avail.

Were we at a stalemate? It was beginning to look more likely I needed to get the Iraqis' blessing in order to sell the arse then we could split the profit fifty-fifty. I really thought that was fair, so I called up the First Secretary at Iraqi Embassy in London only to get fobbed off again. I fully understood Iraq was having a massive number of internal issues back home, but I knew these London-based diplomats were having the time of their lives, some of them drinking, dancing and gambling all night long. I was at a dead end. The person or persons who had been ordering poor old Plod around were not playing, and neither were Plod, they had gone quiet too. Were they expecting the arse to show itself again? Were they ready, lying in wait, ambush-like, ready to grab the arse and me and bang me up for seven to ten years, or had they just run out of options and money? I doubt the last one, and when Jim tried to arrange a meeting with the police, someone in the Chief Inspector's office stated they had lost the Arse File. You really couldn't make it up, but this was a game and I understood when big bucks are involved, folk can bide their time.

Some weeks later Brigadier Abdul flew into London for a short break from the sun and wanted to discuss a potential buyer. I wasn't sure if it was someone from the Gulf region or aRussian or whoever. He invited me to stay in his apartment just off Marble Arch and around the corner from a place called Connaught Square. The Kuwaiti are like owls, they only ever come out at night, so it was a dark, dank evening when I crossed Connaught Square carrying my overnight stuff in a small sports grip (I travel light and not with one of those rather sissy small rucksacks, well, not since 7/7) and quite by coincident, Connaught Square houses the Tony Blair family, and as I made my way past his front door, I felt the intimidating ten-metre stare from his armed guards, and that was OK, because these police were only doing their duty. I had no problem with that. Anyway, as I moved on and made a left into Connaught Street there stood a single shadowy figure by a gate, set back off the street. A male, armed, another member of Blair's protection

team. He advanced two paces out from the shadows, MP5 variant slung across his chest looking rather like a rotund Robocop.

'Evening, Officer,' I said cheerily, not in the slightest bit intimidated by his presence.

He sensed this too, so stood his ground and stayed silent. It's an alpha male thing, I think!

'Mate, you certainly picked the short straw,' I said.

'Not sure what you mean,' he replied.

'Well, looking after the traitor Blair. I'm surprised no one's shot the bastard dead by now.'

The policeman snorted, not sure what to make of my comments. These guys are trained to take abuse so he could suck it up easy. It surely must be a punishment posting to be put on Blair's protection team, and I couldn't imagine anything worse than risking one's life for a war mongering war criminal scumbag. Maybe they won't take a bullet for him! I certainly wouldn't, I'd rather see one put in him if it were him or me!

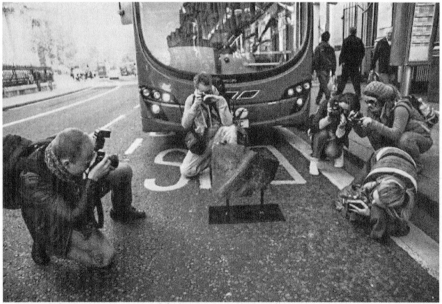

Fans of the Arse just couldn't get enough of it!

The Arse and the Pharaoh.

The Arse exhibiting alongside Damien Hirst's Golden Skulls Exhibition.

I wasn't sure whether he'd seen my grip or not; grips like the one I was carrying are used to carry weapons because of their easy access and easily to ditch if one had to bug-out quick, and he would know that, but if he had seen my grip he didn't let on. Instead, he came up close, probably to get a better picture of whoever was slagging off his boss, and politely, but firmly said, 'Not on my watch.' I thought, Bravo, bravo, great answer. Then someone with a foreign accent shouted so I turned and saw the brigadier waving. We met, embraced one another with the customary Arab thing of cheek-kissing in full view of the tubby Robocop then headed off across the road to The Duke of Kendal pub for light refreshments.

'Saddam's arse?' Brigadier joked pointing to my grip.

'No Brigadier, Saddam's arse is now on the run.'

To be continued ...

Printed in Great Britain
by Amazon